# Cultural Mediation in Europe, 1800-1950

# CULTURAL MEDIATION IN EUROPE

## 1800-1950

EDITED BY

Reine Meylaerts,
Lieven D'hulst &
Tom Verschaffel

LEUVEN UNIVERSITY PRESS

ISBN 978 94 6270 112 0
e-ISBN 978 94 6166 240 8
D / 2017/ 1869 / 52
NUR: 694, 654

Lay-out: Frederik
Cover design: Dogma

GPRC
Guaranteed
Peer Reviewed
Content
www.gprc.be

# Table of Contents

# Introduction

REINE MEYLAERTS (KU LEUVEN),
LIEVEN D'HULST (KU LEUVEN) & TOM VERSCHAFFEL (KU LEUVEN)

This volume aims to deepen our understanding of the figure of the cultural mediator, defined here as a cultural actor active across linguistic, artistic and geocultural borders and as such the central carrier of cultural transfer. In addition to the more traditional focus on linguistic and geographical border crossing in which cultural mediators are involved, this definition crucially wants to stress the need for a comprehensive view of the *process* of transfer, the *overlap* of actor roles, and the crossing of artistic fields. The contributions in this volume will deal with well-known and less well-known cultural mediators such as Georges Hérelle and Valery Larbaud (**Auzoux**), James/Diego/Jaime Clark (**Serón Ordóñez**), Hendrik Willem Mesdag (**Suijver**), Christian Zervos (**Kangaslahti**), Thomas Brown and Alexander Hamilton (**Toremans**), Marcel Breuer (**Sebestyén**), Georg Herwegh (**O'Connor**), Fredrik Pacius, Richard Faltin, Robert Kajanus and Martin Wegelius (**Kurkela and Rantanen**), Walter Mehring (**Weissmann**).

Among the disciplines dealing with complex forms of intercultural interaction, Translation Studies and Cultural Transfer Studies stand out as influential candidates. They have witnessed the last decade an increasing attention for the nature and effects of the role played by the social and cultural agents who are involved in the process of interlingual, intercultural, international and interdisciplinary interaction.

## Translation Studies

Translation Studies, and more in particular one of its most successful subfields Descriptive Translation Studies, has long mainly focused on texts and other types of discursive products (Even-Zohar 2005, Toury 2012) as a privileged way to analyze and explain cultural transfer and cultural history. However, "by focusing on the study of various and variable norms as the 'very epitome' [...] of a target-oriented approach, Toury's model for Descriptive Translation Studies has privileged collective schemes and structures instead of individual actors. It has lent itself to research into texts and their discursive embedding in a broader sociocultural and political context"

(Meylaerts 2008, 91). Definitely, this approach has given valuable insights in the dynamics of literary and cultural history worldwide. Nonetheless, these outcomes should not make us blind for the pitfalls of such a discursive approach that should also be understood as "a form of rationalization that undermines the active role of those who are involved in the process. This [...] undermines, hence leaves unexplained, the negotiations, struggles, tensions" (Buzelin 2005, 206) that accompany all possible transfer processes. These negotiations, struggles and tensions are embodied by the social and cultural agents involved in the intercultural interaction, in the first place the translator.

Since more than two decades now, Translation Studies increasingly witnesses a focus on the literary translator, as a result of a growing interest in sociological approaches (Simeoni 1998, Pym 1998, Gouanvic 1999, Sela-Sheffy 2005, Wolf 2007, Meylaerts 2008). Many studies have been devoted to the role of translators in spreading literary forms, genres, ideas etc. (Chung 2009, Angelelli 2012, Vorderobermeier 2014). Concentrating on the translator role mainly, they do however rarely take into consideration the versatile nature and overlap of agent roles that crucially characterize mediators, as we understand them here. As such, they only partly grasp the complex transfer processes that make up cultural history.

The expression '*cultural* mediator' was first introduced in 1981 by Taft, referring to a "person who facilitates communication, understanding, and action between persons or groups who differ with respect to language and culture" (Taft 1981, 53)[1]. Nowadays, and more specifically in response to increased globalization and immigration, the concept of '*inter*cultural mediator' refers to (sometimes still untrained) people, working in refugee camps, hospitals, police stations etc., who "translate, interpret and do whatever else is necessary to reduce the linguistic, cultural and institutional barriers in favour of their client" (Katan 2013, 90). Unlike the traditional professional translators and interpreters they are not bound to text equivalence, suffer from low status and uncertainty. Although this definition has no link with literary and cultural transfer as defined here, it points towards a given plurality of roles and situations that we claim is needed when studying cultural mediators and their role in complex transfer processes.

In other words, in order to understand such processes and their role in cultural history, we need a much more open category than the ones conceptualized so far by Translation Studies. As is shown by the contributions in this volume, we need a category that leaves room not only to the versatile nature but also to the actual overlap of agent roles of cultural mediators because it is precisely the connection between various (successive or simultaneous) roles which defines to a large extent each role separately (see e.g. D'hulst 2014, Lobbes 2015, Meylaerts 2011, 2013, Meylaerts 2014, Gonne 2015).

A too strong focus on the supposed specificity of a cultural mediator as a sole translator is untenable both from an analytical and historical viewpoint. It makes indeed little sense to split up agents' activities along scholarly or disciplinary lines for mainly two reasons. First, several roles may be tied together by the same agents and secondly these roles' interdependency may change their mutual properties. Several studies have indeed already pointed to the fact that successful translators in general have combined different roles. Marc Gouanvic (Gouanvic 2005) e.g. showed how Boris Vian managed to introduce American science fiction in France because he attended meetings of science fiction amateurs in France, and because he published critiques of science fiction literature and fragments of his translations in various French periodicals. In her study on Martha Muusses, Petra Broomans (Broomans 2006) states that if translators want to mediate successfully, they should combine several functions. She observes how cultural mediators, which she interestingly also calls missionaries, or soldiers, are often simultaneously active as critic, publisher, editor, librarian, author, literary historian or literary scholar. Yet, all these roles remain confined within the field of literature. Without denying the central role of literary studies in approaching cultural transfer and cultural history, we need ways to account for the dialectics of field-transgressing, overlapping agent roles and their function in intercultural transfer. This is not new in itself: we know that the literary, artistic, etc. fields are only *relatively* autonomous.

Yet our disciplines and their related concepts make us partly blind for what otherwise should be evident. **Serón Ordóñez** in this volume studies polyglot Diego Clark, a multilingual author-translator-editor-journalist, who wrote poetry and political articles in Spanish, and whose Spanish translation of Stuart of Dunleath (1851) was a summarized version based not on the English original but on an intermediate French version. As such, he "escapes the clear-cut translator identities into which translation theorists often fall" and illustrates the "potential complexity of mediation roles" (Serón Ordóñez). In **Weissmann**'s article we read how poet, cabaret artist, playwright, novelist, journalist and translator Walter Mehring was a star in 1920s Berlin. As is shown by **Auzoux** in this volume, next to translating Joyce's *Ulysses* and publishing parts of the novel in his journal *Commerce*, Larbaud was also giving conferences on the Irish author within the Parisian networks in which he was involved. The first complete French *Ulysses* (1929) was the result of a collaborative translation in which both Joyce and Larbaud were involved. In his role of reviser of the French translation, Larbaud was inspired by his own short story cycle *Amants, heureux amants* for depicting the female characters in *Ulysses* a less libertarian way. Studying mediators of French theatre in Germany during the first half of the 19th century as a group, Christophe **Charle** concludes that they all conducted

different parallel activities (translator, writer, playwright) among which it is impossible to discern the most important one. Such observations illustrate the usefulness of going beyond the study of individual mediators towards group profiles of mediators which could/should eventually lead to questioning literary, translation and transfer studies' artificial focus on an actor's single role. The most open definition of mediators in this volume (**Kangaslahti**) is based on Bruno Latour who characterizes mediators as "people or things that transform, translate, distort, and modify the meaning or the elements they are supposed to carry". Typically, Latour opens up the concept to both the human and non-human and, unlike Translation Studies' traditional focus on equivalence, stresses the idea of transformation, change. Kangaslahti analyzes the role of publisher, art director, production designer, editor-in-chief, and critic Christian Zervos, "not simply in the global diffusion of artworks, but in the process by which they became art". When **Toremans** qualifies Romantic periodicals as cross-cultural mediators, this echoes Latour's view on non-human mediators. Although Latour's definition of mediators is not widely applied, not in this volume nor within Translation Studies, it opens interesting avenues and deserves to be further exploited.

## Cultural Transfer Studies

Next to Translation Studies, we have mentioned Cultural Transfer Studies as another discipline dealing primarily with intercultural interaction. Indeed, cultural mediation is not limited to literature or text oriented intellectual activities, but is evenly essential in the visual arts, music and film, and the so many aspects of cultural production and practices where media and genres are combined and intertwined. Cultural Transfer Studies examines the literary, musical and artistic exchanges between two or more geo-cultural spaces in a specific historical context, paying large attention to the relation between cultural encounters and the construction of cultural identities. Transfer practices are analyzed in close relationship to their historical context and to the different networks through which the objects or ideas are transferred. Additionally, the way the transferred objects are integrated and sometimes reinterpreted in the receiving culture is taken into account. In this sense Transfer Studies show some similarity with the above mentioned definition of Latour. Also, as **Toremans** in his contribution rightly observes, "soon after Espagne's and Werner's work on cultural transfer in the late 1980s, the relevance of the notion [of transfer] for Translation Studies was suggested by Itamar Even-Zohar in a programmatic article on "Translation and Transfer"". More recently, "repositioning translation and transfer in terms of mediation, Göpferich provides an interesting entry into the study of cultural transfer in British periodicals", which

**Toremans** convincingly applies in his study of *The Edinburgh Review*. The methodological links between Translation and Transfer Studies as illustrated by (D'hulst 2012) provide for Toremans "a firm basis for an analysis of cultural mediation and transfer in Scottish Romantic periodicals and the agents, institutions and techniques involved". In her contribution on translators-mediators in the Irish *Nation* newspaper, **Anne O'Connor** also combines translation and transfer studies.

Under the influence of anthropology, micro-history and *Alltagsgeschichte*, Cultural Transfer Studies focuses less on discursive products and more on the materiality and organization of mediating practices and individuals. These individuals are precisely defined as cultural mediators, i.e. the carriers of cultural transfers whose (institutional and sometimes discursive) mediating practices are studied: their role in transnational and trans-regional networks (art houses, societies, academies, publishing houses, periodicals, salons etc.) in transferring cultural products into another culture (Espagne 1999, Charle 2004, De Vries 2008, to name but a few). The contributions in this volume testify of the importance of networks each in their own way: not only literary circles like the Ateneo de Madrid, the Sociedad del Gato but also the Federal Republican Party facilitated Diego Clark's mediating activities, (**Serón Ordóñez**). Kate **Kangaslahti** focuses on "the review as a network for the diffusion of modern art", in her case the *Cahiers d'Art* (1926-1960), run by the Greek born but Paris based Christian Zervos. Sometimes mediators take on very powerful roles in a variety of networks. So e.g. Willem Mesdag's (1831-1915) positions "on the committees and boards of several important art associations" gave him "a key role in the Dutch art world" and the power to make and break careers (**Suijver**). As a key figure in the "extensive network of modernist architects, designers and journal editors", Marcel Breuer was able to "reach a broad audience" (**Sebestyén**). Obviously, many of these networks were truly international, even if they were used to construct a national culture, such as music in Finland (**Kurkela and Rantanen**). Cultural Transfer Studies moreover stresses the merging of and the reciprocity between diverse transfer activities taken up by a cultural mediator: e.g. being a migrant, a painter, a literary critic, an art dealer, a multilingual writer and a translator. Willem Mesdag was a banker who combined the roles of artist, collector and entrepreneur. **Suijver's** contribution reveals how "Mesdag's background as a banker drove him to create opportunities to sell his own work, buy art for his collection and establish a museum. His different roles complemented one another".

Sometimes Cultural Transfer Studies focus on border regions and historical contexts that are characterized by the vicinity and mixture of neighboring cultures (Cortjaens 2008). Still, actual studies in cultural transfer mostly focus on exchanges between two national cultures (e.g. Charle 2007, Konst

2009), thus reproducing the idea of 'fixed nations', 'static' national entities and binary exchanges. In order to overcome the limited focus on the function of transfers in the sole receiving culture or on a bipolar, binary framework of two nations, from 2000 onwards, Werner and Zimmerman have developed the concept of *histoire croisée*, studying crossing points or points of intersection where cultures meet and where the various elements involved can be affected (to a different extent) by the exchange (see Werner 2004). *Histoire croisée* thus stresses the reciprocity of transfers on all the cultures – including the source culture – involved in the exchange process. In this sense, it joins the concept of cultural appropriation, which implies that the input of ideas, values and forms, which is essential for the formation of a culture, is not a matter of passive reception but of agency (Frijhoff 2007). While acknowledging the strong German influence on music in Finland, **Kurkela and Rantanen** in this volume warn against its "uncritical use", "repeating an old conventional viewpoint, methodological nationalism, which oversimplifies the actual diversity of musical influences and transfers". Instead, the "late 19th-century music festivals in Finland formed a complicated network of local, national, and transnational interdependency". Drawing on Vertovec's transnational approach, Kurkela and Rantanen emphasize that "cultural transfer is seldom based on one-way traffic" but usually "based on multipolar exchange of influences": in Finland "French, Russian, and Scandinavian music was highly popular in the Finnish cultural repertoire, and 'German' orchestral musicians came from various national backgrounds". Painter-designer-architect-teacher-industrial Marcel Breuer was a "true cosmopolitan" and "key figure in the extensive network of modernist architects, designers and journal editors" who distributed his tubular steel furniture through advertisements, exhibitions, articles and lectures but "his tubular steel furniture was also widely used and mediated by other advocates of modernism" such as "Sasha Stone in Germany, Mark Oliver Dell and H.L. Wainwright in Britain, and Jozsef Pécsi and Ernö Bánó in Hungary" (**Sebestyén**). In her contribution, Anne **O'Connor** rightfully stresses that "Irish cultural nationalism benefits from being studied in a European context. She furthermore refers to "entangled histories" to describe the way in which "Alphonse de Lamartine was regularly translated into English by Irish poets and [he] even came to visit the *Nation* newspaper which allegedly inspired the foundation of his own paper *La Patrie* (…). Lamartine's poetry was translated into German by Georg Herwegh and Herwegh's poetry was translated in Ireland".

The contributions in this volume approach cultural mediators from a plural methodological and disciplinary viewpoint, taking into account their plural activities and plural roles and the various ways in which these activities and roles interact and influence each other. If we want to improve our understanding of cultural history, we need to be aware of the fact that the

paths of cultural history are not linear nor unidirectional. National histories do not follow fixed monolingual or territorial schemes, but are as they are conceived and told, as such characterized by cultural exchange and mediation (Berger 2008). This is not new in itself. Still, the study of cultural mediators, clustering a variety of dialectically interacting roles, and thus transgressing conceptual and disciplinary boundaries, makes us critically aware of what should otherwise be evident. It does not make sense to split up fields nor to split up mediator's activities. Rather than being concerned with finished end products within national borders and within a single field, an analytical focus on cultural *mediators* and their transfer *processes* makes it possible to study cultural transfer and cultural history as they develop and change over time. Studying the correspondence process between the actors involved, **Auzoux** discovered that Larbaud adapted the female characters in *Ulysses* according to his own poetics and that the translation was a collaborative process. Cultural transfer in *The Edinburgh Review* is a process combining a wide array of refraction modes **Toremans** rightly observes. **Kurkela and Rantanen** describe the creation of national musical culture in Finland as "a long-lasting process, in which German music and musical culture were transformed and translated to a prominent part of modern national culture". The notoriety of Breuer's design work in the international cultural sphere was the result of a process in which articles, advertisements and photographs in architectural periodicals and illustrated magazines crossed linguistic and geo-cultural border (**Sebestyén**). The mediator is the window through which we can observe shifts in cultural history. "We need histories that describe the meshing and shifting of different spatial references, narratives in which historical agency is emphasized, and interpretations acknowledging that the changing patterns of spatialization are processes fraught with tension" (Middell 2010, 161).

In sum, cultural mediators perform strategic transfer roles, create new mediating practices and institutions and are therefore the true architects of common repertoires and frames of reference that make up cultural history. Their complex, partially overlapping roles, which transgress linguistic, artistic, and spatial boundaries form important cultural practices but are rarely acknowledged as such nor studied at large because they transcend the traditional binary concepts of disciplines like translation studies or transfer studies. These binary concepts prevent us to see the complexity of both the mediators' roles and their mediating practices. As a consequence, the study of cultural mediators and their transfer activities, as is illustrated by the contributions in this volume, should be

• interdisciplinary and collective, bringing together methods from Sociology (Kangaslahti, Charle), Translation Studies (Toremans, Auzoux, Serón

Ordóñez, O'Connor, Charle), Transfer Studies (Toremans, Sebestyén, O'Connor, Kurkela and Rantanen, Weissmann, Charle), Cultural History (Suijver, Toremans, Kurkela and Rantanen, Weissmann, Charle);
- process- and actor-oriented, in order to discover the complex intersections of which cultural products are the surface result;
- start from the assumption that transfer techniques have to be studied in relation to each other (D'hulst 2012) and that "le débat académique opposant transferts, comparaisons et croisements se résout de lui-même dans la recherche empirique" (Charle 2010). Each in their own way, the contributions in this volume confirm that the complex roles of cultural mediators in cultural history can only be grasped if writing, translating, quoting, paraphrasing, commenting, refracting, rewriting, publishing, criticizing, summarizing, editing, publishing, designing, are studied in relation to each other.

This book is divided in three well-balanced parts, each covering aspects and using methods deemed crucial as indicated above. The first part focuses on actors, the second part on journals and the third part on politics.

**Inmaculada Serón Ordóñez'** study of James/Diego/Jaime Clark (1844-1875) shows how binary oppositions such as native-foreign and national-international fall at short when it comes to understand the process of imposing new versions of a well-known and even highly prestigious foreign author within Spanish literature during the last third of the 19th century. It may come as a surprise that this process was initiated outside Spain, by James Clark, a British-Italian chameleonic mediator translating from German, English and French into Spanish. He is the author of the first Spanish Shakespeare collection that was rendered directly from English (1873-1874), an enterprise that has been keenly conducted together with other agents, i.e. critics and publishers.

In her contribution, **Renske Suijver** deals with the famous Hague School painter Hendrik Willem Mesdag (1831-1915). His status as a crucial player in Dutch artistic life by the end of the nineteenth century not only depended on his success as an artist, but mainly on the complex intertwining mediating roles he took up, together with his wife Sientje van Houten, as an entrepreneur, collector, organizer of exhibitions, and as a board member of several (important) art societies. Thus, mediation meant power. Mesdag, who started his career as a banker before he took up painting (mainly trained in Brussel), could make and break careers, using his position and network both to support young artists, Dutch and foreign, while never losing his own position and commercial interests from sight.

Valery Larbaud (1881-1957) is generally considered one of the most prominent French translators at the turn of the 19th and 20th centuries.

However, as is argued by **Amélie Auzoux**, he has never been studied from a broader perspective of intercultural mediation, although his numerous transfer activities cover political as well as literary issues, while his translations of English, Italian or Spanish are accompanied by historical and theoretical writings on foreign literature (including also Portuguese, Russian and Romanian) and on translation theory. Going against the grain of emerging and ambient nationalisms, Larbaud acts in favor of a model of literary cosmopolitism that is plurilingual and pluricultural and at the same time takes a strong stand against upcoming fascism in Europe.

In part two, **Tom Toremans** looks at the role played by translation and translators in a Scottish journal, *The Edinburgh Review*, during the emergence phase of 19th century Romanticism. The policy of this journal is a token of the strategy designed by Scottish actors to by-pass the English intellectual and cultural retreat from world literature through the development of an intense transfer activity applied to many cultural domains such as literature, philosophy, and politics. This activity favors translation from a wide array of continental Europe sources (France and Germany, Scandinavian and Eastern European countries) but also the Orient. Toremans shows how critical and translational mediation serves the growth policy of a smaller culture.

**Ágnes Sebestyén** explores the mechanisms of cultural mediation by studying the success of bent tubular steel furniture, invented by Hungary born architect and designer Marcel Breuer. He had studied himself and later taught at the Bauhaus, where he was a self-conscious promoter of both his own work and modern design in general. Later on, he worked in Berlin, Budapest, London and the US and became a key figure in the international network of modernist architects, designers and journal editors. Journals like the German *Das Neue Frankfurt* and *Die Form*, the Swiss *Das Werk*, and the Hungarian *Tér és Forma (Space and Form)*, were instrumental for Breuer's (self-)promotion. Breuer's "highly biased, highly self-referential publication system" shows "constructed representations that significantly affected the way contemporaries perceived architecture defining what was fashionable and popular".

**Kate Kangaslahti** focuses on the *Cahiers d'Art* (1926-1960), run by the Greek born but Paris based Christian Zervos. The journal characterized an abundant but carefully orchestrated use of photography and marked the ascendancy of the visual essay as a means of knowing art. It brought contributions from artists themselves as well as from an important array of international writers whose analyses were to become key texts in the narrative of modern art. As a result of the breadth of his own aesthetic curiosity and the network of talented artists, writers and dealers he fostered within and beyond France, Zervos brought a wider world of art to Paris;

conversely, through the international circulation of his journal, particularly influential in the US, Germany and Switzerland, he exported a heavily Parisian vision of contemporary art worldwide.

In the opening chapter of part three (politics), **Christophe Charle** discusses a common framework for the study of cultural mediation and more specifically for the large array of functions mediators assume within the numerous cultural domains where they are active. Reflecting upon the research that has been done concerning three specific themes – the circulation of theater between Germany and France during the first half of the 19th century, the intellectual mediation of new ideas and intellectual currents but also the resistance of local academic culture within and beyond Europe, and the artistic mediation in post academic era – allows him to distinguish different types of mediators and various (economic, symbolic) values, but at the same time to show that the rich diversity of mediating figures and activities "obéit donc à un certain nombre de règles générales et permet donc des généralisations entre domaines analogues ou entre pays ayant atteint des stades similaires de la vie culturelle". Therefore, he pleads for research, which does not limit itself to the study of specific cases and to show and explain the diversity, but also develops more general insights in cultural mediation as such.

**Anne O'Connor** uses translation history to widen our understanding of cultural exchange in the 1840's and 1850's and creates new perspectives on historical, political and cultural debates of that period. She discusses how translators who published in the *Nation*, the newspaper of Irish nationalists of the time, mediated between cultures and questions how European literature was framed by a nationalistic agenda. These nationalists chose within European literature and political ideas those elements that were most suited to the Irish situation and thus attest the existence of an "international nationalism" and of what Joep Leerssen has coined as "viral nationalism". The latter concept refers to the speed with which texts, ideas and tropes traveled through Europe. From Italian for instance they did not translate work by Mazzini or Leopardi, but a sonnet from the rather obscure eighteenth-century poet Vincenzo di Filicaia. To its title 'To Prostrate Italy' the words 'read Ireland' in parenthesis were added, thus suggesting that it could be read as a poem on Ireland and Italy. Like other examples, this illustrates, O'Connor argues, "the perceived transferability of national sentiments".

The chapter 'Germany as a Cultural Paragon' by **Vesa Kurkela and Saijaleena Rantanen** highlights the 'translation process' by which music and musical life in Finland were more or less Germanized at the end of the nineteenth century. Its 'modern' music life, with the foundation of the first symphony orchestra (1882), the Finnish National Opera (1911), the Finnish Musicological Society (1916) and other institutions, was established during

this period, which also saw the first symphonies (1900-1902) and other orchestral music by Jean Sibelius and the concept of a 'national style'. All this happened in constant interaction with foreign musicians and writers, mostly from the German speaking countries. Crucial to this process were a "handful of active individuals", both Germans and Finns, all trained in Germany, and working as composers, choirmasters, but also as university teachers, critics, music publishers, importers of pianos, organizers of festivals.

**Dirk Weissmann** finally addresses the emergence of the artistic avant-garde in Germany between 1910 and 1930: he shows in particular how cultural mediator Walter Mehring intertwines in an unprecedented way three cultural forms: the art of cabaret, plurilingual writing and transnational exchange. This intertwining lies the foundation of two new esthetic concepts, i.e. the concept of a transnational literary work of art (*internationales Sprachkunstwerk*) mixing German, French and English, and the concept of rag-time of languages (*Sprachen Rag-Time*) on the background of the first jazz wave in Europe. Again, such efforts also deprive languages and artistic practices from a specific national and cultural identity.

This collection is a selection of papers presented at a conference on "Cultural mediators in Europe 1750-1950", organized at KU Leuven in June 2014. The editors wish to thank the participants at the conference, the scientific and organizing committees, and KU Leuven Conference and Events Office for their strong commitment, and the Research Fund of KU Leuven and FWO Flanders for their generous support.

## Notes

1   This being said, the term mediator is used in Translation Studies, but in a quite different context. The very general view on the translator as a mediator between cultures became popular already in the 1980s when the so-called cultural turn put emphasis on the cultural context of the translated texts more than on the linguistic equivalence between source and target text (Katan 2013, 84). Again, this did not imply any conceptualization in terms of plural and overlapping transfer roles: mediators were reduced to their status as translators.

## References

Angelelli, Claudia V. 2012. *The Sociological Turn in Translation and Interpreting Studies*. Amsterdam/Philadelphia: John Benjamins.

Berger, Stefan & Lorenz, Chris. 2008. *The Contested Nation: Ethnicity, Class, Religion and Gender in National Histories*. Basingstoke: Palgrave Macmillan.

Broomans, Petra. 2006. "Martha Muusses en de drie M's. Over de studie naar cultuurbemiddeling." In *Object: Nederlandse literatuur in het buitenland.*

*Methode: onbekend. Vormen van onderzoek naar de receptie van literatuur uit het Nederlandse taalgebied*, edited by P. Broomans, S. van Voorst, S. I. Linn, M. Vogel, & A. Bay, 56-70. Groningen: Barkhuis Publishing.

Buzelin, Hélène. 2005. "Unexpected allies: how Latour's network theory could complement bourdieusian analyses in Translation Studies." *The Translator. Special Issue: Bourdieu and the Sociology of Translation and Interpreting*, guest-edited by Moira Inghilleri no. 11 (2):193-218.

Charle, Christophe. 2010. "Comparaisons et transferts en histoire culturelle de l'Europe. Quelques réflexions à propos de recherches récentes." *Les cahiers Irice*.

—, Julien Vincent, and Jay Winter. 2007. *Anglo-French Attitudes: Comparisons and Transfers between English and French Intellectuals since the Eighteenth Century*. Manchester: Manchester University Press.

—, Jürgen Schriewer, and Peter Wagner. 2004. *Transnational Intellectual Networks: Forms of Academic Knowledge and the Search for Cultural Identities*. Frankfurt am Main: Campus.

Chung, Yu-Ling. 2009. "Translators as social agents: translated fantasy books in Taiwan." *New Voices in Translation Studies* no. 5.

Cortjaens, Wolfgang, Jan De Maeyer, and Tom Verschaffel. 2008. *Historism and Cultural Identity in the Rhine-Meuse region / Historism und kulturelle Identität im Raum Rhein-Maas*. Leuven: Leuven University Press.

D'hulst, Lieven. 2012. "(Re)locating translation history: from assumed translation to assumed transfer." *Translation Studies* no. 5 (2):139-155.

—, Gonne, Maud, Lobbes, Tessa, Meylaerts, Reine, Verschaffel, Tom. 2014. "Towards a multipolar model of cultural mediators within multicultural spaces. Cultural mediators in Belgium, 1830-1945." *Revue Belge de Philologie et d'Histoire* no. 92 (4. Special issue: Belgian Cultural Mediators, 1830-1945. Crossing Borders, Borders Resisting.):1255-1275.

De Vries, Annette. 2008. *Cultural Mediators: Artists and Writers at the Crossroads of Tradition, Innovation and Reception in the Low Countries and Italy, 1450-1650*. Leuven: Peeters.

Espagne, Michel, and Middell, Matthias. 1999. *Von der Elbe bis an die Seine. Kulturtransfer zwischen Sachsen und Frankreich im 18. und 19. Jahrhundert*. Leipzig: Leipziger Universitätsverlag.

Even-Zohar, Itamar. 2005. Polysystem Theory (Revised). Papers in Culture Research, http://www.tau.ac.il/~itamarez/works/papers/papers/ps-revised.pdf.

Frijhoff, Willem. 2007. *Dynamisch erfgoed*. Amsterdam: Sun.

Gonne, Maud. 2015. "Recyclages, croisements et transferts dans l'œuvre de Georges Eekhoud." *Revue d'Histoire Littéraire de la France* no. 2:391-407.

Gouanvic, Jean-Marc. 2005. "A Bourdieusian theory of translation, or the coincidence of practical instances: field, 'habitus', capital and 'illusio'." *The Translator. Special Issue: Bourdieu and the Sociology of Translation and Interpreting*, guest-edited by Moira Inghilleri no. 11 (2):147-166.

—. 1999. *Sociologie de la traduction: la science-fiction américaine dans l'espace culturel français des années 1950* Arras Cedex: Artois Presses Université.

Katan, David. 2013. "Intercultural mediation." In *Handbook of Translation Studies* edited by Yves and Luc van Doorslaer Gambier, 84-91. Amsterdam-Philadelphia: John Benjamins.

Konst, Jan, Inger Leemans, and Bettina Noak. 2009. *Niederländische-Deutsche Literaturbeziehungen 1600-1830*. Berlin: Ruprecht Verlag.

Lobbes, Tessa, and Meylaerts, Reine. 2015. "Cultural Mediators and the Circulation of Cultural Identities in Interwar Bilingual Belgium. The case of Gaston Pulings (1885-1941)." *Orbis Litterarum* no. 70 (5):405-436.

Meylaerts, Reine. 2008. "Translators and (their) norms: towards a sociological construction of the individual." In *Beyond Descriptive Translation Studies: Investigations in Homage to Gideon Toury*, edited by Anthony Pym, Miriam Shlesinger, and Daniel Simeoni, 91-102. Amsterdam-Philadelphia: John Benjamins.

—. 2011. "Stijn Streuvels en Camille Melloy: schrijven en vertalen in België." *Zacht Lawijd* no. 10 (2):49-69.

—. 2013. "The Multiple Lives of Translators." *TTR Traduction, Terminologie, Rédaction* no. XXVI (2):103-128.

—, and Gonne, Maud. 2014. "Transferring the city – Transgressing borders.Translation, bilingual writing and selftranslation in Antwerp (1850-1930)." *Translation Studies* no. 7 (2):133-151.

Middell, Matthias & Naumann, Katja. 2010. "Global history and the spatial turn: from the impact of area studies to the study of critical junctures of globalization." *Global History and the Spacial Turn: from the Impact of Area Studies to the Study of Critical Junctures of Globalization* no. 5 (1):149-170.

Pym, Anthony. 1998. *Method in Translation History*. Manchester: St. Jerome.

Sela-Sheffy, Rakefet. 2005. "How to be a (recognized) translator: rethinking habitus, norms, and the field of translation." *Target* no. 17 (1):1-26.

Simeoni, Daniel. 1998. "The pivotal status of the translator's habitus." *Target* no. 10 (1):1-39.

Taft, R. 1981. "The Role and Personality of the Mediator." In *The Mediating Person: Bridges between Cultures*, edited by S Bochner, 53-88. Cambridge: Schenkman

Toury, Gideon. 2012. *Descriptive Translation Studies – and beyond: revised edition*. Amsterdam-Philadelphia: John Benjamins

Vorderobermeier, Gisella. 2014. *Remapping Habitus in Translation Studies*. Amsterdam: Rodopi.

Werner, Michael & Zimmermann, Bénédicte. 2004. "Penser l'histoire croisée: entre empirie et réflexivité." In *De la comparaison à l'histoire croisée*, edited by Michael & Zimmerman Werner, Bénédicte, 15-49. Paris: Seuil.

Wolf, Michaela, and Alexandra Fukkari. 2007. *Constructing a Sociology of Translation*. Amsterdam & Philadelphia: John Benjamins.

# Part I

# Actors

# James/Diego/Jaime Clark: Shedding Light on the Translator who Sparked Modern Spanish Translations of Shakespeare

Inmaculada Serón Ordóñez (University of Málaga)

## Abstract

This chapter presents the first major Spanish Shakespeare collection which was rendered directly from English (1873-1874). It provides an intriguing case of how binary oppositions such as native-foreign and national-international can be challenged by translation history. Its only translator, barely known to date, was not Spanish and Spanish was not his first language. Indeed, James, Diego or Jaime Clark, as he was named in different moments of his life, was born and raised in the multicultural Naples of the Bourbon Kingdom of the Two Sicilies, in a British family. Moreover, he studied for several years in Germany before moving to Spain at the age of 20. In Madrid and Barcelona, he translated from German, English and, also, French into Spanish, and he published political essays, press articles and poems written originally in Spanish. His ten Shakespearean plays transformed Spanish Shakespeare history, doing away with the norm of translating from French, which was replaced with the norm of translating directly from English. Furthermore, they provided a model for translating in verse, in contrast with the prosaic tradition; this model is still today taken as a guide to capture Shakespeare's variety of styles in Spanish. Combining a range of approaches including transfer studies, translation sociology and descriptive translation studies, the present case study delves into this key agent's cultural transfer activities and maps his artistic networks with the ultimate aim of working towards a research methodology that comfortably embraces his and other similarly complex mediation roles.

The significance of 'Jaime Clark' (as he is currently known) in the history of Spanish Shakespeare was for the first time acknowledged in the 21$^{st}$ century (Campillo Arnaiz, 2005b). This awakening to his Shakespearean translation

work can be attributed to its influence on subsequent Spanish translations of Shakespeare, an influence which became more evident than ever at that point, for two reasons. Firstly, we had then the hindsight allowing us to discern that his translations did away with the norm of translating Shakespeare from French, replacing it with the norm of translating directly from English. Secondly, one of the most renowned contemporary translators of Shakespeare into Spanish, Ángel Luis Pujante, who – it should be mentioned – is a Professor in English Philology, had stated that he undertook his translation because he deemed it necessary to create a new version that followed Clark's in its systematic respect for Shakespeare's variety of styles (specifically, alternation between prose and verse, and between blank verse and rhymed verse) (Pujante, 2001: 24; 2006: 364). In the philologist's opinion, this respect – which can be traced back to the German translation by August Wilhem Schlegel – was lacking in modern translations (although a tendency towards greater respect for Shakespeare's words can be observed in translations subsequent to Clark's; Serón-Ordóñez, 2012).

Whereas the Shakespearean work of Jaime Clark is now being duly recognised[1], he himself remains a virtually unknown figure. However, the little that is known of him suggests that he deserves a closer investigation. In an obituary brought to light by Campillo Arnaiz (2005b: 28-29) and written by a minor Spanish playwright named Francisco Pérez Echevarría, Jaime Clark was presented as a Neapolitan man of letters who, born in 1844, had started studies in Mechanical Engineering in Dresden but given them up to follow his literary vocation, and wrote a number of works, in addition to his Shakespearean translations, after moving to Spain to learn Spanish. These works include translations of German poets, such as Heine, Uhland and Rückert, articles of manners and politics, and a travel account, as well as unpublished comedies (Pérez Echevarría, 1875: 422). Pérez Echevarría also referred to the identity of Clark, whom he admired, mentioning that the distinguished Hispanist Johannes Fastenrath did not know whether to call him an "English-Spanish, Italian-Spanish or German-Spanish poet" (Pérez Echevarría, 1875: 422; my translation). In this regard, Campillo Arnaiz has speculated on Clark's supposed Anglo-Saxon origin on the basis of the dedication that opens his Shakespearean translations, a dedication written in English for a supposed uncle of his named Joseph Ruston (whom Campillo Arnaiz mistakenly relates – albeit tentatively – to the engineer who headed the Lincoln-based British firm Ruston, Proctor & Company).

The tangled identity of Clark, with Italian, German, Spanish and, apparently, English components, is perhaps the first intriguing aspect of his figure. Next come his multifarious activities, with Spanish translations of both English plays and German poems, as well as original writing in Spanish in the form of plays and articles on customs, politics and travel.

The following section looks at Clark's life, completing the picture to a large extent. After this section, I delve into Clark's professional activities and institutional networks, revealing new, noteworthy data. In the last section I reflect upon the complexity of Clark's figure and mediation role.

## Clark's life

As stated in the aforementioned obituary by Pérez Echevarría (1875), Jaime Clark was born in 1844. The records of the British Chaplaincy in Naples confirm the birth data provided by Pérez Echevarría (Church of England, 1830-1860). Additionally, they provide further details which have allowed me to determine with almost full certainty that the translator belonged to a family of English engineers who moved to continental Europe to work in the shipbuilding industry. The person to whom his Shakespearean translations are dedicated was, according to information that I present below, Joseph John Ruston, the owner of the well-known Danube Steam Navigation Company (commonly known as the 'D.D.S.G.').

Joseph J. Ruston (London, 1809 - Vienna, 1895) was the first son of the owner of a London shipyard and worked as an apprentice engineer at the leading British steam engine manufacturer Boulton, Watt & Co (Kurzel Runtscheiner, 1931-1932: 97-98). After winning a contract to build two steam ships for the D.D.S.G., he left the United Kingdom in 1832 to settle in Vienna. At the time, the D.D.S.G. was run by another Briton, John Andrews, and only had one steam ship, designed by James Watt of Boulton, Watt & Co. When Andrews died in 1847, Ruston took over the firm, including a new shipyard that had been established in Prague in 1840. This shipyard, for which Ruston previously built steam ships, had been managed since 1845 by Ruston's youngest brother, John Joseph Ruston (London, 1820 - Gmunden, Austria, 1873), who left the United Kingdom for this purpose[2].

Different records of the British Chaplaincy in Naples show that Clark's parents, James Clark and Sarah Anne Swenerton, married in Naples on 19th June 1840, and that they had five children: Isabella Anne Clark (baptised on 2nd April 1841), Agnes Elizabeth Clark (baptised on 18th December 1842), James Clark (baptised on 25th February 1844), Mary Alicia Clark (baptised on 17th May 1846) and Joseph Ruston Clark (baptised on 26th December 1847) (Church of England, 1830-1860). Note the middle name of the youngest child, Ruston to which I will return later. Clark's father was an engineer, according to the inscription on the tomb of his mother in the English Cemetery in Naples, which reads: "Sarah Ann CLARK, died 13th January 1848 aged 33 years. The wife of James Clark, Engineer" (Malta Family History, 2001-2012).

In a commentary on Ferdinand von Schill and German literary works dedicated to him, Johannes Fastenrath, who seemingly had a close relati-

onship with Clark[3], inserted a biographical note on the translator. This note provides the key clue that relates the Clarks to the Rustons. It was actually this note that led me to the latter family of London engineers, as well as to refute Campillo Arnaiz's hypothesis that James Clark was a nephew of Joseph Ruston of the Lincoln-based firm Ruston, Proctor & Company. According to the note, Clark had to travel to Vienna in 1869 for family reasons, to visit an uncle who had settled there, and stayed in Vienna and Prague for six to seven months (Fastenrath, 1874: 221). A thorough investigation of both the activities of Ruston, Proctor & Company during the 19th century and the life of its owner (which are well documented; see Hill, 1974, and Wade, 2006) ruled out the possibility of Clark being related to this engineer. There is no record of the firm operating in Austria or of Ruston having settled there. However, the case of the D.D.S.G. and its eventual owner is very different, as I have explained. The company operated firstly in Vienna, then in Vienna and Prague. The name Ruston seems to be a middle name, which appears in the translator's brother's name, Joseph Ruston Clark, as pointed out above.

James Clark was thus born in Naples because his parents had settled there. In his biographical note, Fastenrath mentions that Clark's parents were English (Fastenrath, 1874: 220). He also indicates that the translator spent his early life in Naples and that, at 17, he was sent to Dresden because his parents expected him to study Mechanical Engineering (Fastenrath, 1874: 220)[4]. Its register of students includes Clark from 1861 to 1862 (one academic year only, as opposed to the three he spent studying according to Fastenrath) (Matthias Lienert [University Archive Director], personal communications: 20th April and 4th May 2015). Fastenrath reports that Clark met Spanish students in Dresden and quickly learned Spanish ("in a few months"; my translation) driven by the enthusiasm that reading Calderón, Cervantes, Lope and other Spanish Golden Age authors had sparked in him (Fastenrath, 1874: 220). Clark headed to Spain from Germany in spring 1864,

Figure 1. Notice of Clark's death. Source: *El Imparcial*, 2844, 17th April 1875.

according to Fastenrath[5], where he lived for approximately ten years, until his death in April 1875. His death in Vienna was announced by the major Spanish newspaper *El Imparcial*, in a notice that recognised him as a "very well-known man in the republic of letters for his Spanish translation of Shakespeare's works" ("Sección de noticias", 1875: 3; my translation) (see Figure 1).

This brings me to Clark's professional endeavours, which extend beyond translating Shakespeare, as we have seen in both this section and the introduction, and is stressed below.

## Clark's professional activities and institutional networks

While my search for details of Clark's personal and academic background produced results in Italy, Germany and the United Kingdom, as well as in Spain (some of these results have been omitted for being irrelevant), my search for information on his career has only produced results in Spain. It is therefore this country that dominates the current section as the setting for the translator's career.

According to Fastenrath (1874: 220-221), as from his arrival in Spain, Clark concentrated almost exclusively on learning Spanish. The first record that we have of his work in this period is a note under the poem "Los tres gitanos" by Nikolaus Lenau ("Die drei Zigeuner", originally) in his anthology of German poetry *Poesías líricas alemanas* (1873). This note indicates that the poem was composed in Madrid in January 1865 (Clark, 1873c/1879: 143). According to the corresponding notes under the other poems in the anthology, Clark continued translating for the anthology, both in Madrid and in Barcelona, until its publication in 1873.

Until now, his first published work was thought to be his collection of political articles *El guía del buen ciudadano* (Campillo Arnaiz, 2005b: 29). However, my research has revealed that this was preceded by at least a translated novel and possibly also an article of manners. They were published in a newspaper and a magazine, respectively, which is in line with Fastenrath's (1874: 220-221) statement that since Clark arrived in Spain, he wrote for newspapers and magazines.

An article of manners was mentioned by Fastenrath as Clark's first work. According to him, it was published in January 1865 in the Madrid weekly *La Ilustración Española y Americana* under the title "Una Noche-buena en Alemania" (A Christmas Eve in Germany). However, *La Ilustración Española y Americana* was launched in 1869, so Clark's article could not possibly have appeared in this magazine, especially considering that it was supposed to be his first work (his collection of political articles had appeared in 1868). One might immediately assume that Fastenrath mistook

*La Ilustración Española y Americana* for the magazine it replaced, *El Museo Universal* (1857-1869), but the article is not in this magazine either, nor have I found it in similar magazines publishing issues around January 1865. It might actually have been published one year later, on 8th January 1866, in another Madrid magazine, *La Violeta*, under the title "Noche-buena en Roma" (Christmas Eve in Rome). This article, unsigned, is indeed an article of manners (matching Fastenrath's description), and although its title is not "Una Noche-buena en Alemania", its content refers to Christmas Eve in Germany, contrasting it to that in Rome.

Further evidence that this article is by Clark is, on the one hand, that it contains interference from English or German, and on the other hand, that at least the content about Rome emanates from a foreign newspaper. I will elaborate on these facts. Examples of the interference in question include: "en Alemania hay el árbol" (there should be an indefinite rather than a definite article after the verb *hay*), "Es imposible distribuir las luces mejor que ellos lo hacen" (*lo hacen* is superfluous), and "con sus sombreros [...] adornados de cintas de todos colores" (*colores* is lacking the definite article "los"). Regarding the content from a foreign newspaper, which is acknowledged in the article's opening sentence ("According to a foreign newspaper, in all Roman homes, on the occasion of Christmas Eve, cribs are set up, like in Germany there is the Christmas tree"; "Noche-buena en Roma", 1866: 3; my translation and underlining), Clark was soon to be employed by a periodical to write reviews of foreign news. Perhaps he fulfilled a similar role for *La Violeta*.

Returning to the translated novel, whose instalments began to appear in February 1866, its authorship is not immediately apparent either, but the evidence pointing to Clark is conclusive. Firstly, the novel bears the signature of 'Diego Clark', *Diego* being, like *Jaime*, a Spanish form of the Hebrew proper name *Ya'aqov*, from which the English name James also derives. Secondly, the newspaper in which the novel was published, *El Lloyd Español,* described Diego Clark as an "editor-translator [...] well versed in the main languages of the cultured Europe" ("Artículo prospecto", 1866: 2; my translation), a description that might well correspond to Clark. As an aside, according to the periodical itself, he joined its staff in January 1866 so that it could provide a daily review of foreign news ("Artículo prospecto", 1866: 2). Lastly, Fastenrath reports that in mid-1865 Clark moved to Barcelona and managed to join the editorial team of one of the most important newspapers in the city; this description fits *El Lloyd Español*.

The novel itself, entitled *Leonor Raymond*, is a summarised version of *Stuart of Dunleath* (1851) by the London writer and feminist Caroline Norton. The newspaper presented it as a translation from English (without indicating the original); nevertheless, the lack of correspondence between the English original and the Spanish version, and a comparison of the latter with other

European versions, show that the source text was the French version by Old Nick, *Eleanor Raymond* (1958). This was a *réduction* (in the French translator's own terminology; Old Nick, 1858: vi) that reduced the English novel to less than 20% of its original length. The fact that Clark follows it closely allows us to add the French-Spanish language pair to his translating skills (limited to the German-Spanish and English-Spanish pairs, as mentioned above).

Like "Noche-buena en Roma", *Leonor Raymond* contains multiple cases of interference from other languages, particularly English or French (e.g. the noun 'Calcutta', versus the Spanish *Calcuta*).

Clark resigned from *El Lloyd* in September 1866. The newspaper announced his resignation in a front-page notice in which the management expressed everyone's full approval of the work carried out by the editor-translator, and specified that his decision was motivated purely by his personal interests ("Sección editorial", 1866: 1).

At the time, dissatisfaction with the intolerant regime of Queen Isabel II had been on the rise in Spain for a few years. Although Clark went on translating German poetry (rendering, in particular, a poem by Johann Georg Fischer that he signed in Barcelona in May 1867), he must have spent most of his time writing *El guía del buen ciudadano: colección de artículos políticos escritos para enseñanza del pueblo* (The good citizen's guide: A collection of political articles written for the people's education) (1868). In this collection of articles, Clark defended rights such as universal suffrage and freedom of the press, religion, education and assembly. The collection was published at the end of 1868, right after the dethronement of the queen.

As its title reflects, it was intended as a guide, and may well have served this purpose. It was reviewed in the important liberal newspapers *El Imparcial* and *La Iberia*, which emphasised the instructive value of the articles amid the ongoing political turmoil. *El Imparcial* did so on 20th January 1869 within a last-minute section on the constituent elections of 15th-18th January of the same year. It should be noted that these elections led to what is considered Spain's first democratic constitution, i.e. the monarchical constitution of 1869. Importantly, this constitution granted the above-mentioned rights defended by Clark. Returning to *El Imparcial*, it recommended the Neapolitan's book in the following terms: "written [...] above all with great impartiality [...,] extremely useful, especially in circumstances like those we are going through today" ("Elecciones", 1869: 3; my translation). For its part, *La Iberia* stated that "as the country [tried] to rebuild itself, there [was] nothing more useful nor more interesting for the Spanish citizen than Mr. Clark's easy-to-read pages, where he uprightly and soundly [set] out the fundamentals of the rights achieved, explaining them

and instructing [the Spanish citizen] in laws and institutions that anyone who [wished] to be a truly free citizen had to know about" ("Books", 1869: 4; my translation). The book's dedication and prologue are relevant as well. According to them, Clark believed that the Spanish nation, having got rid of a dynasty – the Bourbons – that had been soiling it for a long time (Clark, 1868: 5), was at a crucial point in its history and could not miss its opportunity; it was therefore his intention to instruct it, educate it and lead it to prosperity via the path of freedom (Clark, 1868: 7-8).

It should be noted that Clark signed the book as 'Jaime Clark', the name he would use from that moment on. It is also worth noting that the publisher, Carlos Frontaura, belonged to the cultural and scientific institution Ateneo de Madrid, and may thus have been Clark's first contact with the institution. The translator became a member of the Ateneo shortly after, on his return from his trip to Vienna (mid-1869 - 30 December 1870) to visit his uncle Joseph Ruston.

This trip is recorded not only in Fastenrath's biographical note, but also in Clark's travel account, which I have found in the magazine *Revista de España* in two parts, published in February and March 1871 respectively (Clark, 1871a and 1871c). Fastenrath's (1874: 221) note provides intriguing details, such as the fact that, on the way to Vienna, the Neapolitan spent half a year travelling around Andalusia, Spain, in addition to most of Italy; and the fact that he spent another six months in Ireland in 1870, after staying in Vienna and Prague for six to seven months and subsequently settling in Naples for a while. The purposes of his long stays in Andalusia and Ireland are completely unknown.

Clark's travel account is dedicated to his return journey "from London to Madrid via Luxembourg, Saarbrücken, Metz, Weißenburg, Strasbourg and Lyon", as its title reads ("De Lóndres á Madrid pasando por Luxemburgo, Saarbrucken, Metz, Weissemburgo, Estrasburgo y Lyon"). The translator describes the scenes, the people and the landscapes he encountered in a Europe marked by the Franco-Prussian war (July 1870 - May 1871), including those he observed in Alsace and Lorraine: "there, all was desolation, discord and grief", he says (Clark, 1871c: 12; my translation).

The Neapolitan's travels through the theatres of war are also reflected in a previously unknown article published in February 1871 in the weekly magazine *La Ilustración de Madrid*, whose literary director was Gustavo Adolfo Bécquer. This article (Clark, 1871b), entitled "An episode of the Strasbourg bombing" ("Un episodio del bombardeo de Strasburgo"), narrates a Strasbourg family's misfortunes in the aftermath of the city's devastating bombing.

Clark's return to Spain marked a shift towards his literary career, on which he seems to have concentrated from 1871 onwards. In that same

year he became a member of the Ateneo, something we know thanks to the membership records of the institution (Ateneo de Madrid, 1891: 39, 115). Among the details provided by these records is Clark's address in Madrid. He apparently lived near the Puerta del Sol, a central square that he missed during his trip – in his travel account, he particularly refers to his longing to sunbathe in the square (Clark, 1871c: 25). What he longed for most, though, was to see the many friends he had left behind in Spain and from whom he had heard nothing for a long time (Clark, 1871c: 25). Perhaps he used to meet some of these friends at the Café de Levante in the Puerta del Sol. In this newly-founded establishment, a literary society (the 'Sociedad del Gato') was created in 1870 by a host of men of letters and artists that used to go to the café, among whom we find Clark (Llanos, 1883: 6; Lustonó, 1903: 163; Boccherini y Calonge et al., 1873). The translator's belonging to the Ateneo and the Sociedad del Gato is perhaps a sign of his extraordinary literary achievements to come. It is interesting to note that his home, at Calle Jovellanos, 5 (Ateneo de Madrid, 1891: 39), and these institutions were all within less than half a mile of each other.

In April 1871, after having seen his travel writings appear in the major literary magazines *Revista de España* and *La Ilustración de Madrid*, Clark published "Sueños y realidades" (Dreams and realities) in the latter. An original Spanish poem, it evokes the life and works of Cervantes on the 255th anniversary of his death (Clark, 1871d). The find of this composition has brought an original poem by the translator to light for the first time, complementing Fastenrath's biographical note, in which he states that Clark wrote Spanish poetry to be published (this would appear, according to Fastenrath, shortly after August 1874) (Fastenrath, 1874: 221).

Most of the German poems that Clark published in Spanish in his anthology *Poesías líricas alemanas* (1873) were translated in Madrid in December 1871, and he signed the anthology's prologue in January 1872. I mention this because at the end of 1871 and the beginning of 1872, early versions of selected anthology poems, by Heine and Uhland among other authors (Clark, 1871e, 1871f, 1872a), appeared in the weekly magazine *La América: crónica hispano-americana*.

It is worthy of note that Francisco Pi y Margall, brother of the anthology's future publisher, Joaquín Pi y Margall, also contributed to the same magazine in this period. Joaquín Pi y Margall and Clark may thus have become acquainted through *La América*. It is also possible, however, that they made each other's acquaintance thanks to *El guía del buen ciudadano*, as Joaquín was an activist of the Federal Republican Party, like his brother Francisco, the soon-to-be president of the First Spanish Republic.

1872 saw the publication of another original poem by Clark. This resulted from the intention of the Sociedad del Gato (now renamed the 'Academia

del Gato') to bring out a series of quality romances in order to combat the mediocre, immoral vulgar romances in circulation at the time. The poems would evoke historical episodes or traditions of Spain that would awaken ideas of greatness and justice in the people (Boccherini y Calonge et al., 1873; Lustonó, 1903: 163). Each of the romances revolved around a given topic, which was the object of an illustration that preceded it. They were all discussed before publication and many were rejected in this process (Lustonó, 1903: 166). They started to appear in September 1870. Although all the authors signed with initials, which could have made their identification difficult, there is a record of authorship (Lustonó, 1903: 163, 166), and romance number 29 corresponds to Clark. He signed it with the initials of his parents ('C.S.'), probably because his own initials matched those of another author (José Cabiedes), and the initials of his first name and his parents' surnames matched those of yet another author (José Castillo y Soriano). Some of the romances of these other authors appeared before that of Clark. His poem was entitled "Jaque al rey" (Check to the king) and dealt with the salvation of Yusuf III of Granada, an honourable monarch who had been dethroned and sent to be executed by his evil brother Mohammed VII. The romance appeared separately, both in chapbook format in 1872 (Clark, 1872b) and, later, in 1873, in the two editions of the collective volume *Romancero español: colección de romances históricos y tradicionales* (Spanish romance collection: A collection of historical and traditional romances) (Clark, 1873a and 1873b), one of which contained only half of the romances. The poems were low-priced but did not meet with success, mainly due to the complicated political situation (Lustonó, 1903: 166; cf. V. P. y T., 1873: 13-14, and Llanos, 1883: 7).

In 1873, the year in which the First Spanish Republic was proclaimed, all of Clark's translations of German poems were finally published in a book, whose full title was *Poesías líricas alemanas de Heine, Uhland, Zedlitz, Rückert, Hoffmann, Platen, Hartmann y otros autores vertidas en castellano por Jaime Clark* (German lyrical poetry by Heine, Uhland, Zedlitz, Rückert, Hoffmann, Platen, Hartmann and other authors rendered into Spanish by Jaime Clark) (Clark, 1873c/1879). Moreover, his Shakespearean translations started to appear. It is worth emphasising that these two sets of translations are Clark's best known works, and the only ones remembered today.

The anthology *Poesías líricas alemanas* was published in the renowned Biblioteca Universal book series by Joaquín Pi y Margall. It contains a selection of German poems by 19 recent authors and a biographical note on each author. The poems were selected on the basis of their popularity. The anthology came to fill a gap in Spanish literature, and this, added to the quality of the translations (assessed as "estimable" by the respected Spanish writer and critic Emilia Pardo Bazán; Pardo Bazán, 1886: 488),

earned Clark the recognition of Spanish critics and fellow writers, as well as of the general public. The anthology was re-edited and reprinted on various occasions up until the first third of the 20th century, and its poems are still read today[6].

Nonetheless, it is the five volumes of *Obras de Shakspeare* [sic] [en] *versión castellana de Jaime Clark* (The works of Shakespeare, rendered into Spanish by Jaime Clark) that truly set Clark apart. They were published undated, which has led to some confusion as regards their publication date. Several researchers have posited the broad approximate interval of 1870-1876 (Juliá Martínez, 1918: 256-257; Ruppert y Ujaravi, 1920: 104; Serrano Ripoll, 1984: 32). Others have pointed more specifically to 1873-1874 (Par, 1935: 22; Campillo Arnaiz, 2005a: 50, 2005b: 30, 2009: 13, fn. 14), but without offering (sufficient) supporting evidence, as discussed in Serón-Ordóñez (2012: 288). Based on a thorough search of newspaper archives, my research has enabled me to determine that the translations appeared in September and October 1873 (first and second volumes, respectively) and February, March and April 1874 (third to fifth volumes) (for details, see Serón-Ordóñez, 2012: 288-289). That is to say, all of the translations were published during the period between the proclamation of the First Republic (11th February 1873) and the start of the Bourbon Restoration (29th December 1874). In this period, after decades of tyranny, the Spanish enjoyed rights that Clark had vigorously defended in his first book. The period was also characterised by considerable instability.

The set of five volumes contained ten plays: *Othello* and *Much Ado About Nothing* (volume I), *Romeo and Juliet* and *As You Like It* (vol. II), *The Merchant of Venice* and *Measure for Measure* (vol. III), *The Tempest* and *Twelfth Night* (vol. IV) and, lastly, *Hamlet* and *The Merry Wives of Windsor* (vol. V). All of Shakespeare's works were originally to appear in the collection, but the translator's death brought the project to an abrupt halt (Medina and Navarro, 1873; Par, 1935: 22; Thomas, 1949: 16; Paz-Soldán y Unánue, 1883/1999). Two further volumes were actually publicised but never appeared. They were to contain *Julius Caesar* and *The Two Gentlemen of Verona* (vol. VI) and *King Lear* and *A Midsummer Night's Dream* (vol. II) ("Casa editorial de Medina y Navarro", 1874: 79; "Boletín bibliográfico", 1874b: 256).[7]

The translator accompanied his Shakespearean translations with an introduction to his own work as a mediator between Shakespeare and the Spanish public and with an article about Shakespeare's life and works, both included in the first volume. This volume also contains a prologue by Juan Valera, an eminent Spanish writer, diplomat and politician with moderate liberal ideas. Clark may have become acquainted with Valera either through the Ateneo, of which the latter was also a member, or through the

magazine *La América*, to which they both contributed in the same period. It should be added that one of the publishers of the translations, Luis Navarro, was a member of the Ateneo as well.

As far as the reception of the translations is concerned, critics and fellow writers alike welcomed them with enthusiasm, unanimously praising, for the next 44-45 years, the translator's fidelity to the source text (not only its content but also its form) and his style (Valera, 1873: xxvii; Huelin, 1873: 655; Michaëlis, 1875: 333, quoted in Ruppert y Ujaravi, 1920: 40; Juliá Martínez, 1918: 74; and others). His poetic talent was later given special attention (Juliá Martínez, 1918: 77; Ruppert y Ujaravi, 1920: 43-44), possibly because the translations by his successor Guillermo Macpherson lacked this quality. Attention turned to Clark's additions and omissions (Ruppert y Ujaravi, 1920: 45-46; Par, 1935: 22; Pujals, 1985: 81) as his translations, as well as Macpherson's, were consigned to oblivion after the first complete set of Shakespeare's works in Spanish was published by Luis Astrana Marín in prose.

Incidentally, while critics always relate Clark's additions and omissions to his translating Shakespeare's verse in verse (some, such as Par, with a disapproving attitude towards verse translation), recent research within Descriptive Translation Studies (Serón-Ordóñez, 2011) has found that:

> Sometimes, amplification is apparently due to [Clark]'s desire to increase dramatic tension or intensity – perhaps with the intention of adapting the text to the target culture –, or to clarify or explain the action. Reduction is occasionally due to his intention to omit puns that he might have found untranslatable, or references to cultural elements completely unknown to the target audience.[8]

Recent research within the same framework has also pointed out that Clark's translations are highly acculturated (Serón-Ordóñez, 2012).

Presumably produced for the literary system, the translations have rarely been staged. Just a chosen few have been re-edited (in Madrid and Mexico), and only then from the mid-20th century onwards (for further details, see Serón-Ordóñez, 2012: 290). The latter point is somewhat surprising as their publication was reported on many contemporary periodicals. Some of them (*El Imparcial* and *La América*) had previously announced or printed other publications by Clark, and another (*La Discusión*) was edited by Francisco Pi y Margall, but others had no apparent connection with the translator (this is the case of *La Época*, *El Diario Oficial de Avisos de Madrid* and *Crónica de la Música*). Of the coverage provided, two articles are worthy of particular attention. On the one hand, *El Diario Oficial de Avisos de Madrid*, which announced volumes IV and V, praised the trans-

lations as a great service and made reference to the success they were achieving ("Segunda sección: diario de noticias generales", 1874: 4). On the other hand, both *La América* and *La Discusión* published a long review article (filling approximately 2.5 newspaper pages) in which the translations' success was also acknowledged (in particular, the author referred to their good reception among the public); however, I mention this review for other reasons, namely because the author, the minor writer Pedro Avial, expanded on the uneasy situation in Spain at the time. In his view, the translations – "a patriotic act" on the part of the translator, towards both the United Kingdom and Spain (Avial, 1874: 8; my translation) – were an anomaly in such a situation, one marked by political turmoil, a dying economy, moribund trade and public disquiet. He urged the Spanish public to do their part and blamed the harsh times for the lack of a broad readership (Avial, 1874: 8; my translation):

> Continually preoccupied with defending freedom from law enforcement abuses, and law enforcement from excesses of freedom, we consider everything that [...] satisfies our momentary passions useless. Serious studies catch the attention of barely a few learned men, respected by all and read by none [...] Cultured and wise [literary] productions have very few readers, while a large number of people avidly devour the [literary productions] devoid of wisdom and culture.

This may help to explain why the whole collection was never re-edited.[9] Macpherson's 23 translated plays, published between 1885 and 1897, were undoubtedly another factor.

It is also worth noting that Avial was familiar with Clark's "beautiful Spanish poems" (Avial, 1874: 8), even though his knowledge of the translator was limited, as demonstrated by the fact that he believed Clark to be English rather than Neapolitan (Avial, 1874: 8).

Turning to another topic, Clark's original comedies, of which we are aware – as mentioned above – thanks to Pérez Echevarría (1875: 422), remain completely unknown. My research has revealed no trace of them. In fact, after the extensive coverage of the translator's Shakespearean work in the press of the time, it is his death which is next reported in a periodical (see the previous section).

Thus, few people must have known about the comedies. Nevertheless, the translator came to be seen as a Spanish writer after having spent barely ten years in Spain. Fastenrath (1897: 390) ended up referring to him as English-Spanish, and Lustonó (1903: 163) described him as a foreigner by birth who was Spanish because of his works. This brings the present secti-

on to an end, leading to my concluding reflections upon the complexity of Clark's figure and mediation role.

## Conclusions

Born James and self-renamed twice in Spain, Jaime Clark easily escapes the clear-cut translator identities into which translation theorists often fall. He was not Spanish, contrary to what might be expected on the basis of his translating Shakespeare from English into Spanish, but he was not English either, nor had he spent a long time in an English-speaking nation, although it is true that, given his English origin, he might well have been brought up in an English-speaking environment within Italian Naples. He certainly was Italian, but, judging by his works, he appears to be more German, French and Spanish or, indeed, English than Italian. He cannot, then, be said to occupy the liminal space between *the source culture* and *the target culture*, but sits somewhere between all of the above-mentioned cultures.

Regarding his areas of activity, we find that they go well beyond translated poetry and theatre to include translated narrative literature, journalism and – as Campillo Arnaiz (2005b) pointed out – politics, as well as original poetry and theatre. In all of these activities, he played, in my opinion, a mediating role. He brought to Spain foreign news and customs (as a newspaper editor), foreign narrative, poetic and theatrical literature (as a translator) and foreign political ideas (as a committed observer), seeking to smoothly integrate them all into Spanish culture, which he respected: "Let's copy from other, foreign homes the good that we see in them; but let's adapt that to our needs, habits and customs; [...] we are Spanish, and we need a home for Spaniards" (Clark, 1868: 175; note that Clark included himself among the Spanish). He also brought (back) to Spain the country's own literature and history (through his poems on Cervantes and Yusuf III of Granada, among other works), helping to reconcile his troubled Spain with its past, which was not as gloomy as, according to Avial (1874: 8) and others, the Spaniards saw it. In so doing, he made it to leading periodicals, publishing houses and cultural institutions in a very short period of time, and came to be seen as a Spanish actor in his own right.

Clark shows how complex and far-reaching (politically or otherwise) mediation roles can be. Nowadays, translators commonly engage in a very wide range of activities other than translation itself, regardless of whether translation is their vocation or (as in Clark's case) not[10]. Add culturally entangling globalisation to this, and the potential complexity of mediation roles becomes self-evident.

# Notes

1   It is included in *Teatro completo*, a recent collection of Shakespeare's plays in Spanish bydifferent translators (Galaxia Gutenberg, 2007; the translations were selected and edited by Ángel Luis Pujante), and is the object of studies such as Serón-Ordóñez (2011).

2   The middle brother of the family, James John (1815-1865), worked as an apprentice engineer at Boulton, Watt & Co before moving to Naples, where he was a shipyard director of the Bourbon Kingdom of the Two Sicilies until King Francis II was overthrown in 1861 (Kurzel Runtscheiner, 1931-1932: 97-98, 100).

3   Fastenrath's tone in his writings when alluding to the Neapolitan is affectionate, as the following fragment shows: "my dear friend the inspired bard *Mr Jaime Clark*" (Fastenrath, 1874: 219; my translation and underlining).

4   What is now the Technische Universität Dresden (the former Königlich Technische Bildungsanstalt Sachsen) specialised in ship building, among other fields of engineering.

5   I have found no records of the three years that he supposedly spent in Germany apart from his inclusion in the register of students of the Technische Universität Dresden. I searched library catalogues and newspaper archives, in addition to consulting the Technische Universität Dresden on possible campus literature, such as a college newspaper or student magazine.

6   Two of them can be read on the educational website <www.escolar.com> (unaccompanied by the translator's name). They are "Los tres gitanos", by Nikolaus Lenau, and "El velo blanco" ("Der weiße Schleier"), by Moritz Hartmann.

7   I believe that Campillo Arnaiz's (2005a: 52-53; 2005b: 30-31; 2009: 16, fn. 27) claim that the translator ceased working on the collection to pursue his playwriting interests is dismissible; not only because of the contrary evidence provided by Medina and Navarro (the collection's publishers), the scholars Alfonso Par and Henry Thomas and the writer Pedro Paz-Soldán y Unánue, but also due to both the excellent reception of the translations (a subject I will deal with later) and Fastenrath's comment that, for Clark, "his main work", his "admirable Spanish version" of Shakespeare's works, "is not just a job like any other, but true worship" (Fastenrath, 1874: 220, fn. 1; my translation). It does not seem plausible to me that Clark might have been interested in interrupting his work on the collection to try his hand at playwriting, especially considering his spirit of service to the Spanish people (reflected, above all, in his first book); in this latter respect, it should be noted that he seemed to feel the need to provide the Spanish with all of Shakespeare's works translated directly from English (Clark, 1873d: xxix).

8   The terms "amplification" and "reduction" are those used by Serón-Ordóñez (2011) to refer to additions and omissions, following Molina and Hurtado Albir's (2002) proposed translation technique classification.

9    It should be specified that the print run of the volumes in the collection is unknown, but, given their fairly limited availability nowadays, it must not have been large.

10   This statement is based both on studies such as those quoted by Pym, Grin, Sfreddo and Chan (2012) when dealing with part-time employment in the translation profession at present (Pym, Grin, Sfreddo and Chan, 2012: 87-88) and on my own knowledge of the contemporary translation industry, which I have acquired during my fifteen years in the industry.

## References

Artículo prospecto. 1866, 6th January. *El Lloyd Español*, p. 2.

Ateneo de Madrid. 1891. *Ateneo científico, literario y artístico de Madrid: lista de señores socios, enero de 1891*. Madrid: Sucesores de Rivadeneyra.

Avial, P. 1874, 28th July. "Shakespeare". *La América: crónica hispano-americana, 14* (año xviii), 7-9.

Boccherini y Calonge, A., Gutiérrez Cabiedes, J., Castillo y Soriano, J., Clark, J., Larraza, P., Muñoz y Ruiz, F. et al. 1873. "Á nuestros lectores". In *Romancero español: colección de romances históricos y tradicionales escritos por los señores Boccherini, Cabiedes, Castillo y Soriano, Clark, Larraza, Muñoz y Ruiz, Navarro y Gonzalvo, Ossorio y Bernard, Vera, y otros* (n.p.). Madrid: Imprenta de J. Noguera.

Boletín bibliográfico. 1874b, 19th April. *Revista Europea, 8* (año i), 256.

Books. 1869, 28th April. *La Iberia*, p. 4.

Campillo Arnaiz, L. 2005a. *Estudio de los elementos culturales en las obras de Shakespeare y sus traducciones al español por Macpherson, Astrana y Valverde*. Unpublished doctoral thesis, Universidad de Murcia, Spain.

—. 2005b. "Shakespeare's neglected translators: Jaime Clark and Guillermo Macpherson". In J. Mateo and F. Yus (Eds.), *THISTLES: A homage to Brian Hughes* (vol. 2: *Essays in memoriam*, pp. 27-37). Murcia, Spain: Compobell.

—. 2009. "Estudio y edición traductológica digital de *Hamlet, príncipe de Dinamarca*, de Guillermo Shakespeare, en traducción de Guillermo Macpherson". In C. Acuña Partal and M. Rodríguez Espinosa (Eds.), *Archivo digitalizado y edición digital de textos literarios y ensayísticos traducidos al español y tratados sobre traducción del siglo xix* (pp. 1-136). Granada, Spain: Atrio. Available, albeit with a slightly different pagination, on the Internet site <http://www.ttle.satd.uma.es/index.php> [last accessed: 29th July 2015].

Casa editorial de Medina y Navarro. 1874, 8th February. *La Ilustración Española y Americana, v* (año xviii), 79.

Church of England, Diocese of London. 1830-1860. *Bishop's transcripts for the Anglican Chaplaincy, Naples, Italy, 1830-1860*. Available on the International Genealogical Index (igi) website at <http://www.familysearch.org/> [last accessed: 30th January 2009].

Clark, J. 1868. *El guía del buen ciudadano: colección de artículos políticos escritos para enseñanza del pueblo*. Madrid: Imprenta de D. Carlos Frontaura, a cargo de Diego Valero.

—. 1871a, ca. 10th February. "De Lóndres á Madrid pasando por Luxemburgo, Saarbrucken, Metz, Weissemburgo, Estrasburgo y Lyon [i]". *Revista de España*, xviii(71) (año iv), 349-369.

—. 1871b, 15th February. "Un episodio del bombardeo de Estrasburgo". *La Ilustración de Madrid*, 27 (año ii), 45-46.

—. 1871c, 10th March. "De Lóndres á Madrid pasando por Luxemburgo, Saarbrucken, Metz, Weissemburgo, Estrasburgo y Lyon [ii]". *Revista de España*, xix(73) (año iv), 5-25.

—. 1871d, 30th April. "Sueños y realidades. En el aniversario de la muerte de Cervantes". *La Ilustración de Madrid*, 32 (año ii), 126.

—. 1871e, 13th December. "Poesías alemanas. Cantares (de Enrique Heine)". *La América: crónica hispano-americana*, 23 (año xv), 14.

—. 1871f, 28th December. "Lejos de ella (de Roberto Prutz); Mi patria (de María Foerster)". *La América: crónica hispano-americana*, 24 (año xv), 14.

—. 1872a, 28th January. "La guirnalda (de Ludwig Uhland)". *La América: crónica hispano-americana*, 2 (año xvi), 14.

—. 1872b. *Jaque al rey (romance histórico) (1406)* (Romancero español: colección de romances históricos y tradicionales, 29) [chapbook]. Madrid: José Noguera y Castellanos.

—. 1873a. "Jaque al rey (romance histórico) (1406)". In A. Boccherini y Calonge, J. Gutiérrez Cabiedes, J. Castillo y Soriano, J. Clark, P. Larraza, F. Muñoz y Ruiz et al. (1873, 1st ed.), *Romancero español: colección de romances históricos y tradicionales escritos por los señores Boccherini, Cabiedes, Castillo y Soriano, Clark, Larraza, Muñoz y Ruiz, Navarro y Gonzalvo, Ossorio y Bernard, Vera, y otros* (n.p.; romance no. 29). Madrid: Imprenta de J. Noguera.

—. 1873b. "Jaque al rey (romance histórico) (1406)". In A. Boccherini y Calonge, J. Castillo y Soriano, J. Clark, J. Gutiérrez Cabiedes, P. Larraza, F. Muñoz y Ruiz et al. (1873, 2nd ed.), *Romancero español: colección de romances históricos y tradicionales escritos por los señores Boccherini, Cabiedes, Clark, Larraza, Castillo y Soriano, Muñoz y Ruiz, Navarro y Gonzalvo, Ossorio y Bernard, Vera, y otros* (pp. 35-45). Madrid: Librería de Alfonso Durán.

—. 1873c/1879, 2nd ed. *Poesías líricas alemanas de Heine, Uhland, Zedlitz, Rückert, Hoffmann, Platen, Hartmann y otros autores, vertidas en castellano por Jaime Clark* (Biblioteca Universal: colección de los mejores autores antiguos y modernos, nacionales y extranjeros, tomo vi). Madrid: Dirección y Administración.

—. 1873d. "Al que leyere". In W. Shakespeare, *Obras de Shakspeare, versión castellana de Jaime Clark. Tomo i: Otelo; Mucho ruido para nada* (pp. xxvii-xxxi). Madrid: Medina y Navarro.

Elecciones. 1869, 20th January. *El Imparcial*, p. 3.

Fastenrath, J. 1874, July and August. "La Walhalla y las glorias de Alemania". *Revista de España, xxxix*(154) (año vii), 210-224.

—. 1897, 22th December. "¿Cuándo ha de celebrarse el centenario de Enrique Heine?" *La Ilustración Española y Americana, xlvii* (año xli), 384-390.

Hill, F. 1974. *Victorian Lincoln*. Cambridge: Cambridge University Press.

Huelin, E. 1873, 24th October. *Obras de Shakspeare*, version castellana de Jaime Clark.—*Otelo.*— *Mucho ruido para nada.*—Madrid: Medina y Navarro, editores, calle del Rubio, núm. 25. *La Ilustración Española y Americana, xl* (año xvii), 654-655.

Juliá Martínez, E. 1918. *Shakespeare en España: traducciones, imitaciones e influencia de las obras de Shakespeare en la literatura española*. Madrid: Tipografía de la «Revista de Archivos, Bibliotecas y Museos».

Kurzel-Runtscheiner, E. von. 1931-1932. „Joseph J. Ruston und John J. Ruston". *Beiträge zur Geschichte der Technik und Industrie, 21*, 97-102.

Llanos, A. 1883, 1st November. "Los ciegos españoles". *El Genio y el Arte, 31* (año iii), 4 and 6-7.

Lustonó, E. de. 1903, 15th March. "La academia del gato". *La Ilustración Española y Americana, x* (año xlvii), 163 and 166.

Malta Family History. 2001-2012. Index to old protestant cemetery - Naples. Available at http://website.lineone.net/~stephaniebidmead/protnaplees.htm. Accessed on 29th July 2015.

Medina, E. de and Navarro, L. 1873. [Back cover]. In W. Shakespeare, *Obras de Shakspeare, versión castellana de Jaime Clark*. Madrid: Medina y Navarro.

Molina, L. and Hurtado Albir, A. 2002. "Translation Techniques Revisited: A Dynamic and Functionalist Approach". *Meta, 47*(4), 498-512.

Noche-buena en Roma. 1866, 8th January. *La Violeta: revista hispano-americana dedicada a S. M. la Reina Doña Isabel II, 162* (año iv), 3.

Old Nick. 1858. "Note préliminaire". In Anonymous (1836/1858), *Violette, chronique d'opéra*; C. Norton (1851/1858), *Eleanor Raymond, histoire de notre temps* (Old Nick, Trans.) (pp. v-vii). Paris: Librairie de L. Hachette et Cie.

Par, A. 1935. *Shakespeare en la literatura española. Tomo ii: Realismo; escuelas modernas*. Madrid: Librería general de Victoriano Suárez.

Pardo Bazán, E. 1886, "May and June. Fortuna española de Heine". *Revista de España, cx*(440) (año xix), 481-496.

Paz-Soldán y Unánue, P. 1999. [Personal letter addressed to Marcelino Menéndez Pelayo, dated 23rd March 1883]. In T. Larramendi, I. González Casasnovas and X. Agenjo Bullón (Coords.), *Menéndez Pelayo digital: obras completas, epistolario, bibliografía* (volume 6, letter no. 63). Santander, Spain: Obra Social y Cultural de Caja Cantabria.

Pérez Echevarría, F. 1875, 30th June. "Á Jaime Clark". *La Ilustración Española y Americana, xxiv* (supplement to this issue) (año xix), 422.

Pujals, E. 1985. "Shakespeare y sus traducciones en España: perspectiva histórica".

*Cuadernos de Traducción e Interpretación, 5-6,* 77-85.

Pujante, Á. L. 2001. "Conferencia-coloquio sobre su actividad como traductor de Shakespeare". In R. Merino, E. Pajares and J. M. Santamaría (Eds.), *Trasvases culturales: literatura, cine, traducción, 3* (pp. 23-28). Vitoria, Spain: Universidad del País Vasco.

—. 2006. "La aventura de traducir a Shakespeare". In C. Gonzalo García and P. Hernúñez (Eds.), *Corcillum. Estudios de traducción, lingüística y filología dedicados a Valentín García Yebra* (pp. 363-377). Madrid: Arco Libros.

Pym, A., Grin, F., Sfreddo, C. and Chan, A. L. J. 2012. *The status of the translation profession in the European Union.* Brussels: European Commission.

Ruppert y Ujaravi, R. 1920. *Shakespeare en España: traducciones, imitaciones e influencia de las obras de Shakespeare en la literatura española.* Madrid: Tipografía de la «Revista de Archivos, Bibliotecas y Museos».

Sección de noticias. 1875, 17th April. *El Imparcial,* pp. 2-4.

Sección editorial. 1866, 14th September. *El Lloyd Español,* pp. 1-2.

Segunda sección: diario de noticias generales. 1874, 14th March. *Diario Oficial de Avisos de Madrid,* p. 4.

Serón-Ordóñez, I. 2011. "Jaime Clark's Shakespearean translations: A comparative study of *La noche de Reyes*". In E. Calvo, M. M. Enríquez, N. Jiménez, I. Mendoza, M. Morón and N. Ponce (Eds.), *La traductología actual: nuevas vías de investigación en la disciplina* (pp. 147-165). Granada, Spain: Comares.

—. 2012. *Las traducciones al español de* Twelfth Night *(1873-2005). Estudio descriptivo diacrónico.* Doctoral thesis, Universidad de Málaga, Spain. Available at <http://riuma.uma.es/xmlui/handle/10630/7301> [last accessed: 29th July 2015].

Serrano Ripoll, Á. 1984. *Bibliografía shakespeariana en España: crítica y traducción.* Alicante, Spain: Instituto de Estudios Alicantinos.

Thomas, H. 1949. "Shakespeare in Spain". *Proceedings of the British Academy, XXV,* 3-24.

Valera, J. 1873. "Prólogo". In W. Shakespeare, *Obras de Shakspeare, versión castellana de Jaime Clark. Tomo I: Otelo; Mucho ruido para nada* (pp. IX-XXVI). Madrid: Medina y Navarro.

V. P. y T. 1873. "Al lector". In A. Boccherini y Calonge, J. Castillo y Soriano, J. Clark, J. Gutiérrez Cabiedes, P. Larraza, F. Muñoz y Ruiz et al. (1873, 2nd ed.), *Romancero español: colección de romances históricos y tradicionales escritos por los señores Boccherini, Cabiedes, Clark, Larraza, Castillo y Soriano, Muñoz y Ruiz, Navarro y Gonzalvo, Ossorio y Bernard, Vera, y otros* (pp. 7-14). Madrid: Librería de Alfonso Durán.

Wade, S. 2006. *Heroes, villains & victims of Lincoln.* Derby, United Kingdom: Breedon.

# Hendrik Willem Mesdag: An Enterprising Artist and Collector*

Renske Suijver (Van Gogh Museum, Amsterdam)

## Abstract

This chapter deals with the complex intertwining of the mediating roles taken up by a major art mediator, the Hague School painter Hendrik Willem Mesdag (1831-1915). In 1902, Mesdag co-organised a lottery exhibition for the benefit of the Boer War victims and their families. He provided a seascape by his hand as the first prize and strikingly enough he also won an important painting in that lottery. This is just one example of how Mesdag took advantage of having different roles – i.e. artist, collector, cultural entrepreneur. The combination of the three made him one of the most important figures in the Dutch art world at the end of the 19th century. Mesdag, who started out his career as a banker, decided to become a painter in 1866. In the same period he started collecting works of art made by his contemporaries. In a few decades he and his wife Sientje Mesdag-van Houten built up a large collection of contemporary Dutch art and paintings and drawings from the School of Barbizon. Mesdag also supported the young Italian artist Antonio Mancini financially. In exchange he received around 150 artworks, most of which he resold. Mesdag sometimes brought in his own works to (partly) finance a purchase, and he never omitted to use his contacts and position to pay a better price for new acquisitions. The artist and collector held several positions in artists' associations in The Netherlands, such as the Hollandsche Teekenmaatschappij (Dutch Drawing Society) and Pulchri Studio in The Hague, which enabled him to promote his own works and the artists represented in his collection.

In 1902 the Dutch artist Hendrik Willem Mesdag (1831-1915) helped organize an exhibition of art provided as prizes in a lottery for the benefit of Boer War victims and their families in South Africa. He donated a seascape he had painted as the first prize and, remarkably, he won an important

picture himself: *An Old Friend* by August Allebé, a painter whose work he did not yet have in his collection. The fact that he accepted it tells us a lot about Mesdag, the hard-headed businessman. No matter how praiseworthy it might have been for him to do his best for this good cause, to modern sensibilities it is unthinkable that one of the organizers should have walked off with a prize. This is just one example of the way Mesdag capitalized on combining different roles – artist, collector and entrepreneur. The melding of the three made him one of the most influential figures in the Dutch art world at the end of the nineteenth century.

Research into Mesdag's correspondence, his network and contemporary reviews has shed light on the different ways he operated in the cultural world through his work as an artist, his collecting strategies and his positions on committees and in art societies. This article explores the way his interlinked activities reinforced one another, concluding with an examination of his involvement in the artists' society Pulchri Studio – another striking instance of his making his own success. One has to bear in mind, however, that Mesdag's own interests and the greater good went hand in hand. Most of his strategic activities enriched Dutch art in general, as well as his own business.

Fig. 1. Hendrik Willem Mesdag, *Pile of bricks*, 1868. Oil on canvas, 40 x 50 cm. Panorama Mesdag, The Hague

Fig. 2. Hendrik Willem Mesdag, *Breakers on the North Sea*, 1870. Oil on canvas, 90 x 180.5 cm. Van Gogh Museum, Amsterdam (gift of J. Poort)

## A Renowned Marine Painter

Mesdag started his career as a banker in his father's stock broking office, but decided to become a painter in 1866 at the age of thirty-five. He was advised by his cousin, the successful painter Lourens Alma Tadema, to take painting lessons from the artist Willem Roelofs in Brussels. His initial style was very detailed, as exemplified in a wonderful painting of a pile of bricks, in which each one is individually depicted (Fig. 1). During a holiday on the coast, Mesdag discovered the sea as an enduring inspiration for his work. He moved to The Hague in 1869 so that he had the sea close at hand at the nearby fishing village of Scheveningen. From then on Mesdag focused on seascapes, generally using broad brushstrokes and a realistic palette. As early as 1870 he won a medal at the Paris Salon with *Breakers on the North Sea*, a very realistic depiction of a rough sea under a cloudy grey sky (Fig. 2). This established his reputation as a marine painter at a stroke. Never one to pass up an opportunity for self-promotion, from then on Mesdag signed his letters 'Mesdag Medaille d'Or Salon 1870'. When he received a congratulatory note from Jean-François Millet, one of the Barbizon artists whom he greatly admired, he framed it and hung it in his studio for everyone to see.

Nowadays most people will know Mesdag from his large panorama of the village of Scheveningen and the surrounding dunes (14.7 metres high and 114.7 metres in circumference), painted in 1881 (Fig. 3). It was commissioned by the Société Anonyme du Grand Panorama de la Haye and Mesdag received a considerable sum of money for it. He called on the assistance of other painters, including his wife Sientje and several younger artists, so that it was completed in only four months.

Fig. 3. Hendrik Willem Mesdag, *Panorama of Scheveningen*, 1881. Oil on canvas, 14.7 X 114.7 m. Panorama Mesdag, The Hague (photo Bob Strik)

Once he had consolidated his reputation, Mesdag won numerous medals for his work in Europe and the United States, and became an honorary member of several artists' associations in the Netherlands and abroad. On the whole his work received favourable reviews, especially in France: "Of all the marine painters ... Mr Mesdag is the one who most makes us experience the sensation of the sea; standing before his grey water and his white-capped waves breaking and foaming on the bows of his fishing boats, one feels the salt spray."[1] He became one of the most highly paid Dutch painters, with annual earnings of between 2,000 and 4,500 guilders in 1870 – comparable to an upper middle class income in The Hague. By 1895 it had grown to almost 22,000 guilders. (Stolwijk 1998, 240-241)

## A Strategic Collector

At the time Mesdag started painting in a detailed manner, he and his wife Sientje Mesdag-van Houten began to collect works of art by their contem-

Fig. 4. Constant Gabriël, *In Groenendaal (near Brussels)*, c. 1866. Oil on canvas, 39 x 62.5 cm. The Mesdag Collection, The Hague

poraries in a similarly precise style, for example a painting of a Belgian farmhouse by Constant Gabriël (Fig. 4). When Mesdag turned to using broader brushstrokes in his own paintings, his interest shifted to works in a similar technique. The artists of the Hague School, to which Mesdag belonged, sought to give an impression of everyday landscapes or rural life at a specific time of day. Inspired by the French artists of the Barbizon School, artists such as Jacob Maris and Anton Mauve focused on rendering atmosphere and light in a scene, rather than photorealistic depictions or a narrative. Mesdag acquired their paintings in large numbers.

Mesdag's father died in 1881, leaving his son a substantial inheritance that enabled him to buy French paintings, which were more expensive. Within a few decades the couple built up a large collection of some 350 contemporary Dutch and French paintings and drawings, and 500 objets d'art, mostly from Asia.[2] Their collection of Barbizon School paintings is the best and largest outside France. Mesdag had a good eye and bought stunning works by Théodore Rousseau, Camille Corot and Charles-François

Fig. 5. Charles-François Daubigny, *Sunset near Villerville*, c. 1876. Oil on canvas, 89 x 130 cm. The Mesdag Collection, The Hague

Fig. 6. Narcisse Diaz de la Peña, *View of the Pyrenees*, 1871-1874. Oil on panel, 59.2 x 79 cm. The Mesdag Collection, The Hague

Daubigny. Daubigny's *Sunset near Villerville*, for example, is a beautiful late work in which one clearly sees influences of Monet's *Impression, Sunrise* painted a few years earlier (Fig. 5). The use of a palette knife gives the work a very modern feel. In 1887 Mesdag built a museum next door to his home so he could show the collection. Knowing what we do about Mesdag, it is not surprising that his own art and that of his wife took centre stage. Every Sunday he gave a personal tour, always guiding visitors through his own and his wife's studios first, making sure that their art would never be overlooked.

Mesdag had an eclectic strategy when it came to buying works of art, and he never paid more than absolutely necessary for them. He was well known for bargaining whenever possible. In his correspondence he made this perfectly clear to Dutch and French art dealers such as C.M. van Gogh and Goupil & Cie.[3] He also tried, sometimes successfully, to pay some or all of the price with his own paintings, creating the dual effect of lowering the price and expanding the market for his own art.

As an artist and collector Mesdag had a taste for sketches, in which the creative process was still recognizable. Fortunately for him such works were also relatively cheap. Several Barbizon artists died at the end of the eighteen-seventies, enabling Mesdag to buy their works, some of them unfinished,

Fig. 7. Antonio Mancini, *The sick child*, 1875. Oil on canvas, 78 x 65 cm. The Mesdag Collection, The Hague

at estate sales. For example an intriguing *View of the Pyrenees* by Narcisse Diaz de la Peña came into the collection in this way (Fig. 6). Diaz did not sign the panel, but he often used this type of loose brushwork and transparent style, and it can therefore probably be regarded as a finished work.

From 1885 onwards Mesdag provided financial support to the young Italian artist Antonio Mancini. It was a generous act on the face of it, but in exchange he received around 150 artworks, most of which he sold. Mesdag also organized exhibitions of Mancini's work, in the hope that the young artist's fame would grow and reflect on Mesdag's collection. Mancini's work, though, with collage-like compositions and often featuring children with a far-away look in their eyes, is quite different from the rest of the art in Mesdag's collection and did not become as popular as Mesdag obviously wished (Fig. 7).

Mesdag bought some works directly from artist friends and he also received works as gifts. This might have been the cause of the rather barbed criticism in a newspaper in 1915, the year he died. "There are also innumerable paintings, presumably included for charitable reasons in order to help or encourage their creators, which are nevertheless out of place in a collection that does not aspire to be an art historical museum."[4] This is an exception, though. Most reviews of his collection and museum were favourable.

The role of his wife should not be underestimated. Sientje Mesdag-van Houten had an important say in how Mesdag compiled his collection and seems to have been less impulsive. A letter written by her husband gives us a telling insight into the way the couple went about acquiring works of art. "I told my wife about your proposal to sell the four Bosboom drawings and

Fig. 8. Photo studio Lion, *Dinner on the occasion of the 70th birthday of Hendrik Willem Mesdag in Pulchri Studio*, 23 February 1901. The Mesdag Collection, The Hague

the two by J.H. Weissenbruch for 2,000 guilders. She advised me to accept your proposal, and so that is what I shall do."[5] Sientje Mesdag was very active in Onze Club, a society for female artists, and taught several female painters in her studio. A relatively large number of works by female artists came into the collection through her.

## Powerful Positions: Pulchri Studio

Mesdag held powerful positions on the committees and boards of several important art associations, and this gave him a key role in the Dutch art world. He served on the hanging committees of several museums and was a member of the board of the Rembrandt Society.[6] His involvement with the Dutch Watercolour Society was typical of his approach.[7] Having co-founded it in 1876, he regularly submitted his own work – which he sold during the annual exhibitions, often very profitably – and he bought works by other artists at low prices. His position in the artists' society Pulchri Studio and the way he managed his interlinked roles are, however, deserving of more detailed analysis.

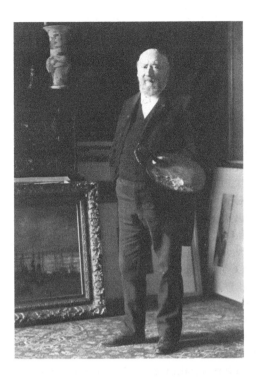

Fig. 9. Antonie Johan Marinus Steinmetz, *Hendrik Willem Mesdag with palette*, The Mesdag Collection, The Hague

Pulchri Studio was found-ed in The Hague in 1847 by a group of artists with the aim of stimulating the production of fine art and organizing art viewings. Mesdag became a member in 1869, soon after his re-turn from Brussels, where he had received most of his training. He became chair of the society in 1889, and the entrepreneur in him saw immediately that Pulchri Studio would need a new, larger build-ing with more space for exhibitions if it wanted to take its place on the world stage. His brother Taco Mesdag, also an artist and collector, was on the board as well, and together they bought a new building for the society without consulting the other board members, presenting the replacement premises as a fait accompli.[8] From then on Pulchri Studio was able to stage large-scale exhibitions in spacious rooms, including several solo shows for Mesdag himself. As chairman, Mesdag organized exhibitions of works from his own collection or of artists represented in it, like Daubigny, Millet and Mancini. This made the works he owned as a collector more widely known. He also initiated exhibitions abroad, which enhanced the international rep-utation of the Hague artists and, at the same time, of his collection. The art of the Hague School became very popular in the Anglo-Saxon countries, where there were many rich industrialists. In the absence of flourishing national schools of painting, from the eighteen-seventies onwards Dutch paintings were an appealing alternative to the more expensive Barbizon art. The society also helped Mesdag to meet other collectors and artists, thus extending his network and providing opportunities to sell his own work as well as enlarge his own collection. Finally, parties and dinners organized for a wide range of guests made Pulchri Studio a central social

location during the early decades of the twentieth century, and Mesdag was largely responsible for the society's popularity (Fig. 8).

## Mighty Mesdag

Mesdag was someone it was important to remain on good terms with, because he could make or break a career. Most of the work he bought was by his own generation or their predecessors. Younger artists were well aware that their work was too modern for his taste, but they also knew that they needed his support. Willem Witsen, one of the Tachtigers – a progressive circle of Dutch painters in the eighteen-eighties – wrote, "I think it's particularly imprudent to make an enemy of the man. Firstly because we have a real obligation, and secondly because we might need him next year. What would we have done without him last year? You know very well that I don't like him either, but I believe this is necessary."[9] Vincent van Gogh wrote to his brother Theo in 1888: "Mesdag and others have got to stop POKING FUN at the Impressionists."[10]

The commercial approach that stemmed from Mesdag's background as a banker drove him to create opportunities to sell his own work, buy art for his collection and establish a museum. His different roles complemented one another. He promoted and sold his own works through the network he had built up as a collector. He sometimes paid for works with his own art to keep the price down. And, as an entrepreneur, he seized every opportunity to influence art institutions and major players on the art scene, all for the benefit of his art and his collection.

Mesdag also tried to rig the market in his own favour beyond the boundaries of the cultural arena. As chairman of Pulchri Studio, and in his personal capacity, he wrote several letters of protest to The Hague City Council, mostly about building plans that were threatening to endanger the environment in and around the city.[11] His was a very well-known name, to the extent that in Johan Broedelet's 1909 novel *Hofstad* Mesdag appears, thinly disguised, as Leefdaag, a vain artist who talks to his own bust every day. "Hardly a day passes without his standing several times in silent contemplation of the immortalization of his own distinguished features. It was wonderful to think that even after his death he would still remain, so to speak, surrounded by his treasures."[12] And indeed, in photographs – even those taken in his studio – Mesdag is always dressed in a three-piece suit, always unsmiling: fully conscious of the image he had built up over the years of a man who cannot be ignored (Fig. 9).

Mesdag's manifold roles made him one of the most powerful figures in the Dutch art world. His personal interests clearly benefited from all his initiatives, but without him nineteenth-century Dutch art, the art market and society would have looked quite different. We would furthermore not have

had Museum Mesdag (now The Mesdag Collection), a valuable institution. Hendrik Willem Mesdag and Sientje Mesdag-van Houten were not the first collectors to establish a museum for their collection, but in 1903 they were the first to donate it to the State, a move that enabled them to safeguard the collection for future generations. A contemporary review summarized the significance of it all. "It is impossible to describe in just a few lines everything that H.W. Mesdag has done for his compatriots. His finest act was to donate the H.W. Mesdag-Museum to the State."[13]

## Notes

\* I should like to thank Mayken Jonkman of the Netherlands Institute for Art History and Maite van Dijk of the Van Gogh Museum for their critical reading of the text. I also want to express my gratitude to the other authors of *Hendrik Willem Mesdag. Kunstenaar, verzamelaar, entrepreneur*, Bussum 2015, which formed the basis for this article.

1 "M. Mesdag, de tous les peintres de marine … celui qui nous fait le plus éprouver les impressions de la mer; on sent les embruns en face de ses eaux grises et de ses vagues moutonneuses qui déferlent et se brisent sur l'avant de ses bateaux de pêche." Yriarte 1893, 95.

2 In this article I focus on the couple's museum collection. They also had a private collection, which was disposed of after Mesdag's death.

3 Letters from Hendrik Willem Mesdag to Goupil & Cie., 22 and 30 June 1872, and letter from Hendrik Willem Mesdag to C.M. Van Gogh, 3 July 1872, in Poort 1996, 87-89.

4 "Ook zijn er ettelijke schilderijen, vermoedelijk opgenomen uit menschlievendheid om de makers te helpen of aan te moedigen, doch misplaatst in een verzameling die geen kunsthistorisch museum wil zijn." Haverkorn van Rijsewijk 1915, 3.

5 "Ik heb mijn vrouw uw voorstel om de 4 tekeningen van Bosboom en 2 van J.H. Weissenbruch voor *f* 2000 over te doen medegedeeld. Zij adviseert om uw voorstel aan te nemen en daarom zal ik dat ook maar doen." Letter from Hendrik Willem Mesdag to Hélène Artz-Schemel, 1 March 1896, *Painters' letters OV2*, The Hague Municipal Archives.

6 The Rembrandt Society (Vereniging Rembrandt) was founded in 1883 and to this day acquires art to retain it for the State.

7 The Dutch Watercolour Society (Hollandsche Teekenmaatschappij) was founded in 1876 to promote making, buying and selling works on paper.

8 Mesdag invested in real estate and was experienced in selling it for a good price or renting it out, sometimes to other artists. See Landheer-Roelants 1995.

9 "'k vind 't bepaald onverstandig dien man tot vijand te maken. Eerstens om dat we werkelijk verplichting hebben, en ten tweeden omdat we hem 't volgend jaar

noodig kunnen hebben; wat hadden we verleden jaar moeten doen zonder hem? Je weet genoeg dat 'k ook niet van hem houd maar 'k vind 't noodig'. Letter from Willem Witsen to Jan Veth, 16 May 1888. Rijksmuseum Amsterdam, *Collection of Autographs*, Jan Veth, letter 35.

10 Letter from Vincent van Gogh to Theo van Gogh, c. 27 February 1888, in Jansen, Luijten en Bakker 2009, letter 580.

11 *Minutes and Proceedings of the City Council* 1851-2005, The Hague Municipal Archives.

12 "En bijna geen dag ging er voorbij, dat-ie niet eenige malen in stille aandacht voor de vereeuwiging van z'n eigen, waardige trekken bleef staan. 't Was heerlijk te bedenken, hoe-ie zelfs na z'n dood als 't ware nog vertoeven zou te midden van z'n schatten." Broedelet 1909 (ed. 2013), 101.

13 "Om in enkele regelen te vermelden alles wat H.W. Mesdag voor zijn landgenoten heeft gedaan, is niet doenlijk. Zijn grootste daad is geweest de schenking van het H.W. Mesdag-Museum aan den Staat." Wolf 1911.

## References

Broedelet, J.W. 1909. *Hofstad*, originally 1909, prefaced and summarized by Frans van der Linden, Baarn: Houtekiet, 2013.

Haverkorn van Rijsewijk, P. 1915. "Museum Mesdag". *Nieuwe Rotterdamsche Courant*, 3 September 1915.

Jansen, L., Luijten, H. and Bakker, N. 2009. *Vincent van Gogh – The Letters. The Complete Illustrated and Annotated Edition*, 6 volumes. Amsterdam-The Hague-Antwerp: Van Gogh Museum, Huygens Instituut, Mercatorfonds.

Landheer-Roelants, A. 1995. *Het onroerend goed in 's-Gravenhage van Hendrik Willem Mesdag*. Scheveningen: Landheer-Roelants.

Poort, J. 1995. *H.W. Mesdag, de Copieboeken, of De Wording van de Haagse School*. Wassenaar/Alphen aan den Rijn: Mesdag Documentatie Stichting.

Stolwijk, C. 1998. *Uit de schilderswereld. Nederlandse kunstschilders in de tweede helft van de negentiende eeuw*. Leiden: Primavera Pers.

Wolf, N.H. 1911, "Hendrik Willem Mesdag". *De Kunst*, 18 February 1911.

Yriarte, C. 1913. *Figaro-Salon 1893*. Paris.

# Paris in the Late Nineteenth – Early Twentieth Century: The Consecration of European Letters or the Production of "Belles Infidèles"?

AMÉLIE AUZOUX (UNIVERSITÉ PARIS IV-SORBONNE)

## Abstract

This paper is devoted to a complex period of interliterary transfer, i.e. the fin-de siècle, and the essential role played by a French mediator, i.e. Valery Larbaud (1881-1957). Travelling through an electrified Europe, between languages and literatures, Larbaud has been a most dynamic literary mediator at the turn of the 19th century. His transfer activities cover several languages and cultural areas, restoring to some extent the 18th century model of literary cosmopolitism and going against the grain of emerging and ambient nationalisms. Larbaud has translated James Joyce, Liam O' Flaherty, Samuel Butler, G.K. Chesterton, Italo Svevo, Emilio Cecchi, Ramon Gomez de la Serna or Gabriel Miro. In his famous *Sous l'invocation de saint Jérôme*, he theorizes the anti-nationalist dynamics of translation, designs bridges between authors, and sketches the lineaments of a truly European literary history. His mediating work covers political as well as poetical issues. En 1935, facing upcoming fascism he takes a strong stand writing "La Neige" combining in an uninterrupted line up to nine European languages (German, English, French, Italian, Spanish, Portuguese, Russian, Romanian). In addition, his work large interacts with the writings of other writers, through quotations as well as concealed borrowings.

## Paris, at the Crossroads of European Literature: Portraits of Literary Smugglers and Parisian Networks

At the turn of the century, Paris seemed to have become a passage and place of consecration for a "sort of intellectual Internationale" ("Sorte d'In-

ternationale intellectuelle") dear to Valery Larbaud. With its strong symbolic potential, the city of Paris appeared to form a "vast market in which all ideas flow and receive a stamp of approval, endorsing them all over the globe" ("vaste marché où toutes les idées accourent et reçoivent l'estampille qui les avalisera sur la surface du globe") (L. Maury 1925: 96-97). Foreign authors therefore chose to penetrate Parisian networks due to the fact that such spheres of influence extended far beyond the scope of French literature. This was the case of Gabriele d'Annunzio, who stopped by Paris to establish his work on a national and an international level[1]. James Joyce's art also found refuge in Paris in the Odéon district. Whereas Gabriele d'Annunzio considered the literary life of his country to be, in his own words, "less than mediocre" ("moins que mediocre")[2], James Joyce's licentious works were not welcome in the Anglo-Saxon world. George Hérelle and Valery Larbaud were, according to Christophe Charles's expression (1998), "double men" ("hommes doubles"), two mediators who, within thirty years of each other, took charge of Gabriele d'Annunzio's oeuvre in the 1890s and of James Joyces's work in the 1920s. These two men travelled throughout Europe, living in England, Belgium, Switzerland, Spain, Greece and Italy; they were migrants in the full sense of the term[3]. In addition to their interest in Latin languages, these two "literary smugglers" of foreign works also introduced authors whose immoralism was scandalous. While d'Annunzio knew how to "scare off the readers of his novels" ("effaroucher les lecteurs de ses romans") (E.-M. de Vogüé 1895: 193)[4], the Joycian epic was "uncommonly daring" ("d'une hardiesse peu commune") and could "very legitimately shock" ("très légitimement choquer")[5]. For Hérelle, as for Larbaud, the act of translation was not a commercial task or a bookseller's affair. Where Hérelle defined the "triple duty of the translator" ("le triple devoir du traducteur")[6], Larbaud theorized on the "joys and duties" ("joies et devoirs") of the translator in his essay *Sous l'invocation de saint Jérôme*, published in 1946.

In December, 1891, Hérelle read d'Annunzio's novel *L'Innocente* for the first time, as it appeared as a serial in the *Corriere di Napoli*. Although he was a philosophy teacher in Cherbourg, Hérelle – also a former classmate of Paul Bourget and Ferdinand Brunetière at the Sainte-Barbe school – wished to introduce d'Annunzio to the big Parisian newspapers. In September, 1892, Hérelle managed to have his translation of *L'Innocente* published in the Parisian newspaper *Le Temps* under the title *L'Intrus*. As early as November, 1892, d'Annunzio "had the pleasure of being understood" ("le plaisir d'être compris") and wrote to his translator:

Comme je suis heureux qu'en France mon œuvre enfin soit *comprise*.
Ici, en Italie, l'ignorance générale, l'indifférence stupide et l'insuf-

fisante culture empêchent qu'une œuvre d'art soit appréciée pour ses qualités les plus hautes et les plus choisies.

L'*Innocente* a eu ici un succès de curiosité et d'étonnement. De curiosité, à cause des événements tragiques qui s'y succèdent; d'étonnement, à cause de la différence entre ce livre et mes autres livres. Deux ou trois critiques à peine ont compris l'esprit véritable de l'œuvre. Ah ! mon cher ami, la France reste bien le pays le plus *intellectuel* du monde ![7]

I am so happy to know that my work in France has finally been *understood*. Here, in Italy, general ignorance, stupid indifference and insufficient culture prevent a work of art from being appreciated for its highest and choicest qualities.

Here, *L'Innocente* was a success of curiosity and astonishment. Curiosity, due to the tragic events that unfold; astonishment, due to the difference between this book and my other books. Only two or three critics understood the true spirit of the work. Ha! My dear friend, France remains the most *intellectual* country in the world!

Amédée Pigeon, one of Hérelle's friends, acclaimed d'Annunzio's work in *La Revue hebdomadaire* in June, 1893 while *Le Figaro* placed *L'Intrus* at the top of the list of books it recommended for the holidays. Thanks to Parisian distribution channels, d'Annunzio received a request for an authorization to translate his work in Spanish. D'Annunzio's "stories of flesh and voluptuousness" ("histoires de chair et de volupté") (Doumic 1895: 393) formed part, from then on, of the Parisian literary world. While *L'Enfant de volupté* had appeared since December, 1894 in *La Revue de Paris*, *Le Triomphe de la mort* was published in *La Revue des deux mondes* as early as June 1895. Eugène-Melchior de Vogüé's article in January, 1895, and René Doumic's conference at the Sorbonne a month later finalized d'Annunzio's consecration as the herald of a "Latin renaissance" ("renaissance latine") (1895:393). In his article, de Vogüé highlighted the French capital city's sphere of influence, writing that "a few fragments of his work, translated into French, have instantly made Mr. Gabriel d'Annunzio into a well-known name in Paris and in all of the cultures circles of Europe" ("quelques fragments de son œuvre, traduits en français, ont fait instantanément à M. Gabriel d'Annunzio un nom célèbre à Paris et dans tous les cercles lettrés de l'Europe") (de Vogüé 1895: 191). In d'Annunzio's own words, France was "the noble and delicate country that provided and still provides such generous hospitality to [his] art" ("noble et doux pays qui donna et donne encore à [s]on art une si généreuse hospitalité") [8.] Similarly, Paris also became a place of refuge for James Joyce's work.

As early as March, 1918, James Joyce published the first episodes of *Ulysses* in the literary magazine *The Little Review*[9]. But in February, 1921, follo-

wing a court trial led by the "Society for the Suppression of Vice", *Ulysses* was banned in the United States[10]. During that same period, Larbaud disco-vered Joyce's work by way of Silvia Beach. The latter American bookseller summarized this in "*Ulysses* à Paris": "*Ulysses* had been abandoned both by England and America. All that was left was France… and me" ("*Ulysses* était donc abandonné à la fois par l'Angleterre et l'Amérique. Restait la Fran-ce… et moi", S. Beach 1950: 20). Consecrating Paris as one of the centres of intellectual freedom (V. Larbaud 1998: 501)[11], Larbaud's conference on December 7, 1921 at 7, rue de l'Odéon, constituted "the very dawn of James Joyce's glory" ("l'aurore même de la gloire de James Joyce"), to borrow Syl-via Beach's expression (1950: 28). In 1922, *Ulysses* was published by Sha-kespeare and Company. Two years later, Larbaud published the first French translations of *Ulysses* in the first issue of the magazine *Commerce* which he co-directed with Léon-Paul Fargue and Paul Valéry. *Ulysses* was finally published in 1929 by Adrienne Monnier's Maison des Amis des Livres in a translation by Auguste Morel, assisted by Stuart Gilbert and entirely revi-sed by Valery Larbaud in collaboration with the author. The Odéon district thus became the hub in which Joyce's work was endorsed. For Larbaud, Paris appeared to be "the Capital city – beyond all "local", sentimental or economic policies – of a sort of intellectual Internationale" ("la Capitale, – au-dessus de toutes les politiques 'locales', sentimentales ou économiques, – d'une sorte d'Internationale intellectuelle") (Larbaud 1958: 783)[12]. The Parisian networks introduced foreign works to the European literary world, but such a mediation was not devoid of complexities and ambiguities.

## The Complexities and Ambiguities of the Act of Mediation: Did Paris Create "*Belles Infidèles*"?

The slight difference between the Ciceronian approach to translation and the "*Belles Infidèles*" tradition of revising and correcting original texts to suit "French taste" was swiftly bridged by many French translators. Where Cicero, in his translation of Greek, advised to "use terms adapted to Latin habits" ("user de termes adaptés aux habitudes latines")[13], many French translators adapted foreign works to suit French habits.

The work of d'Annunzio had to "be neutered" ("être châtrée")[14] for Pa-risian publishers and newspaper editors, thus revealing the complexity of such a mediation. As soon as it was first published in a Parisian publication, d'Annunzio's opuses went through the comb of the French ideology of the time. D'Annunzio qualified the treatment of *L'Innocente* by *Le Temps* news-paper as a "massacre"[15] and claimed that "attacks to the integrity of [his] work" ("attentats à l'intégrité de [s]on œuvre")[16] had been committed by *La Revue de Paris*. The violence of the terms used by the author reveals how

the text underwent a forced naturalization in the French literary realm. When Ferdinand Brunetière wished to "purify" ("purifier")[17] *Le Triomphe de la mort* for the traditional *Revue des deux mondes*, Gabriele d'Annunzio wrote to Georges Hérelle with demonstrable irony:

> Ainsi, Monsieur Brunetière prétend offrir à ses abonnés, non une traduction, mais une *adaptation* de mon ouvrage ! Il faudrait donc écrire en sous-titre: "ad usum Francorum", puisque, d'après Brunetière il existe une si profonde différence entre *l'homme du Nord* et *l'homme du Sud*.[18]
>
> Therefore, Mister Brunetière claims to provide to his subscribers none other than an *adaptation* instead of a translation of my book! A subtitle should therefore be added: "ad usum Francorum", since, according to Brunetière, a profound difference exists between *the man of the North* and *the man of the South*.

When translating d'Annunzio's work, Hérelle implemented a francization and a naturalization of the foreign text, going against the author's wishes, the latter rather encouraging Hérelle to preserve the "strange flavor of the original" ("l'étrange saveur de l'original")[19]. In a letter dated from June 30, 1894, d'Annunzio summarized his thoughts regarding the translation of *Triomphe de la mort*: "as for the translation, it is often *excellent writing by Hérelle, but it is not writing by d'Annunzio*" ("quant à la traduction, souvent, c'est *de l'excellent Hérelle, mais ce n'est pas du d'Annunzio*")[20]. The ambiguity of the art of translation is displayed here. According to Antoine Berman, such an ethnocentric translation, "under the cover of transmissibility, achieves a systematic negation of the strangeness of the foreign work" ("sous couvert de transmissibilité, opère une négation systématique de l'étrangeté de l'œuvre étrangère") (1984: 17). In the case of a French ethnocentric translation, the translator does indeed force the author to be dispossessed of his own foreignness in order to conform to French taste. In a letter sent to Hérelle on January 4, 1905, regarding *Filles de Jorio*, d'Annunzio clearly exposes his approach to translation, akin to the German Romantics:

> Toute l'œuvre est *banalisée* justement parce que *francisée*. Votre conception de la traduction est – selon moi – erronée. Vous tendez à transformer en une œuvre française une œuvre italienne, en répugnant à toutes les particularités et à toutes les aspérités de l'original, par crainte de violer le génie de votre langue et le commun sentiment des lecteurs médiocres. [...]
>
> Il ne faut pas chercher le rythme exact, le rythme consacré dans la métrique française, mais chercher à reproduire le rythme exotique.

C'est ce que j'ai fait en travaillant (hélas ! inutilement) sur votre traduction française. Dans mon texte le rythme est continuellement *brisé*. Pourquoi donc ne devrait-il pas être *brisé* aussi dans la traduction.

Heureusement, les traducteurs d'aujourd'hui ont compris qu'une œuvre traduite ne doit pas entrer dans la littérature nationale, en faire partie, mais conserver son empreinte originale, fût-ce *contre* le génie de la nation qui l'accueille. [...]

Un exemple caractéristique de votre incoercible besoin de *logique* est dans la question que vous me posez sur le sens de l'exorcisme d'Aligi: "Au milieu de mon visage, etc." Cet exorcisme est traditionnel et il est obscur pour moi aussi. C'est une de ces formules populaires dans lesquelles le mot est plutôt employé comme son que comme lettre. Si vous, traducteur, cherchez à *éclaircir* cette formule mystérieuse, vous la trahissez. Vous m'écrivez: "la phrase française a quelque chose de gauche et d'à peu près inintelligible !" Très bien ! Gauche et inintelligible, c'est *ainsi qu'elle doit être*.

Comme vous voyez, nous ne nous comprenons pas. Ce qui pour vous est – en l'espèce – un défaut, est, pour moi, une qualité. [...]

Une traduction est une manière plus ou moins ingénieuse de mettre le lecteur en *état de divination*. Une bonne traduction moderne ne doit pas rapprocher l'œuvre du lecteur mais bien le lecteur de l'œuvre, serait-ce *malgré lui*. Voilà franchement mon opinion.[21]

The whole piece is *trivialized* precisely because it is *francized*. Your approach to translation is – in my view – erroneous. You have a tendency to transform an Italian work into a French one, rejecting the original's particularities and asperities, for fear of violating the genius of your language and the average feelings of mediocre readers. [...]

One shouldn't seek an exact rhythm, a rhythm that would be specific to French metrics, but one should rather look to reproduce the exotic rhythm.

This is what I did when I worked (Alas! for nothing) on your French translation. In my text, the rhythm is constantly *broken*. Why shouldn't it be *broken* in the translation, too.

Fortunately, translators today have understood that a translated work shouldn't enter national literature and form a part of it, but should maintain its original imprint, even if that means going *against* the genius of the nation that welcomed it. [...]

A characteristic example of your uncontrollable need for *logic* lies in your question on the meaning of Aligi's exorcism: "In the middle of my face, etc." This exorcism is traditional and it is strange for me too.

It is one of those popular expressions in which a word is used more as a sound than as a letter. If you, as the translator, attempt to *clarify* such a mysterious expression, you betray it. You wrote to me: "The French sentence seems quite gauche and more or less unintelligible!" Very well! Gauche and unintelligible, *that is how it should be*.

As you can see, we do not understand each other. What is, to you – in essence – a defect, is, to me, a quality. […]

A translation is a more or less ingenious way of putting the reader in a *state of divination*. A good modern translation shouldn't bring the work closer to the reader but rather bring the reader closer to the work, even if it is *against his will*. That is, frankly, my opinion.

In his letter, d'Annunzio follows the translation approach exposed by Friedrich Schleiermacher in his conference on "different translation methods" ("différentes méthodes du traduire")[22]. If, according to Blaise Wilfert (2009: 213), d'Annunzio stepped into a "game of re-fabrication" ("jeu de refabrication") of his work "for the use of the French" ("*à l'usage des Français*"), we are led to wonder how the French translation of *Ulysses* came about.

Unlike d'Annunzio's work, Joyce's oeuvre did not go through the filter of French decorum. The obscenity and transgression of the Joycian text were relayed by much more avant-garde networks. The translation of *Ulysses* operated in places such as Adrienne Monnier's bookstore and the *Commerce* literary magazine which were unlike the much more traditional and academic *Revue des deux mondes*. The *Ulysses* translation was nevertheless revised by a writer deemed "fundamentally classical, profoundly cultured, filled with tact and moderation" ("foncièrement classique, profondément cultivé, plein de tact et de mesure") (J. Brown 1975: 40). Larbaud officiated as a renowned French author in the *Ulysses* translation team, which was also composed of Auguste Morel and Stuart Gilbert. As Maurice Saillet wrote, "Larbaud's signature contributed as much, if not more than Joyce's, in the text becoming a success for a cultured French audience" ("[la] signature de Larbaud contribua autant sinon plus que celle de Joyce à la réussite de l'ouvrage auprès du public français lettré")[23]. Larbaud could have stymied the boldness of the Joycian word since he had defended Paul Claudel's "infidèle" translations as true "transsubstantiation[s]"[24] and payed tribute to Nicolas Perrot d'Ablancourt, the father of the "Belles Infidèles". Let us recall the letter Larbaud sent to the author Jean-Richard Bloch in January, 1913:

Je songe depuis longtemps à écrire un court essai sur *l'art de la traduction*. J'y dirais tout ce qu'on peut dire encore de nos jours en faveur des Belles Infidèles, j'y ferais valoir les avantages de la traduction littéraire sur la traduction littérale.[25]

> I have been thinking for a long time of writing a short essay on *the art of translation*. I would continue to say all the good that can be said today in favour of the Belles Infidèles, I would assert the advantages of literary translation over literal translation.

Larbaud was faithful to the "spirit of the text" of *Ulysses* and recognized the more licentious passages; and yet he also defended a literary vision of the Joycian epic, the latter vision informing his choices as a translator. Regarding the reception of *Ulysses* in the French literary world, Salado wrote:

> Ainsi, la réception de *Ulysses* par Larbaud s'inscrit dans son projet de promotion d'une haute littérature européenne qui l'amène à valoriser la littérarité du texte de Joyce, ou du moins une forme de littérarité susceptible de faciliter la reconnaissance de *Ulysses* comme grand texte. Sa volonté d'imposer le roman de Joyce en tant qu'épopée des temps modernes l'incline à un ennoblissement relatif des Blooms, qui recoupe la propre position de Larbaud dans le champ social. Reconnaître en la parole de Molly la possibilité du "vocabulaire de *Mallarmé*", aussi incongru que cela paraisse, est logique du point de vue de Larbaud, dès lors qu'il a investi le monde de *Ulysses* et ses protagonistes d'un certain nombre de valeurs, sociales, littéraires et plus largement culturelles. Par ailleurs, on ne peut exclure tout à fait la tentation homologique qui entraîne Larbaud à considérer les principaux personnages joyciens, ces "princes [...] sortis de la vie profonde de l'écrivain", en référence à ses propres créations romanesques. D'où la réduction de la distance à laquelle se livre Larbaud, alors que Fargue avait symétriquement tiré le texte de Joyce à lui à grand renfort de "cochonneries". (Salado 1994: 840-841)[26]

Therefore, Larbaud's reception of *Ulysses* was imbedded in his project to promote high European literature, leading him to value the literary nature of Joyce's text, or, at least, a form of literary quality that could facilitate *Ulysses* as being recognized as a great text. His will to impose Joyce's novel as a modern-day epic pushed him to make the Blooms relatively noble, as this also matched his own place in the social sphere. From Larbaud's standpoint, recognizing in Molly's words hints of "*Mallarmé*'s vocabulary", as odd as that may sound, made sense since he had invested a certain number of social, literary and, more largely cultural values to the world of *Ulysses* and its protagonists. Moreover, one can't completely exclude the homologous temptation that led Larbaud to consider the main Joycian characters as "princes [...] stemming from the deep life of the writer", in reference to his own creations from his novels. This explains Larbaud's

reduced distance, whereas Fargue symmetrically brought Joyce's text closer to him through the use of *"cochonneries"*.

Larbaud refused to depict the women in *Ulysses* as "sorts of girls from the street" ("des espèces de filles du trottoir")[27], instead drawing them closer to the women from his cycle of short stories *Amants, heureux amants...*, published in 1923. He was keen on introducing the internal monologue form, which he discovered in *Ulysses*, to the French elite, and therefore wished to read excerpts from Molly Bloom's final monologue at his conference on December 7, 1921. A portion of Molly Bloom's dialogue had therefore been translated by Jacques Benoist-Méchin with Joyce's help and had been revised by Léon-Paul Fargue, who was meant to "spike" ("corser") the text. Larbaud was not satisfied with Fargue's translation, deeming that the latter hadn't found the "right tone" ("ton juste"), and finding that Molly Bloom did not use "the words of brothel women" ("des mots de femme de bordel") (*ibid.*) He reworked the translation and, at the last moment, omitted reading certain passages. Larbaud was modern while also being classical, and this *in extremis* suppression tells us a lot about his will to make the Joycian text more literary. On December 10, 1921, Joyce thus wrote to Harriet Shaw Weaver:

> At the last moment he decided to cut part of the "Penelope" fragment but as he told me so only when he was walking to the table I accepted it. I daresay what he read was bad enough in all conscience but there was no sign of any kind of protest and had he read the few extra lines the equilibrium of the solar system would not have been greatly disturbed. (1975: 287).

Although Larbaud cut out certain licentious passages from Molly Bloom's monologue at his conference, his first French translation of *Ulysses* in the *Commerce* magazine, which he co-directed with Paul Valéry and Léon-Paul Fargue, also informed his strategy as a translator. The "distinguished Larbaud" ("*distingué Larbaud*") (E. Pound 1922: 314) chose to introduce the final, much more chaste, part of Molly Bloom's monologue to his reader friends rather than the more transgressive passages of the stream of consciousness. The obscenity of the Joycian monologue only appeared in the integral translation of 1929.

Since the public reading of the Joycian text had already stirred some commotion, the 1929 translation team wished to francize the English text, naturalizing it as French. And yet, the "translator's fundamental error" ("l'erreur fondamentale du traducteur"), according to Rudolf Pannwitz, "is to conserve the contingent state of one's own language instead of submitting it to the strong action of the foreign language" ("est de conserver l'état con-

tingent de sa propre langue au lieu de la soumettre à la puissante action de la langue étrangère")[28]. Within the translation team made up of Auguste Morel, Stuart Gilbert and Valery Larbaud, the latter was "the literary polisher of the whole endeavour" ("le polisseur littéraire de l'ensemble") (A. Anglès 1979: 41). Joyce wished to see *Ulysses* in "French dress" ("robe française")[29], as his own expression attests, and counted on Larbaud's final edits. When we closely observe the French translation, we notice that it often comes with a neutralization, a normalization of the syntactical distortions present in the Joycian text, as is shown by Topia (2004)[30]. In the summer of 1927, Stuart Gilbert, who had then joined the translation team, warned Larbaud of the risk of attenuating syntactical distortions, of a French watering-down of the original text:

> My principle is to translate *all* passages where the French seems incorrect or incomplete, and to explain, briefly and simply, the defects as they strike me… the tendency of the translation is to smooth out syncopations and neologisms (inevitable to a certain extent – for English words are like blocks which can be fitted together in almost any mosaic pattern, while French words, usually terminating à queue d'arronde, do not lend themselves to transpositions, and cry out to be correctly fitted together). I mention this point as I would like to know if I should indicate neologisms, inversions, unorthodox combinations of words etc., which in the translation have been smoothed out, tamed. If it would be of any help, I could underline phrases and words whose edges have been abraded in translation.[31]

When he received this letter, Larbaud was still inhibited and therefore wished to "dare, in terms of neologisms and deformations, towards the Extreme Left" ("oser, en fait de néologismes et de déformations, jusqu'à l'extrême gauche")[32]. D'Annunzio wrote something similar when he asked Hérelle to go "to the extreme limits permitted by the language's genius" ("jusqu'aux extrêmes limites permises par le génie de sa langue")[33]. By francizing the text "all the way to the Extreme Left" ("jusqu'à l'Extrême-Gauche"), as he wrote again to Adrienne Monnier in October, 1927, Larbaud "dares as much as possible" ("ose autant que possible")[34]. He deformed the French language as much as he could, given his position as a renowned author, but he also made a few concessions to his readership[35]. Let us recall the conclusions of Daniel Ferrer, head of the Joyce team at the ITEM institute, examining the genetic records of the French translation:

> D'après le dactylogramme de la collection Berg, qui a servi, au moins partiellement de copie d'imprimeur, il semble que les interventions

de Larbaud aient porté sur une proportion relativement peu impor-
tante du texte (moins de 10%), qu'il ait [...] joué un rôle important
d'unification et de recherche du ton juste, mais que son souci de
"francisation" l'ait souvent empêché d'"oser" autant qu'on pourrait le
souhaiter (mises à part quelques trouvailles décisives)[36].

According to the printed manuscript from the Berg collection,
which served at least partially as a printer's copy, it appears that
Larbaud's interventions only concerned a relatively small proportion
of the text (less than 10%), that he [...] played an important role in
unifying the text and finding the right tone, but that his wish for
"francization" often prevented him from "daring" as much as he may
have wanted (apart from a few decisive findings)

## Conclusion

Far from being invisible in his activity as a literary smuggler, Larbaud re-
fined the translation as a whole and added his French author's signature
to the Joycian piece. While George Hérelle established himself as a French
author thanks to the Académie Française Prix Langlois in 1897 for his
translation of *Vierges aux rochers*, which was "so beautifully dressed in
French brocade" ("si bien habillées en brocart français")[37], in 1929 Larbaud
presented a monument of French literature which "enriche[d] national li-
terature" ("enrichit sa littérature nationale") and "honore[d] its own name"
("honore son propre nom") (Larbaud 1997: 71). Therefore, the translator's
hospitality and invisibility shouldn't conceal the power dynamic at play
between languages, a dynamic which Larbaud often euphemized as a re-
lationship between a foreign text – which was translated and feminized
– and a conquering translator. Antoine Berman named it the "ordeal of the
stranger" ("épreuve de l'étranger"); translation is a battle with the linguis-
tic other. At a time when critical voices were keen on evoking the loss of
vitality of French literature and the French language's decline due to the
menacing expansion of English, the translation of foreign works appeared
to be both a means to increase and regenerate the national literary herita-
ge as well as a way to illustrate and defend the French language, the very
vehicle of the nation.

## Notes

1    Blaise Wilfert and Thomas Loué highlight this in their article on Gabriele d'An-
     nunzio's introduction to the French literary world: "la diffusion très significative
     des grandes revues parisiennes hors de France, et notamment dans la péninsule,
     lui laissait espérer quelque profit symbolique en Italie même" (2006: 106).

2    Letter by d'Annunzio to Hérelle, May 3, 1893: "En somme, la vie littéraire, dans mon pays, est moins que médiocre. J'ai pensé parfois qu'il faudrait franchir les Alpes et tenter quelque chose à Paris, avec vous comme *associé...*" (1946: 142). Ever since the scandal provoked by the publication of *Il Piacere* in 1889, Treves, the Turin publisher, no longer accepted to publish d'Annunzio's work for reasons related to decency.

3    Guy Tosi wrote how Georges Hérelle was, like Valery Larbaud, attentive to the landscape, but how he was even more attentive to the "pittoresque humain": "Le présent l'intéresse autant que le passé. Il adore, avant d'entrer dans un musée, respirer l'air du pays, aller à pied dans les quartiers populaires, interroger l'indigène, regarder un costume, noter un trait de mœurs", *op. cit.*, p. 20.

4    De Vogüé therefore continued: "Aucune publication française n'a osé donner intégralement les inventions de ce terrible homme. Il y faut couper des pages, parfois des chapitres, comme dans *Le Plaisir*. La langue italienne a le privilège, soit qu'elle le doive à sa parenté plus proche avec le latin, soit parce qu'elle est restée plus près du peuple, de braver dans ses mots tout ce que brave le latin", éd. cit., p. 205. Regarding *L'Enfant de volupté* which had appeared in *La Revue de Paris*, Jean Ciseaux had also written: "Cela est si brûlant qu'on halète à le lire et qu'il semble vous couler dans les membres comme des flammes liquides !", "Journaux & Revues", *Gil Blas*, 16 décembre 1894, p. 3. The publication of *L'Enfant de volupté* in Louis Ganderax's *La Revue de Paris* had not been a smooth process, as is suggested in Ganderax's letter to Hérelle, on February, 14, 1895: "Après la première et la deuxième parties, nous avons déjà reçu certaines réclamations. Un membre du Conseil d'administration a écrit à Calmann menaçant de donner sa démission si l'on persévérait dans une pareille voie... Mais si nous laissions intacte la septième partie, que dirait le même administrateur ? Il serait furieux et ne serait pas le seul. Pour le public français, pour le public de la revue, nous sommes allés jusqu'à l'extrême limite...", cited by Tosi, *op. cit.*, p. 228.

5    Text on the poster-program of the conference presented by Larbaud at the Maison des Amis des Livres, December 7, 1921, cited in the catalogue of the exhibit *Autour d'Ulysse: James Joyce, Valery Larbaud*, Vichy, Bibliothèque Municipale, May 31-July 10, 1986, p. 2.

6    Hérelle, cited by Tosi, *op. cit.*, p. 103.

7    Letter by d'Annunzio to Hérelle, November 14, 1892, *op. cit.*, p. 124. Underlined in the original letter. Tosi reiterated the importance of French literary acclaim for d'Annunzio: "quels qu'aient été les rapports de d'Annunzio avec ses traducteurs anglais, allemands ou espagnols, on peut affirmer, sans crainte de se tromper, que seule la traduction française lui importe vraiment", *op. cit.*, p. 61.

8    Letter by d'Annunzio to Hérelle, June 27, 1894, *op. cit.*, p. 177.

9    Episodes 1 to 14 of *Ulysses* appeared in increments from March 1918 to September-December 1920. These increments were partially published in 1919 by the British periodical *The Egoist*.

10    In September of 1920, John Saxton Sumner, a representative of the "Society for the Suppression of Vice" pointed to fourteen pages in the latest issue that were "si obscènes, impudiques, lascives, sales, indécentes et dégoûtantes qu'une description détaillée serait offensante pour la Cour", cited by S. Beach (1950: 18).

11    For d'Annunzio, France also seemed to be the "pays de la grande liberté intellectuelle", letter to Hérelle, May 9, 1893, *op. cit.*, p. 144

12    Although *Ulysses* appeared in a German translation in 1927, according to Richard Ellmann, Joyce, "s'intéressait davantage à la traduction française" (1987: 242).

13    Cited by G. Mounin (1955: 80).

14    Letter of d'Annunzio to Hérelle dated May 9, 1893, concerning the publication of *L'Intrus* in volumes, *op. cit.*, p. 143.

15    Letter of d'Annunzio to Hérelle dated from October 1892, *op. cit.* p. 121. As was remarked by Tosi, the massive cuts made by the *Revue des deux mondes* and the lighter ones by *La Revue de Paris* "portent soit sur des notations d'une sensualité ou d'un réalisme jugés excessifs, soit sur des considérations religieuses, philosophiques, politiques, jugées inopportunes", *op. cit.*, p. 87-88.

16    Letter of d'Annunzio to Georges from January 22, 1894, *op. cit.*, p. 165.

17    Letter of d'Annunzio to Hérelle, dated from August 1894, *op. cit.*, p. 186. Brunetière had found the "note générale" of the third part to be "furieusement sensuelle" as he had told Georges Hérelle in a letter dated July 14, 1894, cited by B. Wilfert and Th. Loué 2006: 104.

18    Letter of d'Annunzio to Hérelle from August 6, 1894, *op. cit.*, p. 189. Underlined in the original letter. When he published his work in volume form, D'Annunzio wanted to restore the passages that had been deleted in literary magazines. However, the definitive text does not seem to be entirely conform to the original. Tosi noticed that the structure of *L'Enfant de volupté* differs from the Italian original: "si la somme et la teneur des chapitres est à peu près identique, leur ordre diffère: il est plus conforme, dans la version française, à l'ordre chronologique des événements", *op. cit.*, p. 88.

19    Letter of d'Annunzio to Hérelle from February 14, 1892, *op. cit.*, p. 113.

20    Letter of d'Annunzio to Hérelle from June 30, 1894, *op. cit.*, p. 178. Underlined in the original letter. Édouard Rod wrote in the *Journal des Débats* of May 10, 1895: "M. d'Annunzio n'aurait-il donc pas lu les merveilleuses traductions de M. Hérelle ? Car enfin, ces traductions, qui sont de véritables œuvres d'art, suppriment beaucoup de détails que le public français ne soupçonne même pas et traitent le texte avec la plus grande liberté. N'en déplaise à M. d'Annunzio, ce n'est pas lui que comprend et goûte le public français, c'est *lui, revu, abrégé et atténué* par M. Hérelle", cited by Tosi, *op. cit.*, p. 58.

21    Letter by d'Annunzio to Hérelle, January 4, 1905, *op. cit.*, p. 384-387.

22    According to Friedrich Schleiermacher, "le traducteur doit laisser l'écrivain le plus tranquille possible et faire que le lecteur aille à sa rencontre" (1999: 49).

23    Maurice Saillet, cited by Régis Salado (1994: 964).

24   The expression is by Paul Claudel himself, used in a letter to André Gide on May
     14, 1911. While defending Nicolas Perrot d'Ablancourt's translations, Claudel
     defined good translation as being a "véritable transubstantiation" (1949: 172).

25   Letter by Valery Larbaud to Jean-Richard Bloch, January 1, 1913, *Cahier des
     Amis de Valery Larbaud*, n°29, Vichy, 1991, p. 20. Underlined in the original
     letter. We must note that Larbaud placed himself under the invocation of saint
     Jerome who, in his *De optimo genere interpretandi*, stated the following trans-
     lation maxim: "non verbum e verbo, sed sensum exprimere de sensu". Saint
     Jerome wanted to render the meaning of a text rather than the actual words.
     He therefore returned to the Ciceronian critique of word-by-word translation
     and admired in Cicero's work "tout ce qu'il y a d'omis, d'ajouté, de changé
     pour expliquer les idiotismes du grec par les idiotismes du latin", cited by G.
     Mounin (1955: 80).

26   Salado pointed out the fact that the translation conflict that opposed Larbaud
     to Morel was a "conflit de lecteurs". On reading errors and cases of over-in-
     terpretation of the Joycian text by French post-structuralist criticism, see G.
     Lernout (1990).

27   Letter by Larbaud to Adrienne Monnier, October 6, 1927 (Larbaud 1991: 317).

28   R. Pannwitz, *Die Krisis der europäischen Kultur*, cited by W. Benjamin (2000:
     260).

29   Joyce's expression in a letter by Larbaud dated August 5, 1928, cited by J.L.
     Brown (1983: 43).

30   Fritz Senn wrote, when comparing the French, Spanish, Italian, German, Swed-
     ish, Danish and Yugoslav translations of *Ulysses*: "The French translation goes
     further than all the others in its tendency to adapt personal names: Hornblower
     becomes Cocorne, Wisdom Hely Lesage Hely, Father Coffey le Père Serqueux
     or Cerqueux, Nosey Flynn is Blair Flynn, and we have Henry Fleury, Dache
     Boylan, Alexandre Cleys and le révérend Hugues C. Amour. Even the *Freeman's
     Journal* is turned into *L'Homme Libre* [...]" (1967: 182).

31   Letter by Stuart Gilbert to Larbaud, August 5, 1927 preserved in the Berg col-
     lection, cited by Régis Salado (1994: 951).

32   Letter by Larbaud to Adrienne Monnier, August 8, 1927, *op. cit.*, p. 309.

33   Letter by d'Annunzio to Hérelle, March 16, 1896, *op. cit.*, p. 276.

34   Letter by Larbaud to Monnier, October 1, 1927, *op. cit.*, p. 312.

35   Let us examine two examples taken from the first episode and studied by André
     Topia (2004: 142 and 145). At the beginning of the opus, when Buck Mulligan
     and Stephen Dedalus stop to contemplate the bay, the original text "they hal-
     ted, looking towards the blunt cape of Bray Head" was translated as "ils s'ar-
     rêtèrent et regardèrent la pointe émoussée de Bray Head" ("ils s'arrêtèrent, le
     regard tourné vers le promontoire obtus de Bray" in the new 2004 translation).
     By coordinating and conjugating the two verbs in the passé simple, the French
     sentence results in a "chronological normalization" which doesn't occur in the

English version, since the English sentence seems to oscillate between succession and simultaneity. The translation therefore seems to reconstruct the Joycian chronology. The second example is a little bit further along, when Stephen sees the head of a seal in Mulligan's head as he swims: the original text "a sleek brown head, a seal's" is translated in 1929 as "une tête lisse et brune de phoque" ("une tête marron, lisse, celle d'un phoque" in the new 2004 translation). In this case, the French translation didn't render the metaphorical apposition "a seal's" but instead flattened it by coordinating the whole thing. The new 2004 translation meant to stick more closely to the syntax, to the word order which is organized "selon une sorte de 'phénoménologie de la perception'" (J. Aubert 2004: 1163).

36   Notes by Daniel Ferrer, head of the Joyce team at the ITEM institute, who explored the genetic records of the French translation of *Ulysses*. These records are found in the Berg Collection of the New York library, cited by Régis Salado (1994: 961). Larbaud also adapted the Joycian internal monologue in *Amants, heureux amants*.... Far from giving way to a deflagration of sounds and images, the Larbaldian monologue seems instead to answer to an ideal of French sobriety. Jacques Rivière noticed this when reading *Amants, heureux amants...*: "Mon cher ami, si seulement Joyce avait dans la tête le plomb que vous y avez ! Je ne comprends la valeur de son procédé que depuis que vous vous l'êtes assimilé. Par quel subtil et heureux mélange de bon sens il est, chez vous, tempéré ! On ne cesse pas de sentir où on va; on est lesté. Ce n'est pas ce vagabondage aride de la pensée, cette espèce de maladie de l'imagination" (Valery Larbaud & Jacques Rivière 2006: 167-168).

37   Vogüé's expression, cited in a letter by d'Annunzio dated November 1896, *op. cit.*, p. 301.

## References

Anglès, Auguste. 1979. "Accueils français à Joyce entre les deux guerres". *Joyce & Paris*, éd. Jacques Aubert et Maria Jolas. Paris: Éditions du CNRS.

Aubert, Jacques. 2004. "Écrire après Joyce". *Ulysse*. Paris: Gallimard.

Beach, Sylvia. "*Ulysses* à Paris". *Mercure de France*, 1er mai 1950.

Benjamin, Walter. 2000. "La tâche du traducteur". *Œuvres*, t. I. Paris: Gallimard.

Berman, Antoine. 1984. *L'épreuve de l'étranger, culture et traduction dans l'Allemagne romantique*. Paris: Gallimard.

Brown, John L. 1975. "Valery Larbaud et la littérature américaine", *Colloque Valery Larbaud*, Vichy, 17-20 juillet 1972. Paris: A.G. Nizet.

Brown, John L. 1983. "Ulysses into French". *Joyce at Texas: Essays on the James Joyce Materials at the Humanities Research Center*, ed. Dave Oliphant and Thomas Zigal, Austin: The University of Texas at Austin.

Charle, Christophe. 1998. *Paris fin de siècle, culture et politique*. Paris: Seuil.

Claudel, Paul. 1949. *Correspondance Paul Claudel-André Gide, 1899-1926*, éd. Robert Mallet. Paris: Gallimard.

D'Annunzio, Gabriele. 1946. *D'Annunzio à Georges Hérelle. Correspondance*. Guy Tosi, ed. Paris: Éditions Denoël.

Doumic, René. 1895, March 30. "M. Gabriel d'Annunzio". *Revue bleue*.

Ellmann, Richard. 1987. *Joyce 2*. Paris: Gallimard.

Joyce, James. 1975. *Selected letters of James Joyce*, Richard Ellmann ed. New York: Viking Press.

Larbaud, Valery. 1958. "Paris de France". *Jaune Bleu Blanc. Œuvres*, éd. G. Jean-Aubry et R. Mallet. Paris: Gallimard, coll. Pléiade.

Larbaud, Valery. 1997. *Sous l'invocation de saint Jérôme*. Paris: Gallimard.

Larbaud, Valery. 1998. "Une renaissance de la poésie américaine". *Ce vice impuni, la lecture, Domaine anglais, suivi de Pages retrouvées*, éd. Béatrice Mousli. Paris: Gallimard.

Larbaud, Valery. 1991. *Lettres à Adrienne Monnier et à Sylvia Beach, 1919-1933*, éd. Maurice Saillet. Paris: IMEC.

Larbaud, Valery & Jacques Rivière. 2006. *Correspondance 1912-1924*, éd. Françoise Lioure. Paris: Éditions Claire Paulhan.

Lernout, Geert. 1990. *The French Joyce*. Ann Arbor: University of Michigan Press.

Maury, Lucien. 1925. *Babel*. Paris: Perrin & Cie.

Mounin, Georges. 1955. *Les Belles Infidèles*. Paris: Éditions des Cahiers du Sud.

Pound, Ezra. 1922, June 1st 1922. "James Joyce et Pécuchet". *Mercure de France*.

Salado, Régis. 1994. *Ulysses de Joyce, laboratoire de la modernité: étude de réception comparée dans les domaines français et anglo-saxon (1914-1931)*. Nanterre: Université de Paris X-Nanterre, t. III. [Thèse de Doctorat inédite.]

Schleiermacher, Friedrich. 1999 [1813]. "Des Différentes méthodes du traduire", trad. Antoine Berman. Paris: Seuil.

Senn, Fritz. Spring 1967. "Seven against *Ulysses*". *James Joyce Quarterly* IV: 3. 170-193.

Topia, André. 2004. "Retraduire *Ulysses*: le troisième texte". *Palimpsestes* n° 15, 129-151.

Vogüé, Eugène-Melchior de. 1895, 1st January. "La Renaissance latine – Gabriel d'Annunzio: Poèmes et romans". *Revue des deux mondes*, 187-206.

Wilfert-Portal, Blaise. 2009. "Littérature, capitale culturelle et nation à la fin du XIXe siècle, Paul Bourget et Gabriele d'Annunzio entre Paris et Rome 1880-1895". *Le Temps des capitales culturelles: XVIII-XXe siècles*, eds. Christophe Charle & Giovanna Capitelli. Paris: Champ Vallon, 277-318.

Wilfert, Blaise & Thomas Loué. 2006. "D'Annunzio à l'usage des Français: la traduction comme censure informelle (fin du XIXe siècle)". *Ethnologie française* 36:1, 101-110.

Part 2

# Journals

# Cultural Mediation Through Translation in *The Edinburgh Review*, 1802-1807

Tom Toremans (KU Leuven)

## Abstract

This chapter deals with the position of foreign literature and culture during early Romanticism in Scotland. Contrary to the insular retreat from world literature in the English-dominated Victorian Age (as analysed, among others, by Franco Moretti), the Scottish-dominated literary production of the early nineteenth century exhibited an eagerness to explore, review and translate foreign literary, philosophical and political texts. These texts came mainly from France and Germany, but also from the Orient and from Scandinavian and Eastern European countries. The two key mediating periodicals were *The Edinburgh Review* and *Blackwood's Edinburgh Magazine*. As recent work by Ian Duncan, Ina Ferris and others has shown, both magazines were instrumental in the emergence of a British literary market that would be the driving force behind the literature now designated as "Romantic". What is often obscured in the decade-long national perspective on Romanticism, is precisely the crucial role played by the reviewing and translating of foreign literatures in the emergence of the literary market that functioned as the broader platform on which this Romantic culture could thrive. As Peter France has recently argued, the presence of foreign literatures in both periodicals and the specific modalities of their mediation "has yet to be full explored". By means of a close comparative analysis of key moments of intercultural mediation in the Whig *Edinburgh Review* and the Tory *Blackwood's* in the period between 1802 (the founding of the former) and 1829 (the year until which Francis Jeffrey edits the ER) this chapter pursues a more precise description and critical understanding of foreign literature in Romantic periodical culture and the mechanics of critical mediation that drove the literature and criticism of Romanticism.

There can be little doubt that since their gradual rise to prominence since the beginning of the nineteenth century, periodicals in Britain have actively

participated in the mediation of foreign cultures in a variety of ways. In the wake of the founding of *The Edinburgh Review* in September 1802, a veritable "empire" of the periodical press emerged that firmly established periodicals as "the predominant purveyors of scientific, economic, and social information" and "arbiters of literary and artistic taste" (Schoenfield 2009: 1) in the opening decades of the 19th century, eventually making magazine writing "the pre-eminent literary form of the 1820s and '30s in Britain" (Parker 2006: 1).[1] Despite the recent renewed critical interest in the phenomenon of the Romantic periodical, however, its function as cross-cultural mediator has been assumed rather than studied or analysed. As a propaedeutic to such an analysis, I propose in this paper to look more closely at the processes of transfer, translation and refraction in the first two numbers of *The Edinburgh Review* This textual corpus is of course much too limited to provide a solid basis for conclusions about cross-cultural transfer in *The Edinburgh Review* or Romantic periodicals as such. My main objective here is more modest and is to outline possible directions that such a more extended analysis might take.

In what follows, I will first offer some preliminary reflections on recent methodological developments in the historical research on mediation, transfer and translation. Subsequently, I will sketch the broader context of the Romantic periodical press and of the founding of *The Edinburgh Review* in particular. In a third and final movement, I will engage in a close analysis of the inaugural volume of *The Edinburgh Review* and the periodical's active engagement with cultural transfer and translation. My argument, then, will proceed from a general, contextual level to a textual one, or from distant to close reading, taking its cue from Lawrence Venuti's advice that "[t]he focus on translation is to redefine the study of literature in the most material ways" and in order to be productive, this study of translation must "combine distant and close reading of translations" (2013: 191).

## Mediation, Transfer and Translation

Like mediation, the notion of transfer is sufficiently vague to allow for a broad application across disciplines and methodologies, while at the same time suggesting a process that is concrete and important enough to invite systematic analysis. Thanks to sustained methodological and theoretical reflections that have driven the discipline of Translation Studies over the last five decades, the notion of translation has been delineated much more sharply, albeit from a variety of angles. Recent interventions in the field of Translation Studies have provided compelling pleas for a renegotiation of the relation between the notions of transfer and translation. In fact, soon after Espagne's and Werner's work on cultural transfer of the late 1980s,

the relevance of the notion for Translation Studies was suggested by Itamar Even-Zohar in a short programmatic article on "Translation and Transfer", published in *Poetics Today* in 1990.[2] In the essay, Even-Zohar returned to Roman Jakobson's neglected suggestion of an analogous relation between interlingual and intralingual translation in his seminal essay "On Linguistic Aspects of Translation" (1959) and argued that it would be "profitable" for Translation Studies "to think and work explicitly rather than implicitly in terms of a *transfer* theory" (1990: 73). When turning to the study of transfer and translation in periodicals, two recent articles that have taken up Even-Zohar's suggestion are of particular relevance: Susanne Göpferich's plea for an integration of *Transferwissenschaften* into Translation Studies and Lieven D'hulst's urging for "a renewed alliance between the concepts of cultural transfer and translation" and a conceptualization of transfer "as a tool for the historical study of large sets of correlated discursive and institutional transfer techniques (including translation)" (2007: 139).

Promoting a mutual exchange of theories and methodologies between Translation Studies and Transfer Studies (in the shape of *Transferwissenschaften* as established by Gerd Antos and Sigurd Wichter), Göpferich situates her own concept of transfer in between Even-Zohar's broad definition and Anthony Pym's narrower one (focusing on the material displacement of texts). Göpferich's notion of transfer is focused on making "what is transferred, cognitively accessible in the target culture" (2007: 33). Translation Studies, then, come to be defined as "the field of research whose object of research is any mediated transformation of offers of information performed to fulfill specific functions and meet the needs of specific audiences" (2007: 34). Thus repositioning translation and transfer in terms of mediation, Göpferich provides an interesting entry into the study of cultural transfer in British Romantic periodicals, which precisely occurs as an inter- and intralingual mediation of knowledge to a readership of its own creation.

In a recent article Lieven D'hulst provides concrete methodological guidelines for historical transfer research. D'hulst introduces the notion of "assumed transfer" – analogous to Gideon Toury's "assumed translation" – to avoid the straightjacket of source/target thinking that tends to determine the discourse on translation, thus including in his analysis "all features presented or regarded as transfer features within a given cultural setting."

> There are several conditions that such a concept must fulfil: (1) it should do justice to the interrelatedness of cultural exchange processes; (2) it should encompass as many features of these processes as possible, taking into account the fact that some are verbal and others not, that some are labelled explicitly (translation and imitation often are) and others are not (such as concealed translation or pla-

giarism); (3) it should be able to address the historical evolution of these features. (2012: 142)

"Assumed transfer", then, implies a non-linear view on cultural mediation that takes into account the many aspects of transfer and its historical evolution. As D'hulst indicates later in his argument, such a view cannot be exclusively limited to movements of import and/or export, but will also have to

> focus on certain subsets or parts of the entire process of exchange between cultures (such as institutional networks, publishers or translators) and on the transferred items themselves (such as anthologies of translations, literary histories of foreign literatures or adaptations for children). (2012: 142)

On a practical level, historical transfer research should rely on a methodology that starts from a well-defined corpus that "offers enough material evidence of transfer having occurred (through the visibility of transfer agents, transfer techniques, the effects of transfer within the target culture, and so on)" and then analyses features of this transfer process, starting from the most salient and observable ones and proceeding to the less conspicuous ones. In the case study that makes up the second part of his article, D'hulst discusses the construction of a Belgian literature in the nineteenth century (from 1830 onwards) by means of detailed analyses of the intricate and at times paradoxical processes of intercultural (between Belgium and France) and intracultural (the edition or adaptation of past chronicles or novels within the Belgian frame) transfer. Interestingly, D'hulst subsequently focuses on the "newly founded journals" as "the most dynamic and innovative segment of print culture in Belgium' and with their broad generic diversity a "gold mine for the study of discursive techniques" (2012: 146).

Together with Göpferich's emphasis on the mediation of knowledge through transfer/translation involving specific functions and audiences, D'hulst's methodological suggestions for historical transfer research provide a firm basis for an analysis of cultural mediation and transfer in Scottish Romantic periodicals and the agents, institutions and techniques involved.

## Scottish Romantic Periodical Culture and Translation

Partly in the wake of a rich and diverse body of scholarship on Victorian periodical culture, Romantic scholarship has in recent years started to highlight the crucial role that periodicals have played in the formal and thematic development of Romantic literature and its broad cultural dissemination. Especially during the last decade, the study of Romantic

periodicals has focused on a wide range of aspects, such as the economics of periodical production (Erickson 1996), the politics of periodical publication (Parker 2006), the impact of periodical press on notions such as genre and literary identity (Schoenfield 2009) or on gender, politics and nationalism (Cronin 2010), the late-Romantic entanglement of periodical publication and empire (Fang 2010), the metropolitan context and readership of the periodical press (Stewart 2011), and the relation between literary and periodical writing (Wheatley 2003). Other monographs and collections of essays have provided detailed studies of periodicals such as *The Edinburgh Review* (Christie 2009, Fontana 2008) and *Blackwood's Magazine* (Finkelstein 2006, Morrison and Roberts 2009). Recent articles in the field have dealt with the relation between Scottish periodical culture and community formation (Stafford 2002), the specific national public culture they emerged from (Benchimol 2011), cultural mediation as such (Butler 2010), performative media in the 1820s (Esterhammer 2013), and performative self-authorization (Mole 2013). If the study of Romantic periodicals has thus produced a considerable body of scholarship that exhibits a remarkable methodological and thematic variety, one aspect of periodical publication persistently remains unexplored: the issue of translation and the process of cultural transfer it facilitates.

This lack of critical attention is symptomatic of a relative neglect of the issue of translation in Romantic studies as such. Translation only recently resurfaced as an object of critical inquiry in 19th-century studies, as indicated by publications by David Clark (2007), Frederick Burwick (2008), Maria Filippakopoulou (2011), Padma Rangarajan (2014) and myself (Toremans 2010, 2011, 2015). With specific reference to *The Edinburgh Review*, it is generally acknowledged that it was deeply engaged with non-English literature and writing (Brand 1975, MacKenzie 1982). Yet, a close analysis of the actual form and substance of this cross-cultural dimension has never been fully pursued. As J.H. Alexander indicated in his 1990 article on Continental literatures in *The Edinburgh Review* and *Blackwood's Magazine*, the presence of translations in both periodicals required "much more thorough and systematic study" (1990: 118), with the adequacy of translations and the knowledge of foreign language among authors and their reading public as possible objects of further research. In a recent article, Peter France notes that "the nineteenth century was a time when British culture, although increasingly insular in many ways, was also increasingly aware of a wide spread of world literature" and that an "important part in this exploration was played by the thriving new periodical literature, which found space both for translations of foreign works and for long reviews that often contained substantial translated passages." France subsequently provides a wide overview of instances of translations in both periodicals, presenting as a first

general observation that one can discern in *Blackwood's* an "interest in a great variety of foreign writing, ancient and modern, (above all from Germany) and in the process of translation, while *The Edinburgh Review* tends to concentrate on recent French culture" (2009: 2). As France himself indicates, this rich but unexplored field needs to be further explored through systematic analysis. A closer look at the inaugural issues of *The Edinburgh Review* provides a first idea of what such analysis might look like.

## The Edinburgh Review

In October 1802, the English cleric and private tutor Sydney Smith and two Scottish lawyers, Francis Jefffrey and Francis Horner publish the first issue of *The Edinburgh Review* with the Edinburgh publisher Archibald Constable, who would in the ensuing years become the main publisher of Walter Scott's poems and novels. The first issue contained 257 pages, cost 5 shilling and, as Ina Ferris has argued, "established itself from the start as a journal directed to 'middling' class readers with time on their hands and a certain intellectual or cultural ambition." As Ferris also notes, it were precisely these readers that were "spearheading the marked boom in reading that characterized the early decades of the nineteenth century, readers who relied on the literary reviews as the primary source of information about new publications." This public quickly picked up the new periodical format: the first edition of 750 copies sold out quickly and within five years *The Edinburgh Review* outsold "all the major London journals with a print run of 7,000" and selling more than 13,000 copies in 1814.

The magazine had a direct impact on review journalism in a number of ways. In the first place, where previous review journals had aimed at comprehensiveness, *The Edinburgh Review* was to be selective. In the advertisement accompanying the first number, the editors explicitly indicate that they wish their review "to be distinguished, rather for the selection, than for the number of its articles" (iii). Accordingly, instead of the dominant form of the 18th-century review (such as the *Critical Review* and the *Monthly Review*) appearing on a monthly basis and containing between 40 and 80 reviews spread across some 120 pages, *The Edinburgh Review* appeared as a quarterly of twice that length and carrying only 29 reviews. The reviews were considerably longer and would continue to grow in size over the following years and decades. A second defining characteristic of the newly founded *Edinburgh Review* concerned the types of works selected for review. Instead of the literary works, classical scholarship and theology reviewed in the traditional reviews, *The Edinburgh Review* mainly targeted works on the natural sciences, moral philosophy and political economy – interests central to the Whig editors responsible for the selection. Thirdly,

*The Edinburgh Review* also distinguished itself from its British 18th-century predecessors by means of a more openly critical, poignant and arrogant tonality. From the third issue until 1829, the magazine was edited by Francis Jeffrey, who established *The Edinburgh Review* as a prestigious magazine as the site of the emergence of the "specialist critic" or "professional reader" who would grow into the figure of the "public intellectual" genre Thomas Carlyle and Matthew Arnold (Ferris).[4]

In a recent article, Will Christie provides a clear outline of the function of *The Edinburgh Review* in the knowledge economy of its time. Quoting Biancamaria Fontana's description of *The Edinburgh Review* as "a popular encyclopaedia of both natural and moral sciences, a principled digest of philosophical and scientific opinions for the consumption of the educated middle classes" (2009: 125), Christie focuses on the incisive impact that the periodical had on the dissemination of knowledge and the shaping of public understanding. Not only did *The Edinburgh Review* lead to the emergence of the professional reviewer (often combining this critical activity with other professions such as law, medicine, academic philosophy, etc.), it also saw him "affecting a kind of omniscience and assuming greater authority than both the author and the reader" (2009: 122), turning the Reviews into "observers and decoders of historical signs, masters of interpretative techniques and purveyors of 'the knowledge'" (2009: 124). As Christie also notes, *The Edinburgh Review* was essentially multi-disciplinary in a radically innovative manner:

> the Edinburgh continued to map traditional disciplines, like philosophy and classical literature, along with various emerging knowledges: the latest 'sciences' (as they would soon be called), historiography, anthropology, sociology, foreign policy, education, political economy – and to map them often in novel and provocative ways that justified its incursion into an already crowded market. (2009: 126)

Apart from this broad disciplinary scope, *The Edinburgh Review* depended on "extraordinarily cosmopolitan literary resources" (2009: 128) and was strongly embedded in the post-Enlightenment Scottish knowledge economy (most notably the Scottish educational system and the Scottish Enlightenment) and in the booming publishing and lecturing industry of the time. Both this cosmopolitanism and this educational thrust were driven by a strong liberal Whig belief in free and competitive trade as "at once the condition and the immediate beneficiary of any public enlightenment" (136). It is this strong ideological profile that will subsequently give rise to competing Tory contenders such as the *Quarterly Review* (founded in 1809) and *Blackwood's Edinburgh Review* (founded in 1817).

## Transfer and Translation in *The Edinburgh Review*

The liberal, multidisciplinary and cosmopolitan orientation of *The Edinburgh Review* provided particularly fertile ground for cultural transfer and translation. Almost half (19) of the 52 works reviewed in the first two numbers were works originally written in another language than English. The vast majority (13) of the latter were, not surprisingly, of French origin. Other reviews concerned works in Latin (3), German (2) and Italian (1). In the majority of cases (12) the critics reviewed the works in the foreign language, translating and/or paraphrasing fragments into English in the reviewing process. Only 2 out of 6 reviews of translated works mention the translator. In the case of the non-translated works, the reviewer himself will often translate passages, but since all reviews were initially published anonymously, also here the translator remains invisible. The broad disciplinary range of the works reviewed is remarkable, including works of political and moral philosophy, natural science, sermons, literature, medicine, history, and travel accounts.

This broad picture is further complicated when one analyses in further detail the intricate position of translation in the transfer process. Most generally, translation should by no means be taken as the only marker of cross-cultural transfer. A line count reveals that 93% of the language of *The Edinburgh Review* is quite unsurprisingly English,[5] yet substantial portions of these English passages are actually paraphrases of non-English works and/or languages. Also, many English passages are actually translations from an original work supplied by the reviewer (a total of 709 lines or roughly 3.1%, the majority from French) or quoted from a translated work (728 lines, or roughly 3.2%). Much less common (a total of 273 lines) are passages that are left untranslated by the reviewer, mostly to complain about the affected style of the French, but also when quoting Latin sources to back up an argument.

A typical example of this dynamic interchange between paraphrase, translation and quotation is the review of Madame Necker's *Reflexions sur le Divorce*, published anonymously in the second issue and later claimed by founding editor Sydney Smith. Apart from extensive paraphrases of and commentaries on Necker's argument, about 16% of the review consists of translations of extensive passages of Necker's original text. And when near the end of the review Smith wants to substantiate his claim that Necker's style should not be taken as exemplary by British female authors, he quotes a paragraph "in the original, as a translation might give but a very imperfect idea of the merits or defects of Madame Necker's style" (494).[6] In addition, it might be noted that Smith also quotes the Law of the Twelve Tables and its pronouncements on the issue of divorce in Latin (490). As this review demonstrates, cultural transfer in *The Edinburgh Review* is es-

sentially a multifarious and multilingual process, combining paraphrase, translation, quotation and commentary.

Another characteristic of cultural transfer in the inaugural volume of *The Edinburgh Review* is that it often and in different ways occurs as a process of refraction. The notion of refraction – and its later reconceptualization as "rewriting" – was introduced by André Lefevere in the 1980s in a series of essays later republished in the volume on *Translation, Rewriting and the Manipulation of Literary Fame*. In the introduction to this volume, Lefevere provides the following definition:

> All rewritings, whatever their intention, reflect a certain ideology and a poetics and as such manipulate literature to function in a given society in a given way. Rewriting is manipulation, undertaken in the service of power, and in its positive aspect can help in the evolution of a literature and a society. Rewriting can introduce new concepts, new genres, new devices and the history of translation is the history also of literary innovation, of the shaping power of one culture upon another. But rewriting can also repress innovation, distort and contain, and in an age of ever increasing manipulation of all kinds, the study of the manipulation processes of literature are exemplified by translation can help us towards a greater awareness of the world in which we live. (1992: vii)

Perhaps the most straightforward example of refraction in the opening volume of *The Edinburgh Review* is the review of Charles Villers's book *Philosophie de Kant, ou Principes Fondamentaux de la Philosophie Transcendentale*, printed in Metz in 1801 and sold by a London bookseller (De Boffe). The review, which opens the second issue, was published anonymously but later attributed to Thomas Brown, the Scottish philosopher who would be appointed the Chair of Moral Philosophy at the University of Edinburgh in 1810. As René Wellek noted in his *Immanuel Kant in England*, Brown's review of Villers marks the first account of Kant's transcendental philosophy in Britain by a professional philosopher (Brown was "the first to enter into any details of criticism and to take Kant sufficiently serious to criticize him at all" (1931: 33)) and the review had a decisive influence on the reception of Kant in Britain for many years.

Villers is generally acknowledged to be the first main critic and translator of Kant's works to a broad French readership and his account of the Critical Philosophy "was replaced only by Madame de Staël's book on Germany and Cousin's lectures as the most available information on Kant for France" (Wellek 1931: 32).[7] That Villers's account substantially rewrites Kant's philosophy was already indicated by F.W. Schelling in a very harsh

review of the book in the *Kritisches Journal der Philosophie* in 1802. As Wellek points out, Villers "has understood Kant only psychologically, never logically and therefore missed the whole point of Kant's criticism" and, consequently, "Brown's attack, which is frequently enough very penetrating, is therefore an attack against a ghost created by Villers and not against the actual Kant of history" (1931: 33).

Interestingly, Brown himself foregrounds cultural transfer as a process confronted with national and ideological boundaries in the opening paragraphs of his review. Despite the cosmopolitan belief in the Republic of Letters, Brown argues,

> [t]here are in every country names as illustrious, which have been stopped, in the process of their glory, by the unfortunate position of a mountain or a river [...]. The tardiness with which the discoveries of Newton, so simple and so important, and so readily corresponding with the general habits of science, were adopted in that large province of the literary republic in our immediate neighbourhood, is well known; and we therefore feel no astonishment, that the glory of illuminating his countrymen, in *purisms* and *supersensibles*, should have been reserved for M. Charles Villers [...]. (253-54)

If Brown thus highlights the obstacles to successful transfer of Kant's thought via France to Britain, he is also very much aware of his own place in this chain of mediations and of the inevitable rewriting that accompanies cultural transfer, as when he openly acknowledges that "we are unacquainted with [Kant's] original works, and that the justness of our sketch, and consequently of our own objections, must therefore depend wholly on the fidelity of his expositor" (257). As one of Villers's most salient reconceptualizations of Kant, Brown mentions his "little mercy for the methodical habits of sober and contented investigation" with the explicit hope of "gaining over the lighter fancy of his countrymen" (257). Villers's recontextualizes Kant's philosophy into recent French history, most notably to "the crimes of mobs, and encyclopedists, and guillotines" and "to the saving virtues of the armies and the emigrants" (257). Like Smith's review of Madam Necker's book on divorce, Brown also inserts French quotes. This time, however, the quotations are not motivated by stylistic observations: they are added precisely to ascertain that the reviewer has not misapprehended the text under review. As Brown notes before providing a lengthy French quote in a footnote:

> [w]e think it necessary to add the whole passage from the original, as we may have been led into a misapprehension of its meaning, by the

attention which M. Villers has paid to an excellent rule of rhetoric: a subject, in itself most obscure, he has certainly succeeded in treating with all appropriate obscurity. (272)

The process of refraction is also highlighted by more or less explicit translational gestures. One such gesture is the Brown's translation of *Kritik der reinen Vernunft* as "*Review of pure Reason*", adding in a footnote that

> [t]he German title of this work is *critic der reinen vernunft*; and the system it contains is commonly known under the very absurd name of the *critical philosophy*, which, at least to an English reader, is very little significant of the peculiar process of thought it is intended to denote. The *self-reviewing* philosophy would have been a term more diagnostic. But the other term has now almost prescriptive right; and we have therefore retained it in the discussion which follows. (256)

Brown's translation of the notion of "Kritik" as "Review" substantially rewrites Kant's critical philosophy, precisely to the extent that it fails to capture the difference between Kant's notion of "Kritik" and the English word "criticism". A similar translational rewriting occurs at the moment when Brown decides to translate "Verstand" as "*intelligence*", rather than the more common "understanding". Motivating his choice of words, Brown swiftly moves between languages – from German, French and Latin to English.

> The original terms is *verstand* (*entendement*) which may be more simply translated *understanding*; but the term we have chosen, which is merely the Latin corresponding word with an English termination, however singular its use may at first appear, is preferred by us to its more common synonym, from the very circumstance that it *is* less common. In the use of a term to which we have long been accustomed, there is much danger of error, when the limitation of its meaning is not precisely the same [...]. (259)

Also in other reviews, the translation process itself becomes the explicit object of commentary, as in Robert Morehead's extensive comments on Henry Boyd's translation of the *Divina Commedia* and Alexander Hamilton's review of the sixth volume of the *Asiatic Researches*, the title given to the Transactions of the Society Instituted in Bengal. The latter is especially interesting in the way in which it explicitly dismisses a particular instance of cultural transfer by means of a detailed criticism of the translation process on which it depends.[8] As an established orientalist, linguist and polyglot,

Hamilton advises "the historian, the antiquary, the botanist and the geographer" to "acknowledge important obligations to the ardour of literary research, excited in the centre of Asia" (26). In general relatively favourable on several scientific accomplishments in Asia, Hamilton strikes a more critical note with regard to the piece "On the Religion and Literature of the Burmans" (30) by the Scottish physician zoologist, botanist and geographer Francis Buchanan. Buchanan's form of literary study should by no means be held as an example, according to Hamilton:

> As we shall find it necessary to object, in many instances, to the information furnished by this gentleman, and, in most, to dissent from his conclusions, it is proper to account, in some measure, for the confidence with which we venture to contradict a writer, whose opportunities of information on the subjects he treats of, are peculiar to himself, and the other gentlemen of the mission. (30)

Interestingly – and crucially for our interest in cultural transfer – Hamilton targets Buchanan's self-confessed ignorance of "the languages of the East" (30) and spends quite some time correcting his flawed rendition of Burmese religions and literature. This corrective commentary targets an intricate chain of transfer through translations and refractions. Unversed in the language of the Burmese, Buchanan took recourse to three treatises by the Italian priest Vincentius Sangermano, who resided in Burma from 1783 until 1808 and whose manuscript on *The Description of the Burmese Empire* would be published posthumously in English in 1833. As he indicates himself, Buchanan only had access to the Latin version of the treatises, which he translated himself and then united into a coherent narrative of the culture religion of the Burmese people. Buchanan's eventual narrative, Hamilton argues, is thoroughly flawed as the result of inaccurate and incomplete translations. One of the three treatises Buchanan procures from Sangermano is entitled "Cosmographia Burmana" and is in fact a Burmese transcript of an ancient Sanskrit poem "Khetra Nirmana" ("the division of the countries"). The version that Buchanan consults is the Latin translation of this Burmese translation of the ancient Sanskrit poem, intermixed with observations by Sangermano himself. According to Hamilton, Sangermano's interpretation/translation, and by extension, Buchanan's narrative, are based on erroneous translations. To prove his point, Hamilton subsequently provides his own English translation of the original Sanskrit poem: "Let our readers compare the above passage with the following, which we translate literally from the Khetra Nirmana" (33). Further on in his review, Hamilton translates from Abu Fazil's Persian translation of a Sanskrit history of Casmir, originally produced for the Mughal emperor Akbar. The passage unmistakably proves Buchanan's assumptions

on the spread of Buddhism in India wrong. In a lengthy footnote, Hamilton provides what he calls "a literal translation" (35-36) of the Sanskrit history of Casmir to substantiate his argument. Hamilton's extensive corrective comments of faulty translational movements between Sanskrit, Persian, Latin and English aptly foregrounds cultural transfer as a process of refraction and subsequently sets out to redirect the erroneous translational gestures from which this refraction derives.

A third and final aspect of cultural transfer in the opening volume of *The Edinburgh Review* concerns the "institutional and discursive transfer techniques" that Lieven D'hulst referred to and that relate to the import of institutional, textual and generic models. Some 30 years before the emergence of journals in the first decades of an independent Belgium, *The Edinburgh Review* already posited itself as an innovative medium in the literary marketplace by means of transferring discursive techniques from France to Britain. It is no coincidence that this crucial transfer occurs in the opening review of the first issue, since it is here that *The Edinburgh Review* establishes its cultural authority by means of a critical review of a French work on the role of public intellectuals. In 1801 French philosopher and former president of the Constituent Assembly Jean Joseph Mounier published his book *De l'influence attribuée aux philosophes, aux francs-maçons et aux illuminés sur la Révolution Française*, in which he exonerated the French philosophers by blaming the collapse of the government on economic factors. As Mark Schoenfield has argued, Francis Jeffrey's review of the book stages the latter as modeling "a middle ground, one reasonable and systematic, for *The Edinburgh* to occupy" (2009: 68).[9] On the one hand, Jeffrey concedes Mounier's point that the philosophers were not directly responsible for the Revolution and the Terror that ensued. At the same time, however, Jeffrey is careful not to deny public intellectuals any regulating power. On the contrary, Jeffrey argues that any society is mediated through print media and processes of transmission that are essential for this society's health and stability, thus establishing the periodical (and *The Edinburgh Review* in particular) as the medium *par excellence* to avoid Revolution and Terror and to mediate ideological extremes into civil consensus. As Ina Ferris has argued:

> Jeffrey makes two points of particular salience for understanding the function of the public journal: first, he promotes a model of modern society as a highly complex system of interacting social, economic, political, and ideological forces; second, he argues that this is a highly mediated system, thoroughly saturated by print media. Discounting assumptions of "natural" or "spontaneous" public energies, he shifts attention to notions of transmission, which place on public genres (like periodicals) a responsibility to be "dispassionate" and to

avoid the "extravagance" and "absurdity" of a writer like Rousseau
[...]. A stable (but not static) modern social system thus requires a
considered public discourse like the one displayed in his own sober
and carefully analytic opening piece.

Although Jeffrey's review does not simply import a discursive strategy, it
is in its critical transfer of Mounier's political argument that it unfolds as
a performative event: while critically responding to a French tract on the
political power and social responsibility of philosophers, it inaugurates *The
Edinburgh Review* as an authoritative and effective public medium that oc-
cupies a distinctive position in the knowledge economy of the time.

## Conclusion

Our critical analysis of cultural transfer in the first two numbers of *The
Edinburgh Review* is far from exhaustive. We could also have discussed the
remarks on the German origins of the poetry of the Lake Poets in Francis
Jeffrey's harsh review of Robert Southey's *Thalaba*, perhaps the most
famous review of the first issue. Or the review of Heberden's *Commentarii
de Morborum Historia & Curatione*, published in English and in Latin,
"each apparently written by the original author" (468). Or the intriguing
case of Anquetil-Duperron's Latin translation of the Persian translation of
the Upanishads that he received in 1775 and published in Paris in 1801 as
*Oupnekhat*. Translation also occupies central positions in two reviews of travel
accounts by Henry Brougham in the first number. One concerns *The Journal
of Frederick Horneman's Travels*, a work originally published in English in
1802, but apparently translated from the German diaries of Horneman. And
in his review of Acerbi's *Travels Through Sweden, Finland, and Lapland
to the North Cape*, Brougham conjectures that the Italian explorer cannot
possibly be the author of the work and claims that "the traveller has done
little more than furnish the materials for these volumes" (171).

These and other cases indicate that there is much more material in *The
Edinburgh Review* that invites further analysis of cultural transfer and
translation in the periodical. In this contribution, we have merely suggest-
ed a blueprint for such analysis, emphasizing the necessity of combining
contextual analysis (the concrete circumstances of the founding of the pe-
riodical, the agents involved and its ideological programme) with detailed
close readings (of reviews and translations). In particular, our analysis has
demonstrated the dynamic interchange between cultural transfer and trans-
lation, in which the latter occupies different positions and functions to
enhance and/or complicate the former. As the most basic material trace of
cultural transfer, translation redirects transfer both to its broader socio-po-

litical context and to the local textual gestures of the Romantic critical review as it performs its mediating function in the inaugurating numbers of *The Edinburgh Review*.

## Notes

1   The notion of a literary "lower Empire" was famously introduced in 1823 in Byron's *Don Juan*, where it refers to the dominion of the periodical press.

2   In fact, this article presents a rewritten version of an argument Even-Zohar had already articulated in *Poetics Today* as early as 1981 ("Translation Theory Today: A Call for Transfer Theory." *Poetics Today* 2.4 (1981): 1-7.)

3   For a comprehensive account of the foundation of *The Edinburgh Review* and its relation to British Romantic culture, see Will Christie's *The Edinburgh Review in the Literary Culture of Romantic Britain* (2009).

4   Ideally this percentage would be based on a word count, but since no format is available that allows such a word count, we resorted to a manual line count on the basis of the physical print copy.

5   Similar quotations in French occur in Francis Jeffrey's review of Herrenschwand's *Addresse aux Vrais Hommes de Bien* in the first issue, stating that "we are persuaded, that no one can read through it, without acknowledging that it is impossible for any translation to do it justice" (100).

6   For a fuller account of Villers as a mediating figure, see Ruth Ann Crowley's *Charles Villers* (1978).

7   Hamilton performs a similar translation criticism in the second number, in which he reviews the Latin translation of the Upanishads by Anquetil Duperron (published in 1801 in Paris as *Oupnekhat*), who based himself on a Persian translation. Also in this review, Hamilton reads the translation closely, concluding that "the value of the work before us is considerably diminished, by coming through the medium of a Persian translation" (421).

8   It is interesting to note that the title of Jeffrey's review refers to the French edition, published in Tubingen in 1801, while an English translation was published in London in the same year. As the title page of this English translation indicates, it was "translated from the manuscript, and corrected under the inspection of the author by J. Walker". The translator's preface is dated "25th June, 1801", which seems to suggest that it was published before Jeffrey's review was published in October.

## References

Alexander, J. H. 1990. "Learning from Europe: Continental Literature in the Edinburgh Review and Blackwood's Magazine 1802-1825." *The Wordsworth Circle* 21:3, 118-23.

Benchimol, Alex. 2011. "Periodicals and Public Culture." *The Edinburgh Companion to Scottish Romanticism*. Ed. by Murray Pittock. Edinburgh: Edinburgh UP, 84-99.

Brand, Charles P. 1975. "Ugo Foscolo and the *Edinburgh Review*: Unpublished Letters to Francis Jeffrey." *Modern Language Review* 70, 306-23.

Burwick, Fredrick. 2008. "Romantic Theories of Translation." *Wordsworth Circle* 39:3, 68-74.

Butler, Marilyn. 2010. "Culture's Medium: The Role of the Review." *The Cambridge Companion to British Romanticism*. Ed. Stuart Curran. 2$^{nd}$ ed. Cambridge: Cambridge UP, 127-52.

Christie, William. 2009. *The Edinburgh Review in the Literary Culture of Romantic Britain: Mammoth and Megalonyx*. London and Brookfield: Pickering and Chatto.

—. 2013. "The Modern Athenians: The Edinburgh Review in the Knowledge Economy of the Early Nineteenth Century." *Studies in Scottish Literature* 39:1, 114-37.

Clark, David. 2007. "Lost and Found in Translation: Romanticism and the Legacies of Jacques Derrida." *Studies In Romanticism* 46:2, 161-182.

Cronin, Richard. 2010. *Paper Pellets: British literary culture after Waterloo*. Oxford: Oxford UP.

Crowley, Ruth Ann. 1978. *Charles de Villers, Mediator and Comparatist*. Bern: Lang.

D'hulst, Lieven. 2012. "(Re)locating Translation History: From Assumed Translation to Assumed Transfer." *Translation Studies* 5:2, 139-155.

*The Edinburgh Review or Critical Journal for Oct. 1802 ... Jan. 1803*. 1814. 10$^{th}$ ed. Vol. 1. Edinburgh: Archibald Constable.

Erickson, Lee. 1996. *The Economy of Literary Form: English Literature and the Industrialization of Publishing, 1800-1850*. Baltimore: Johns Hopkins UP.

Esterhammer, Angela. 2013. "'Maga-scenes': Performing Periodical Literature in the 1820s." *The Public Intellectual and the Culture of Hope*. Ed. Joel R. Faflak and Jason Haslam. Toronto: University of Toronto Press, 31-50.

Even-Zohar, Itamar. 1990. "Translation and Transfer." *Poetics Today* 11:1, 73-78.

Fang, Karen. 2010. *Romantic Writing and the Empire of Signs: Periodical Culture and Post-Napoleonic Authorship*. Charlottesville and London: University of Virginia Press.

Ferris, Ina. "The Debut of *The Edinburgh Review*, 1802." *BRANCH: Britain, Representation and Nineteenth-Century History*. Ed. Dino Franco Felluga. Extension of *Romanticism and Victorianism on the Net*. Web. Accessed 29 June 2014.

Filippakopoulou, Maria, ed. 2011. *Readings in romantic translation*. Special issue of *Translation and Literature* 20:1.

Finkelstein, David, ed. 2006. *Print Culture and the Blackwood Tradition 1805-1930*. Toronto: University of Toronto Press.

Fontana, Biancamaria. 2008. *Rethinking the Politics of Commercial Society: the Edinburgh Review, 1802-1832*. Cambridge: Cambridge University Press.

France, Peter. 2009. "Looking Abroad: Two Edinburgh Journals in the Early Nineteenth Century." *Forum for Modern Language Studies* 46:1, 2-15.

Göpferich, Susanne. 2007. "Translation Studies and Transfer Studies. A Plea for Widening the Scope of Translation Studies." *Doubts and Directions in Translation Studies*. Ed. Yves Gambier, Miriam Shlesinger, and Radegundis Stolze. Amsterdam: John Benjamins, 27-39.

Lefevere, André. 1992. *Translation, Rewriting and the Manipulation of Literary Fame*. London: Routledge.

MacKenzie, Raymond N. 1982. "Romantic Literary History: Francophobia in the Edinburgh Review and the Quarterly Review." *Victorian Periodicals Review* 15:2, 42-52.

Mole, Tom. 2013. "'We Solemnly Proscribe this Poem': Performative Utterances in Romantic Periodicals." *European Romantic Review*, 24:3, 353-362.

Morrison, Robert and Daniel S. Roberts, eds. 2013. *Romanticism and Blackwood's Magazine: 'An Unprecedented Phenomenon'*. Basingstoke: Palgrave.

Mounier, J.J. 1801. *On the Influence Attributed to Philosophers, Free-Masons and to the Illuminati on the Revolution of France*. Trans. J. Walker. London: W. and C. Spilsbury. *Google Book Search*. Web. 29 June 2015.

Parker, Mark. 2006. *Literary Magazines and British Romanticism*. Cambridge: Cambridge University Press.

Rangarajan, Padma. 2014. *Imperial Babel: Translation, Exoticism, and the Long Nineteenth Century*. New York: Fordham University Press.

Schoenfield, Mark. 2009. *British Periodicals and Romantic Identity: the 'Literary Lower Empire'*. New York: Palgrave Macmillan.

Stafford, Fiona. 2002. "The *Edinburgh Review* and the Representation of Scotland." *British Romanticism and the Edinburgh Review*. Ed. by Massimiliano Demata and Duncan Wu, eds. Basingstoke: Palgrave-MacMillan.

Stewart, David. *Romantic Magazines and Metropolitan Literary Culture*. London: Palgrave, 2011.

Toremans, Tom. 2010. "Geniale Koinzidenz. Transzendentalphilosophie und/als Übersetzung in Coleridge's *Biographia Literaria*." *Germanistische Mitteilungen* 72, 9-28.

—. 2011. "*Sartor Resartus* and the Rhetoric of Translation." *Translation and Literature* 20:1, 61-78.

—. 2015. "Killing What Is Already Dead: 'Original Materialism', Translation and Romanticism after de Man." *Romantic Materialities*. Ed. by Sara Guyer and Celeste Langan. Series title: Romanticism Circles. Web. 29 June 2015.

Venuti, Lawrence. 2013. "World Literature and Translation." *The Routledge Companion to World Literature*. Ed. by Theo D'haen, David Damrosch and Djelal Kadir. New York: Routledge, 180-193.

Wellek, René. 1931. *Immanuel Kant in England, 1793-1838*. Princeton: Princeton UP. *Archive.org*. Web. 29 June 2015.

Wheatley, Kim, ed. 2003. *Romantic Periodicals and Print Culture*. London: Frank Cass.

# Mediating Breuer: The Transfer of Images and Texts on Marcel Breuer's Tubular Steel Furniture

Ágnes Anna Sebestyén (Hungarian Museum of Architecture, Budapest)

## Abstract

This chapter deals with the European dissemination of furniture during the inter-war period, as exemplified by the work of Marcel Breuer. Breuer was one of the leading architects of the 20th century, and a true cosmopolitan: born in 1902 in Pécs, in Southern Hungary, he went abroad in 1920 to study at the Academy of Fine Arts in Vienna, but quickly left to study at the Bauhaus, where he became a teacher. After leaving the Bauhaus in 1928, he pursued his career in Berlin, Budapest and London before emigrating to the USA in 1937. Breuer is primarily recognized as the inventor of tubular steel furniture, also as an innovative interior designer, and as a hugely influential teacher at the Bauhaus, where he served as the head of the cabinetmaking workshop, and a self-conscious promoter of both his own work and modern design in general. In this chapter I discuss the complex issue of the representation and dissemination of Breuer's tubular steel furniture in Europe. More specifically, I investigate how Breuer's works passed linguistic and geo-cultural frontiers to enter into the international cultural sphere of the modern movement. The focus is on influential photographs and articles – published in different languages and in different European countries – which circulated in architectural magazines. Attention is given to the problems of transfer and translation and to the effects of the publications within the international architectural discourse.

Marcel Breuer is considered to be one of the canonical "form-givers" of the 20th century as the *Time* magazine dubbed him in 1956. He is recognized as the inventor of bent tubular steel furniture, as a prominent designer of interiors and steel, aluminium and plywood furniture, as a successful architect, and as an influential teacher at the Bauhaus, and later, at Harvard University. He is also regarded as a cultural mediator, who contributed greatly to the dissemination of modern design in Europe in the 1920s and 1930s.

Breuer was a true cosmopolitan who lived in many European countries before immigrating to the USA in 1937. He was born in 1902 in Pécs, in Southern Hungary. He went abroad in 1920 to study at the Academy of Fine Arts in Vienna, but left after only a few weeks for the Bauhaus in Weimar. He started as a painter, but he very soon specialized in carpentry and he designed wooden furniture.[1] He graduated in 1924 and moved to Paris, but before long he returned to the Bauhaus to be the head of the cabinet-making workshop as a 'Young Master'. Breuer represented crucial changes in the institution, as his work reflected the shift from the Bauhaus' craft orientation towards the principle that Walter Gropius, director of the Bauhaus, declared as "art and technology – a new unity". Gropius wished to produce artistic objects that could be mass-produced and consumed by a broad audience. Breuer's invention of fabricating furniture made of steel easily fitted into Gropius' concept of the merging of art and industry (Wilk 1981, 16).

Breuer designed the first tubular steel furniture in 1925: this was the first prototype of the iconic B3 club armchair now known as the "Wassily" chair. The name was coined when the chair came to be marketed by the Italian firm Gavina in the 1960s after Wassily Kandinsky, who was one of the chair's first admirers.[2] According to Breuer's statements, it was the tubular steel handlebars of his Adler bicycle that gave him the idea of constructing a chair made of steel. Contrary to his first concerns, the tubular steel furniture became a great success, as it perfectly expressed the requirements of the new architecture with regards of functionality, simplicity, mobility and hygiene. He commented in 1927: "Two years ago, when I saw my first finished steel club armchair, I thought that among all of my pieces to date, it would earn me the most criticism. In both external appearance and in material expression, it is the most extreme; it is the least artistic, the most logical, the least 'cosy', the most machine-style. What actually happened was the opposite of what I had expected." (Breuer 1928, 133, translation in Máčel 2003, 62) Gropius quickly acknowledged the design of his protégé and he commissioned Breuer to create the furnishings for the new Bauhaus school building and the Masters' houses in Dessau. (Fig. 1) Especially due to the wide-spread circulation of the photographs of the new Bauhaus buildings in various publications, the tubular steel furniture became generally known in modernist circles and inspired new designs by Mies van der Rohe, Charlotte Perriand and Le Corbusier among others. In 1928, Breuer left the Bauhaus – along with such leading *Bauhäuslers* as Walter Gropius and László Moholy-Nagy – and then worked in Berlin, Zürich, Budapest and London before his immigration to the USA.

This paper discusses the mediation of Marcel Breuer's tubular steel furniture during the interwar years in Europe with a special focus on the coun-

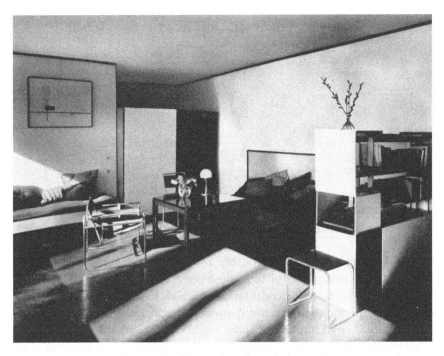

Fig. 1. Lucia Moholy's photograph of her and László Moholy-Nagy's apartment in Dessau, featuring Marcel Breuer's B3 club armchair, 1926. Published in Gropius, Walter, *Bauhausbauten Dessau* (Bauhausbücher 12), München: Albert Langen Verlag, 1930, abb. 135.

tries where Breuer resided in the 1920s and 1930s, i.e. Germany, Switzerland and Hungary. In 1935, he moved to London, where he no longer made furniture of tubular steel but of plywood for the firm Isokon. During these particular years, his tubular steel furniture passed linguistic and geo-cultural frontiers and entered into the international sphere of the modern movement. As such, they became indispensable pieces of the modern interior and reached a wide audience. Breuer's furniture received extensive exposure via the printed media: his works were distributed in architectural periodicals, illustrated magazines, advertisements and Bauhaus publications. The major sources of my argument are mainstream architectural journals of the period like the German *Das Neue Frankfurt* and *Die Form*, the Swiss *Das Werk* and the Hungarian *Tér és Forma* (*Space and Form*). With reference to influential articles in these magazines, to word-and-image relations, and to iconic pictures, my paper examines the social and cultural context of his work. This paper principally describes how the imagery of Breuer's tubular steel furniture reflects on the social aspects of its dissemination.

The main background of my analysis is "a highly biased, highly self-referential publication system", which constructed representations that sig-

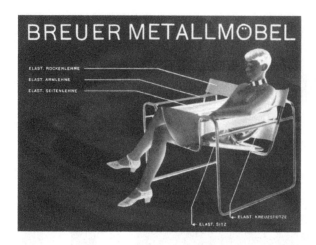

Fig. 2. The cover of the Standard Möbel brochure of 1927, designed by Herbert Bayer.

nificantly af-
fected the way
contemporaries
perceived archi-
tecture defining what was fashionable and popular (Rattenbury 2002, 125
and xxii). The perception of this constructed imagery intermingled with
"an additional social form: consumption", which began to appear with the
emergence of "photography, the illustrated magazine, and tourism".[3] Em-
phasising the social implications, the study on Breuer's mediation closely
concerns Beatriz Colomina's argument on architecture's engagement with
the media and mass culture, especially while regarding architecture as a
commodity, i.e. as an article of consumption. (Colomina 2000). In this arti-
cle, I consider Breuer's tubular steel furniture first and foremost as a com-
modity, and I trace what the forms of mediation and the circulating images
tell us about the social context of these pieces of furniture.

## Photographing and mediating tubular steel furniture

Breuer was a key figure in the extensive network of modernist architects,
designers and journal editors: he kept in touch with his Hungarian col-
leagues, his Bauhaus companions and other modern architects throughout
his entire career.[4] He was able to reach a broad audience by exploiting
media tools available at his time: his designs circulated on photographs
in a great variety of publications from the *Bauhausbücher* to architectural
magazines of the era. These photographs were the "currency of architec-
tural exchange" (Elwall 1994, 5 and 2004, 8) and served as the ultimate me-
diators of modern architecture and design during the interwar era. On the
one hand, he used the media to distribute his own works: he launched the
firm Standard Möbel for mass-producing his tubular steel furniture, which
he advertised in brochures. He also presented his designs in different exhi-
bitions and wrote articles and gave lectures. On the other hand, his tubular
steel furniture was widely used and mediated by others.

The second edition of *Bauhausbücher* no. 1 entitled *Internationale Architektur* contains two designs of houses by Breuer (Gropius 1925b, 90-91), and his pieces of furniture produced in the Bauhaus in Weimar were included in *Bauhausbücher* no. 7. His tubular steel furniture was displayed in *Bauhausbücher* no. 12, which presents the buildings of the Bauhaus complex in Dessau (Gropius 1930). Since Gropius commissioned Breuer to furnish the interiors of the new Bauhaus buildings, this volume features Breuer's work and especially his new tubular steel furniture to a great extent. These pieces appeared in the hall and the canteen of the school building, the living, the dining and the bedroom of Gropius' and László Moholy-Nagy's houses, among others. These images were taken mainly by Lucia Moholy and Erich Consemüller around 1926, when the new Bauhaus buildings had just been finished. Their photographs were used widely for promotional purposes, not just in the Bauhaus books series, but in a great variety of other publications.[5]

Lucia Moholy took a photograph of the early, 1925-version of Breuer's B3 club armchair, which reached the definitive structure during 1927-28. The B3 club chair was followed by several new designs: like the B5 side chair and its armchair version the B11, the B7 swivel chair, the B35 armchair, the B9 nestling tables, the B15 chaise lounge, etc.[6] Breuer's tubular steel furniture was initially made by the firm 'Standard Möbel', which was founded by Breuer himself together with another Hungarian architect, Kálmán Lengyel in 1926-27. As Otakar Máčel pointed out "[i]n 1927, tubular steel furniture remained largely unknown to the public. The clientele was restricted to the circle around the Bauhaus itself, and no serious manufacturer was willing to contemplate such a hazardous undertaking. Standard Möbel was the first manufacturer to specialise in contemporary tubular steel furniture – although it was not a large factory, but instead a workshop that produced only a limited number of pieces" (Máčel 2003, 69). The name 'Standard Möbel' was programmatic, as it expressed that instead of individualised furniture they fabricated standardised and serially produced items – more

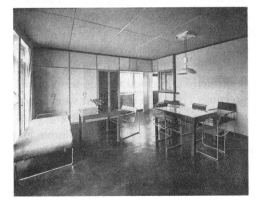

Fig. 3. Interior of the house designed by Walter Gropius at the Weißenhofsiedlung in Stuttgart, 1927, steel furniture by Marcel Breuer. Published in Riezler, Walter: „Die Wohnung", *Die Form* 2, no. 9 (1927), 263.)

specifically: types. They promoted tubular steel furniture in advertising brochures: the first Standard Möbel catalogue was issued in 1927 (Fig. 2), the second – entitled "Das Neue Möbel" ("The New Furniture") – in 1928. The company, however, could not survive due to the lack of enough profit, and as a result, Breuer entered into a contract with Thonet in 1928 to manufacture his designs.

Besides individual furniture, Breuer designed a number of apartments, house renovations and exhibition interiors. Still working at the Bauhaus, he received a commission to refurbish the Berlin-apartment of a well-known avant-garde theatre producer, Erwin Piscator and his wife in 1927. In the same year, his furniture was used in the houses designed by Mart Stam and Walter Gropius at the Weissenhofsiedlung exhibition in Stuttgart organized by the German Werkbund, which presented modern architecture to the broad public. (Fig. 3) As Christopher Wilk emphasised "[w]hen the Weissenhof exhibition opened in June 1927, not only were most of the designs produced by Standard-Möbel exhibited, but also new tubular-steel furniture designs by leading architects, including Mart Stam, Mies van der Rohe, J. J. P. Oud, S. van Ravesteyn, Heinz and Bodo Rasch, and Arthur Korn. Until that point most metal furniture was made by the architects themselves or by manufacturers producing in very limited quantities. The Weissenhof exhibition evoked wide discussion of tubular steel and sparked the interest of larger companies in its manufacture." (Wilk 1981, 66) Leaving the Bauhaus in 1928, Breuer was an active architect designing interiors such as the De Francesco and the Boroschek apartments and an apartment for a gymnastics teacher in Berlin (1929-30), model apartments for the exhibition of the German Werkbund in the Salon des Artistes Décorateurs Français in Paris in 1930 and for the Berlin Building Exhibition of 1931. He was also the architect of the Harnischmacher House in Wiesbaden (1932) and the Doldertal Apartment Houses in Zürich (1933-36) that Breuer co-designed with Alfred and Emil Roth on the commission by Sigfried Giedion. Through his friendship with Giedion, Breuer was also assigned to redesign the stores of the Wohnbedarf – a company devoted to the distribution of the latest modern furniture – in Zürich and Basel.

The above-mentioned interiors were equipped with Breuer's tubular steel furniture, which was considered to be the ultimate modern piece of furniture from its very inception, as it perfectly expressed the modernist aesthetics and suited to the new architecture. The main ideas that were associated with tubular steel furniture were standardization, mass-production, mechanization, functionality, rationalization, impersonal design, simplicity, health, hygiene, cleanliness, mobility, openness, lightness and transparency. These characteristics were completely in sync with the requirements of the 'new living', as the genuine modern space was open, airy and trans-

**DAS MATERIAL**

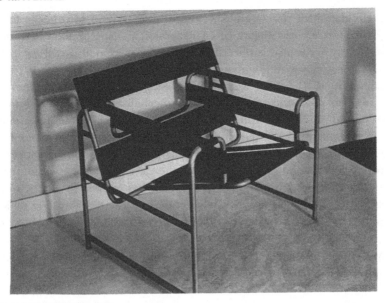

MARCEL BREUER, BAUHAUS DESSAU
*Stahlstuhl mit Stoffgurten, 1925 / Phot. Lucia Moholy, Dessau*

Fig. 4. Lucia Moholy's photograph of the early version of Breuer's B3 club armchair in Hannes Meyer's article "Die neue Welt", *Das Werk* 13, no. 7 (1926), 210.

parent, had big windows that let the sun and the fresh air into the interior, and the furnishings were limited to the necessary minimum adjusting to the needs of the inhabitants.

The objectivity of these free-flowing and transparent interiors presented an 'easy' subject of the photographers associated with the 'new photography'. These photographers created such visually powerful images that they became the most prevailing devices in the dissemination of modern architecture and design. These photographs were usually taken by the best possible photographers, immediately after the building or the interior had been finished, as generally one decisive series was shot for publication. Some of the photographers were actually artist photographers, but a significant number of them were specialised solely in architectural subjects. Exponents of the 'new photography' frequently undertook commissions from modernist architects and their images materially defined the way modern architecture was represented. Notable examples, besides Lucia Moholy and Erich Consemüller, of those who took photographs of Breuer's works, include: Sasha Stone in Germany, Mark Oliver Dell and H. L. Wainwright in Britain, and József Pécsi and Ernő Bánó in Hungary.

## The "new world" and tubular steel furniture

The circulation of photographs of these interiors and of Breuer's tubular steel furniture created a platform of discussion in contemporary periodicals. A very early account was published in the Swiss journal *Das Werk* in 1926 by architect and second Bauhaus-director Hannes Meyer (Meyer 1926). The article entitled "Die neue Welt" ("The New World") is about the remarkable progress of science and the overall mechanization that determine the "new world" and also locate the role of architecture.[7] He writes about all the developments that fascinated modernists at that time: the dynamism of the metropolis, speed, cars, flying, the increased possibilities of movement, transport and communication, hygiene, the 'new woman', new photographic and cinematographic processes, the growing interest in sports and exercise, and of course the new architecture and the new lifestyle which is characterized by the semi-nomads of today's economic life, which brought the standardization of their housing, clothing, food, etc.[8] In this new world, Meyer considers metal and concrete the ultimate new materials, which he simply labels "Das Material". Breuer's B3 is featured under this label: the image shows the early 1925-version of the club chair shot by Lucia Moholy.[9] (Fig. 4)

In 1928, many more accounts appeared in architectural publications. *Die Form* reported on an important exhibition held in Stuttgart in 1928, which was organized by architect Adolf G. Schneck (Büddemann 1928). A great variety of chairs were

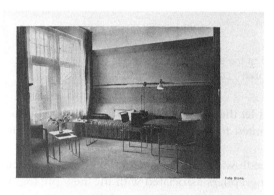

AUS DER WOHNUNG VON PISCATOR, BERLIN
Eingerichtet von Marcel Breuer, Berlin

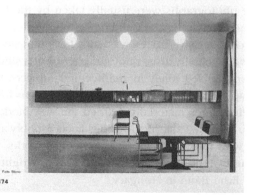

Fig. 5. Sasha Stone's photographs of the Piscator Apartment in Berlin, 1927. Published in Stone, "Sasha: Zurück zur Fotografie". *Die Form* 4, no. 7 (1929), 174.

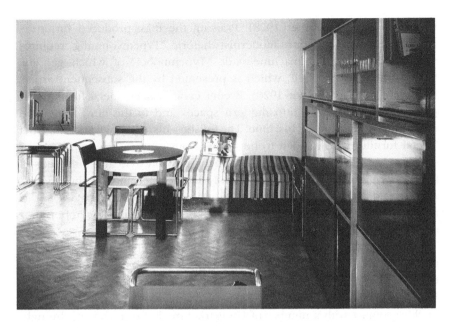

Fig. 6. Ernő Bánó's photograph of Farkas Molnár's apartment in Villa Delej, Budapest, 1929–30, steel furniture designed by Marcel Breuer © Hungarian Museum of Architecture, Budapest, ref. no. 74.01.73

displayed, and metal chairs were among them: they represented the recent experiments that showed that there were still new solutions in furniture design.[10] *Die Form* whilst publishing several examples of the new architecture on an up-to-date basis, remained critical in a few cases. In 1927, *Die Form* published comprehensively on the Weissenhofsiedlung in Stuttgart (Gräff and Lotz 1927). The article written by Walter Riezler is basically affirmative of the exhibition, but emphasises also the negative characteristics (Rietzler 1927). One concern described metal furniture as 'cool' and 'impersonal': Walter Riezler opined that even the modern man will need warmth and cosiness eventually.[11] However, three years later Wilhelm Lotz wrote an enthusiastic article in *Die Form* on the German section at the Paris Salon des Artistes Décorateurs in 1930 (Lotz 1930). The exhibition was organized by Gropius, Breuer and their former Bauhaus colleagues. The core of the display featured items designed for mass-production, as Lotz described it: "High ethics have their part in this effort and endeavor to give every living human being the right and the possibility of participating in the good gifts of modern form." (Lotz 1930, 296)

The journal *Das Neue Frankfurt* was very conscious and progressive in the promotion of modern architecture. In 1928, architect Ferdinand Kramer published an article in this magazine under the title "Individuelle oder

typisierte Möbel" (Kramer 1928). Praising the mass-produced furniture, the text represents the pure modernist rhetoric. "Typenwohnung" requires serially produced and machine-made "Typenmöbel" of which genuine form is the "Metallmöbel", which is presented by the subsequent article by Breuer himself (Breuer 1928). Breuer conceives his metal furniture as pieces that perfectly fit into modern spaces and to the new, faster and more changeable life of his time. He finishes his essay with stating that "metal furniture is intended to be nothing but a necessary apparatus for contemporary life".[12] References to life, the new lifestyle and the needs of the modern man appear very frequently in such accounts in these years. Architect Mart Stam in his article "Das Mass • Das richtige Mass • Das minimum Mass. Unsere Hausgeräte und Möbel" emphasises the importance of the right dimensions of the furniture that suit its users.[13]

In Hungary, German-language publications describing tubular steel furniture were initially available, but the first reports in Hungarian soon followed them in 1928-1929 by Breuer's early Hungarian advocates: architects Virgil Bierbauer, Farkas Molnár and Pál Forgó.[14] As I mentioned above, Breuer was in close contact with a number of Hungarian modernist architects throughout his career, and *Tér és Forma*, which was the most important Hungarian journal with regards to modern architecture, regularly reported on Breuer's works during the early 1930s.[15] What is more, his designs were usually presented along with those of the members of the Hungarian chapter of the *Congrès Internationaux d'Architecture Moderne* (CIAM), thereby giving evidence on their cooperation. Breuer's furniture were also featured in Pál Forgó's book entitled *New Architecture* and Forgó was the one who introduced one of the most iconic interiors of Breuer to the Hungarian public in *Space and Form* in 1929: Erwin Piscator's apartment in Berlin.[16] The article

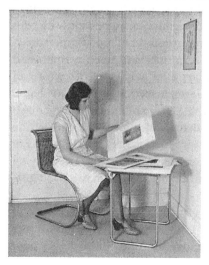

on the Piscator Apartment was accompanied by the decisive series of photographs by Sasha Stone, which appeared in the same year e.g. in *Die Form* and the Dutch architectural magazine *Bouwkundig Weekblad Architectura* (Stone 1929 and Muylaert 1929). (Fig. 5)

Fig. 7. A woman in a steel-tube chair. Published in Lotz, Wilhelm, "Ewige Formen − Neue Formen", *Die Form* 6, no. 5 (1931), 163.

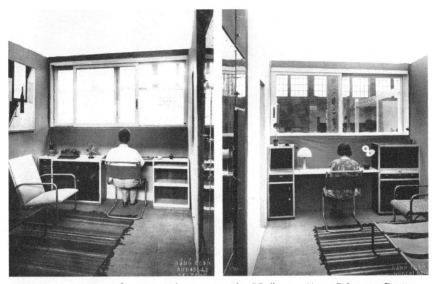

Fig. 8. Separate rooms for men and women in the "Collective House", Interior Design and Household Goods Fair, Budapest, 1931, photographs by Ernő Bánó © Hungarian Museum of Architecture, Budapest, ref. no. 74.01.51 and 74.01.88

Breuer's other main advocate was Farkas Molnár,[17] one of Breuer's closest Hungarian friends. They were fellow students at the Bauhaus and they remained in contact throughout their lives. Molnár studied at the Bauhaus in Weimar between 1921 and 1925 and during those Weimar years he also worked in Gropius' office as a student of architecture. After returning to Hungary, he stayed connected to international modernist circles, especially to his colleagues and friends like Breuer, Gropius and Moholy-Nagy. Molnár became one of the leading modernist architects in Hungary during the interwar era and, as an active propagandist and the head of the Hungarian chapter of the CIAM, he strongly advocated the dissemination of modern design in his home country. Molnár frequently used Breuer's tubular steel furniture in the interiors of the apartments, family houses and villas that were built in Budapest according to his designs in the early 1930s. A notable example is his own apartment in Budapest from 1929 situated in the so-called *Villa Delej*,[18] which he furnished with Breuer's tubular steel chairs. The apartment functioned as a showcase interior. Photographs of the apartment were published widely and it was opened to public visits on Sundays. (Fig. 6)

Molnár dedicated a whole article to Breuer's tubular steel furniture in the journal *Magyar Iparmű vészet* (*Hungarian Applied Arts*) in 1928, which he closed with the following lines: "The shining, linear, slender and flexible

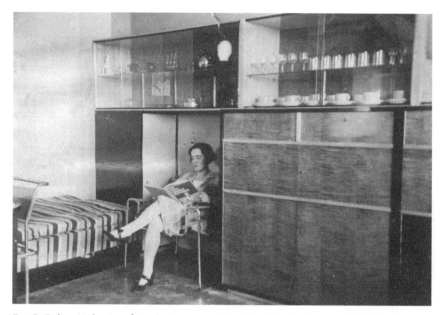

Fig. 9. Farkas Molnár's wife in their apartment in Villa Delej, Budapest, 1929–30, steel furniture by Marcel Breuer © Hungarian Museum of Architecture, Budapest, ref. no. 74.01.57

steel suits well to our enthusiasm for exercise, speed, sport, modern women's clothing, wide windows and new architecture. All bears the characteristics of modesty and moderate form and colour to let the man be more free and bold in it. The world has changed: we have recognized that the focus is not on the environment but on the man who is living within it."[19] The same notion appears in Wilhelm Lotz's article on form, where he gives the example of the modern woman whose chair and clothing represent the same attitude.[20] (Fig. 7) The focus is again on the user – but who were the users of tubular steel furniture and how was it reflected in architectural imagery?

The idea was to serially produce easily accessible furniture to the masses. This was Gropius' intention when he imagined that Bauhaus products would be designed by artists but made mechanically for the wide public. The reality was, however, that like several other Bauhaus products, tubular steel furniture remained a luxury object available only for the elite.[21] Thus, as Breuer's tubular steel furniture is an expensive 'design classic' today, it was similarly expensive in the 1930s, which limited its customer-appeal. Tubular steel furniture became very soon associated with the 'new man' and the 'new woman', who represented the young and modern metropolitan men who used modern technology, new devices, took exercise, played sports and lived a fast and dynamic life. Charlotte Perriand's lines in her

article entitled "Wood or Metal?" excellently illustrates what the 'new man' and the 'new woman' meant at that time: "I understand by the NEW MAN the type of individual who keeps pace with scientific thought, who understands his age and lives it: The Aeroplane, the Ocean Liner and the Motor are at his service; Sport gives him health; His House is his resting place." (Perriand 1929, 278) These individuals were well-off intellectuals belonging to the sophisticated upper-middle class, who were the major clients of modern architects. The followings will demonstrate that this specific target group was clearly reflected in modern architectural imagery.

On the one hand, however, 'utopian' images were also published in pursuit of a new social order. A good example is the so-called "Collective House", a utopian plan of Farkas Molnár and a few of his Hungarian colleagues, which was presented at the Interior Design and Household Goods Fair in 1931 in Budapest. The Collective House would have provided separate spaces for married couples: man and women would have lived in identical cells as it is shown on the photographs taken by Ernő Bánó. (Fig. 8) The house intended to be the home of a new collective society; and tubular steel furniture appears as a characteristic element for their habitat. In contrast to this leftist utopian concept, Molnár himself built almost exclusively villas, family houses and elegant apartment houses. Another utopian notion was the idea of sitting on air which was

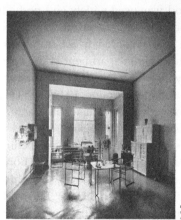

Behandlungszimmer eines Zahnarztes
Cabinet de traitement d'un dentiste
A dentist's work-room

Das Behandlungszimmer seines
Großvaters
Le cabinet de traitement de son grand-père
His grandfather's work-room

308

Fig 10. A dentist's work-room as opposed to his grandfather's work-room. 'Das Behandlungszimmer des Arztes', *Die Form* 6, no. 8 (1931), 308.

expressed by Breuer himself via a sequence of photographs.[22] The image was published in the *Bauhaus* journal in 1926 under the title "a bauhaus film, five years long" that depicts the development of Breuer's chairs from the so-called 'African chair' to the B3 club chair of 1925 and ends with the picture of a woman who, as the caption read "sits on a resilient column of air".[23] Wilhelm Lotz referred to this image in an article published in *Die Form* in 1931 as a joke but he also stated that we can never know what the future brings.[24]

On the other hand, publications usually featured the 'real users'. The posture of the woman sitting on air remained and, as she appeared on a photograph by Erich Consemüller, lived on in several manifestations.[25] A young woman in exactly the same position sits in the B3 on the cover of the 1927-catalogue of Standard Möbel. (Fig. 2) This ultimate Bauhaus-image became commonly used in portrayals of an attractive woman lying on a sofa or a reclining chair. Thus this picture has its roots in the Bauhaus, where everyday photographs could be converted into advertising materials, and where life, art and propaganda were intermingled.

In this way, the image of a young woman sitting or lying on tubular steel furniture turned into a modernist topos and was used widely and perhaps automatically by photographers, newspaper editors and advertisers. Hilde-gard Piscator, the wife of Erwin Piscator, was recorded while sitting and reading on a sofa on the photographs of their Berlin-apartment in the same way as Hedvig Herrfuhrt, Farkas Molnár's wife, was featured in the series of photographs taken in their apartment in Budapest around 1929-30.[26] (Fig. 9) This particular picture also penetrated into advertising materials, e.g. into promotional brochures and posters of Wohnbedarf.[27] The same applies to the image of the working man or woman sitting back to the viewer behind a desk like Farkas Molnár in his Budapest-apartment,[28] the man in a Thonet catalogue of 1933[29] and a young woman in *Bauhausbücher* no. 12 behind a multifunctional desk in Gropius' house (Gropius 1930, ill. 94). Perriand's above-referenced article "Wood or Metal?" incorporates an image of her lying on the chaise lounge of her design and ends with the following lines: "We must keep morally and physically fit. Bad luck to those who do not."[30]

These phrases perfectly echo the enthusiasm for sport, exercise and health of the era that Breuer described as the "healthy body culture".[31] Both the written accounts and the imagery of this period favoured the slender, sporty and youthful body. What is more, as the aforementioned printed materials demonstrate, tubular steel furniture became associated with the image of the slim, elegant and young woman (Overy 2007, 79-80), who basically served to sell steel furniture, to prevail upon man to aspire and buy the shiny and machine-like chair and to be that man who owns a chair and a woman like this.

## Conclusion: tubular steel furniture as a universal language

In 1929, *Die Form* dedicated a few articles exclusively to photography. These included the essay by Wilhelm Lotz on Albert Renger-Patzsch, one of the major exponents of New Objectivity, and another by photographer Sasha Stone (Lotz 1929; Stone 1929). Stone's piece entitled "Back to Photography" expresses a pure modernist concept on the photographer's role; that is: the photographer should use his medium according to the characteristics which belong to the medium's own area of competence. With regards to photography, it means that photographers should not imitate painting. This Greenbergian idea is illustrated with a sequence of photographs terminating with five pictures of the Piscator Apartment. (Fig. 5) These particular images were widely published throughout Europe – as if demonstrating Stone's closing lines: "We have in our hands the greatest gift of our times, with which we should document our world... Therefore, back to photography, the only universal language, the optical language."[32] Photography was in fact universal and also very successful in mediating modern architecture, as English architecture critic Philip Morton Shand claimed in 1934: "Without modern photography modern architecture could never have been "put across."" (Shand 1934, 12) It can be argued that tubular steel furniture also became a "universal language" as a widely known, characteristic element of the modern interior. It turned into a statement item that was eventually placed deliberately into the frame of the camera as a sort of attribute of modernism.

As we have seen, Breuer used the usual way of promoting his own works – with advertising and publications. But his tubular steel furniture, and designs by several of his notable colleagues, became so embedded in modern architectural imagery that their wish to design impersonal items truly succeeded. Certain examples show that Breuer sometimes did not even received credit for featuring his work or it lost its importance behind the pre-eminence of the case of modern design in general. The 'impersonality' Breuer wished to achieve is that his works should not reflect the personality and individuality of the architect and the inhabitants but should express the functionality of modern design that serves the users not represent them (in a sense of social representation that defined fin de siècle interior design). A remarkable example is a dentist's work-room, which was published in *Die Form* in 1931, where a modern dentist's work-room is opposed to his grandfather work-room, a typical fin-de-siècle interior.[33] (Fig. 10)

But, despite this 'impersonality', his chairs rose to such an iconic status over the 20th century that they evolved into a status symbol and it became a statement act to sit on them. Breuer had himself photographed in the B3 around 1926 to express his authorship at a very early age,[34] and now we can see him sitting confidently in a tubular steel armchair on a photograph

that Knoll – which now manufactures Breuer's designs – uses for adver-
tising Breuer's furniture on their website.[35] Both images, though there are
several decades between them, invite us to become the modern man by
acquiring this object of our consumerist dreams.

## Notes

1   For the detailed analysis of Breuer's work as a designer of furniture and inte-
    riors, see: Wilk 1981, Droste and Ludewig 1992, Von Vegesack and Remmele
    2003, Bajkay 2010, especially Horányi 2010.

2   For more on the production of Marcel Breuer's furniture by Gavina, see: Cac-
    ciola 2003.

3   "Until the advent of photography, and earlier of lithography, the audience
    of architecture was the user. With photography, the illustrated magazine, and
    tourism, architecture's reception began to occur also through an additional so-
    cial form: consumption. With the enormous amplification of the audience, the
    relation to the object changed radically. The audience (the tourist in front of a
    building, the reader of a journal, the viewer of an exhibition or a newspaper
    advertisement, and even the client who often is also all of the above) increas-
    ingly became the user, the one who gave meaning to the work." Colomina
    1988, 9–10 (introduction).

4   To mention but a few of his artist and architect friends and acquaintants, he
    was in contact with Walter Gropius and his wife, Ise Gropius, Herbert Bayer,
    Sigfried Giedion and also his Hungarian colleagues: Farkas Molnár, József Fis-
    cher and Virgil Bierbauer among others. Breuer's surviving correspondence is
    available online at: http://breuer.syr.edu/ (Accessed on 14 March 2015)

5   For more, see: Schuldenfrei 2013.

6   For the development of Breuer's tubular steel furniture in detail, see: Wilk 1981
    and Máčel 2003.

7   For more on Hannes Meyer's "new world", see: Hays 1999.

8   "Dem Halbnomaden des heutigen Wirtschaftslebens bringt die Standardisi-
    erung seines Wohnungs-, Kleidungs-, Nahrungs- und Geistesbedarfes lebens-
    wichtige Freizügigkeit, Wirtschaftlichkeit, Vereinfachung und Entspannung."
    Meyer 1926, 223.

9   Marcel Breuer, Bauhaus Dessau, Stahlstuhl mit Stoffgurten, 1925 / Phot. Lucia
    Moholy, Dessau – Meyer 1926, 210.

10  "Exemplaren auftritt, umschließt noch viele Fragen. Er bringt jedoch neben der
    Verwendung des neuen Materials eine neue Lösung: die Federung der Rücken-
    lehne, die entweder aus Stoff, Leder, beim Autositz aus Metall ist." Büddemann
    1928, 307.

11  "Niemand kann sich dem Eindruck entziehen, den die bis zum Letzten durch-
    dachten, von einer wahrhaft "sauberen", sozusagen ingenieurhaft-sachlichen

Gesinnung gestalteten Räume in den Häusern von Gropius machen – und doch wissen wir nicht, ob nicht diese Wohnungen in ihrer sachlichen Kühle und Unpersönlichkeit (die bei so vielen Besuchern den Vergleich mit dem Hotel oder Sanatorium, ja der chirurgischen Klinik hervorruft) weit über das hinausgehen, was der modern gesinnte Mensch, der aber nicht auf diese Fragen eingeschworen ist, in seiner Wohnung erträgt, – und ob nicht auch der Fanatiker der neuen Wohngesinnung schon in wenigen Jahren das Bedürfnis fühlen wird, mit allen Mitteln eine gewisse "Wohnlichkeit", die man auch als die Atmosphäre seelischer Wärme bezeichnen kann, zu schaffen. (Wir wollen uns doch darüber klar sein: auch der neue Mensch wird noch seelische Wärme verlangen, auch wenn der Prozeß der Entpersönlichung noch weiter fortgeschritten ist!)" Riezler 1927, 262–263.

12 "diese metallmöbel sollen nichts anderes als notwendige apparate heutigen lebens sein." Breuer 1928, 11. For the English translation, see: Wilk 1981, 67.

13 "Die Maße unserer Räume sollen den Maßen des Menschen Rechnung tragen, sollen von den physischen und psychischen Bedürfnissen ausgehen." Stam 1929, 29.

14 For more on Marcel Breuer's reception in Hungary, see: Ernyey 2010 (in Hungarian language with English summaries).

15 The journal *Tér és Forma* (*Space and Form*) was the main organ of modernist architects in Hungary. It reported on modern architecture on an up-to-date basis during the interwar period and presented both Hungarian and international examples and also theoretical arguments. The magazine was launched in 1926 as the appendix of the journal *Vállalkozók Lapja* (*Entrepreneurs' Journal*), but it was published as an independent periodical from 1928 under the editorship of architect Virgil Bierbauer until 1942. In 1943, the journal was taken over by an editorial board led by József Fischer. *Space and Form* ceased to be published soon after the Second World War. The magazine put an emphasis not only on the textual but also on the visual presentation of buildings. Due to its aims and objectives and also its layout and content, *Space and Form* can be paralleled with such periodicals as the German *Die Form* and *Das Neue Frankfurt* or the Swiss *Das Werk*.

16 Forgó 1928 (page 134 features the image by Lucia Moholy of the 1925-version of the B3 club chair, the same, which was published in Meyer 1926, discussed above) and Forgó 1929, 165–167.

17 The comprehensive monograph of his work is only available in Hungarian: Ferkai 2011.

18 Villa Delej, 1929, designed by Pál Ligeti and Farkas Molnár (address: Mihály Street 11, 1st district – Budapest) – for more, see: Csengel-Plank, Hajdú and Ritoók 2003, 100–105.

19 "A csillogó, vonalszerűen éles, vékony, a végletekig rugalmasságot jelentő fém nagyon jól illik a mi mozgás-, gyorsaság-, sportszeretetünkhöz. A nők modern

ruházatához, a széles napfényes ablakokhoz, az új építészethez. Ezeknek mind jellemzője az a bizonyos visszavonultság, a mérséklet a formában, a színességben, a színben, hogy az ember annál teljesebb, szabadabb, feltűnőbb legyen benne. Valahogy átalakult a világ: észrevettük, hogy nem a környezet a cél, hanem a benne élő ember." Molnár 1928, 232 (translation from Hungarian into English by the author).

20    "Steel-tube Chair. Here, again, the attitude and clothing of the present day form with the chair a complete entity" Lotz 1931, 163.

21    For the analysis of Bauhaus products being expensive, one-off objects, see: Bittner 2009, 331–336 and Schuldenfrei 2009.

22    For more on the idea of sitting on air, see: Wilk 2006a, 225–247.

23    "es geht mit jedem jahr besser und besser. am ende sitzt man auf einer elastischen luftsäule" Breuer, Marcel: 'ein bauhaus-film, fünf jahre lang'. *Bauhaus* no. 1 (Juli 1926). For the English translation, see Wilk 2006a, 226.

24    "Das Bauhaus hat vor einigen Jahren in einem Prospekt einmal eine sehr witzige Darstellung der Entwicklung des Stuhls gebracht, vom Holzstuhl zum Stahlrohrstuhl, und dann als letztes einen Menschen, der auf nichts, sozusagen auf einer Luftschicht sitzt. Das ist natürlich ein Scherz, aber ein nicht kleines Körnchen Wahrheit ist dabei, denn wir wissen nicht, aus welchen Materialien die Sitzgelegenheiten in späteren Zeiten bestehen werden und welcher Art die Verbindung der eigentlichen Sitze mit Decke, Boden oder Wänden sein werden." Lotz 1931, 161.

25    On Consemüller's photograph, a Bauhäuslerin wearing a mask from Oscar Schlemmer's Triadic Ballet sits in a version of the B3 that Breuer considered to be its first "final" version. See Wilk 1981, 38.

26    The vintage photographs are held in the collection of the Hungarian Museum of Architecture in Budapest, ref. no. 74.01.57

27    Wohnbedarf catalogue of 1934 under the copyright of the Marcel Breuer Papers, Syracuse University Library, see online at: http://breuer.syr.edu/xtf/ view?docId=mets/4600.mets.xml;query=wohnbedarf;brand=breuer (accessed on 14 March 2015); Max Bill: Wohnbedarf poster, 1933, Merrill C. Berman Collection (see reproduced in Wilk 2006a, 246, cat. no. 166)

28    This image belongs to the same series of photographs that includes Molnár's wife sitting in the B3, see note 47.

29    Thonet catalogue of 1933 under the copyright of the Marcel Breuer Papers, Syracuse University Library, see online at: http://breuer.syr.edu/xtf/view?do-cId=mets/4579.mets.xml;query=;brand=breuer (accessed on 14 March 2015)

30    Perriand 1929, 279; for more on the image of Perriand lying on the chaise lounge see: Rüegg 2005.

31    Wilk 1981, 61 and Wilk 2006b.

32    "Wir haben in unserer Hand die größte Gabe unserer Zeit, das Dokumentverfahren: die Fotografie, die ein unzweifelhafter Fortschritt gegenüber den uns hinterlassenen Hieroglyphen der Ägypter ist. Wir haben mit ihr das Mittel, die Kultur unserer Zeit zu schildern. Deshalb zurück zur Fotografie, zur einzigen

Weltsprache, der optischen Sprache." Stone 1929, 168 (translation from German into English by the author).

33   "Das Behandlungszimmer des Arztes", 1931.

34   Photograph in the repository of Syracuse University, see online at http://breuer.syr.edu/xtf/view?docId=mets/4269.mets.xml;query=marcel%20breuer;brand=breuer (accessed on 14 March 2015)

35   See online at http://www.knoll.com/shop/by-designer/marcel-breuer (accessed on 10 November 2014)

## References

Bajkay, Éva, ed. 2010. *Von Kunst zu Leben – Die Ungarn am Bauhaus*. Pécs: Janus Pannonius Múzeum.

Baldavári, Eszter, Horányi, Éva, Ritoók, Pál and Sebestyén, Ágnes Anna, eds. 2017. *Breuer at home again*, exhibition catalogue. Budapest: Museum of Applied Arts.

Bittner, Regina. 2009. "The Bauhaus on the Market. On the Difficult Relationship between the Bauhaus and Consumer Culture". In: Bauhaus Archiv Berlin/ Museum für Gestaltung – Stiftung Bauhaus Dessau – Klassik Stiftung Weimar, eds., *bauhaus – a conceptual model*. Ostfildern: Hatje Cantz, 2009, 331-336.

Breuer, Marcel. 1928. "Metallmöbel und moderne räumlichkeit". *Das Neue Frankfurt* 2: 1, 11-12.

Büddemann, Werner. 1928. "Ausstellung 'Der Stuhl' Stuttgart 1928". *Die Form* 3, no. 10, 304-308.

Cacciola, Donatella. 2003. "Established Modernism – The Furniture of Marcel Breuer in Production by Gavina and Knoll International". In: Von Vegesack and Remmele, eds., 148-165.

Colomina, Beatriz, ed. 1988. *Architectureproduction*. New York: Princeton Architectural Press.

—. 2000. *Privacy and Publicity: Modern Architecture as Mass Media*. Cambridge, Mass. – London: MIT Press, '1994' (2000).

Csengel-Plank, Ibolya, Hajdú, Virág and Ritoók, Pál. 2003. *Fény és Forma. Modern építészet és fotó 1927-1950 / Light and Form. Modern Architecture and Photography 1927-1950*. Budapest: Kulturális Örökségvédelmi Hivatal.

"Das Behandlungszimmer des Arztes". 1931. *Die Form* 6: 8, 307-308.

Droste, Magdalena and Ludewig, Manfred. 1992. *Marcel Breuer. Design*. Cologne: Taschen.

Durand-Dupont. 1930. "Der Deutsche Werkbund im Salon der 'Artistes-Décorateurs', Paris". *Das Werk* 17: 7, 197-204.

Elwall, Robert. 1994. *Photography Takes Command: The Camera and British Architecture 1890-1939*. London: RIBA Heinz Gallery.

—. 2004. *Building with Light. The International History of Architectural Photography*. London-New York: Merrell Publishers.

Ernyey, Gyula. 2010. "Breuer magyar kapcsolatai és recepciója (Breuer's Hungari-

an contacts and reception)". In: Ernyey, Gyula, ed., *Breuer Marcell. Elvek és ered-mények* (Marcel Breuer. Principles and Results). Pécs: Pannónia Könyvek, 107-130.

Ferkai, András. 2011. *Molnár Farkas*. Budapest: TERC.

Forgó, Pál. 1928. *Új építészet* [New Architecture]. Budapest: Vállalkozók Lapja Könyvkiadó Osztálya.

—. 1929. "A korszerű lakás" [The modern apartment]. *Tér és Forma* 2: 4, 165-167.

Gräff, Werner and Lotz, Wilhelm. 1927. "Werkbund-Ausstellung 'Die Wohnung'. Das Ziel. Eröffnung". *Die Form* 2: 8, 249-252.

Gropius, Walter. 1925a. *Internationale Architektur*. Bauhausbücher 1. Second edition. München: Albert Langen Verlag, '1927' (1925).

—. 1925b. *Neue Arbeiten der Bauhauswerkstätten*. Bauhausbücher 7. München: Albert Langen Verlag.

—. 1930. *Bauhausbauten Dessau*. Bauhausbücher 12. München: Albert Langen Verlag.

Hays, K. Michael. 1999. "Diagramming the New World, or Hannes Meyer's 'Scientiza-tion' of Architecture". In: Galison, Peter and Thompson, Emily, eds: *The Architecture of Science*. Cambridge, Mass. – London: The MIT Press, 233-252.

Horányi, Éva. 2010. "Stahlrohrmöbel: Marcel Breuer und seine ungarischen Partner in Deutschland". In Bajkay ed., 224–233.

Kramer, Ferdinand. 1928. "Individuelle oder typisierte Möbel?" *Das Neue Frankfurt* 2: 1, 8-11.

Lotz, Wilhelm. 1929. "Fotografie und Objekt. Zu den Fotos von Renger-Patzsch". *Die Form* 4: 7, 162-167.

—. 1930. "Ausstellung des Deutschen Werkbundes in Paris". *Die Form* 5: 11-12, 281-296.

—. 1931. "Ewige Formen – Neue Formen". *Die Form* 6: 5, 161-166.

Máčel, Otakar. 2003. "Marcel Breuer – 'Inventor of bent tubular steel furniture'". In: Von Vegesack and Remmele, eds., 50-115.

Meyer, Hannes. 1926. "Die neue Welt". *Das Werk* 13: 7, 205-224.

Molnár, Farkas. 1928. "Az új fémbútorokról" [On the New Metal Furniture]. *Magyar Iparművészet* 31: 11-12, 231-232.

Muylaert, M. J. 1929. In *Bouwkundig Weekblad Architectura* 50: 40, 313-320.

Overy, Paul. 2007. *Light, Air and Openness: Modern Architecture Between the Wars*. London: Thames and Hudson.

Perriand, Charlotte. 1929. "Wood or Metal?" *The Studio* 97, 278-279.

Rattenbury, Kester, ed. 2002: *This Is Not Architecture: Media Constructions*. London – New York: Routledge.

Riezler, Walter. 1927. "Die Wohnung". *Die Form* 2: 9, 258-266.

Rüegg, Arthur. 2005. "The Role of Furniture Photography in Modernist Propaganda". In: Baudin, Antoine, ed., *Photography, Modern Architecture and Design: The Alberto Sartoris Collection. Objects from the Vitra Design Museum*. Lausanne: Ecole Polytechnique Fédérale de Lausanne Press in collaboration with the Vitra Design Museum, 174-183.

Schuldenfrei, Robin. 2009. "The Irreproducibility of the Bauhaus Object". In: Salet-nik, Jeffrey and Schuldenfrei, Robin, eds., *Bauhaus Construct. Fashioning Identity, Discourse and Modernism*. London – New York: Routledge, 37-60.

—. 2013. "Images in Exile: Lucia Moholy's Bauhaus Negatives and the Construction of the Bauhaus Legacy". *History of Photography* 37: 2, 182-203.

Shand, Philip Morton. 1934. "New Eyes for Old". *The Architectural Review* 75: 446, 11-13.

Stam, Mart. 1929. "Das Mass · Das richtige Mass · Das minimum Mass. Unsere Haus-geräte und Möbel". *Das Neue Frankfurt* 3: 2, 29-30.

Stone, Sasha. 1929. "Zurück zur Fotografie". *Die Form* 4: 7, 168-176.

Vegesack, Alexander von, and Remmele, Mathias, eds. 2003. *Marcel Breuer: Design and Architecture*. Weil am Rhein: Vitra Design Museum.

Wilk, Christopher. 1981. *Marcel Breuer: Furniture and Interiors*. London: The Ar-chitectural Press.

—, ed. 2006. *Modernism: Designing a New World 1914-1939*. London: V&A Pub-lishing.

—. 2006a. "Sitting on Air". In: Wilk 2006, 225-247.

—. 2006b. "The Healthy Body Culture". In: Wilk 2006, 249-295.

# Spreading the Word and Image of Modernism: Christian Zervos and *Cahiers d'Art*, 1926-1960

KATE KANGASLAHTI (KU LEUVEN)

There are small enterprises that leave a greater imprint upon history than those with large capital and a numerous staff. But to achieve this, the incessant work, enthusiasm and imagination of one individual is needed – one who can inspire the co-operation of a few people to produce miracles that may influence a whole epoch.[1]

L. Moholy-Nagy, Institute of Design, Chicago, September 1945

## Abstract

This chapter studies the role played by art mediator Christian Zervos, through reviews, and later a publishing house and gallery founded under the same name, in the global diffusion of artworks and the ideas surrounding their creation in the first half of the twentieth century. From 1926 until 1960, Greek-born Zervos conceived and painstakingly compiled 97 issues of *Cahiers d'art*. In the interwar Parisian art world, still then the world's premier market and hardly bereft of publications on art, Zervos's review immediately stood apart, both in style and substance. Each number was characterized by clear and sympathetic typography, a shrewd appreciation of white space and an abundant, but carefully orchestrated, use of photography: *Cahiers d'art* marked the ascendancy of the visual essay as a means of knowing art and in its pages the work of art entered (what Benjamin later heralded as) the age of its mechanical reproduction. As for content, Zervos deftly intermixed a diverse range of subjects and approaches, combining articles about ancient practices with items on the modern and contemporary, juxtaposing extra-European and European traditions, alternating critical or historical texts with literary pieces. He sought contributions from artists themselves as well as from an important array of international writers whose analyses – on painting, sculpture, architecture, design, cinema, photography, poetry, ethnology, even music – were to become key texts in the narrative of modern art. As a result of the breadth of his own aesthetic curiosity and the network of talented artists, writers and dealers he fostered within and beyond France, Zervos brought a wider world

of art to Paris; conversely, through the international circulation of his journal, particularly influential in the US, Germany and Switzerland, he exported a heavily Parisian vision of contemporary art worldwide. Among the different strengths and limitations of his cultural legacy to be considered here: the exceptional importance Zervos accorded to Pablo Picasso and Cubism; his near willful misrepresentation and neglect of genuinely abstract art; and his emphasis upon art-making as an intuitive, quasi mystical process.

From 1926 until 1960, Greek-born Christian Zervos published 97 issues of *Cahiers d'Art*. In the interwar Parisian art world, the world's premier market and hardly bereft of publications, his review was quickly prized among the global cognoscenti for the diversity of its contents and quality and abundance of its photographic reproductions. Zervos deftly interwove different subjects and approaches, combining articles on ancient practices with items on the contemporary, juxtaposing extra-European and European traditions, alternating critical or historical texts with literary pieces. Lavishly illustrated, he exploited the practice where works were increasingly photographed before being, or in order to be commercialised, and printing technologies which allowed for the affordable reproduction of images on the page. In the absence of either a large staff or significant economic resources – his financial circumstances were often precarious – the appearance of each issue was, as László Moholy-Nagy later wrote, a small wonder, attesting not only to Zervos's own unceasing dedication, but also the cooperation he inspired in others. If *Cahiers d'Art* was a singular enterprise, largely the work of one man, a conspiratorial air still suffused its pages.[2] Serving as publisher, art director, production designer, editor-in-chief, and critic, Zervos depended upon the donated time, texts, photographs, translations, advertisements, and other services he elicited from an array of international writers, artists, dealers and collectors, who in turn helped to distribute the journal worldwide. Moholy-Nagy, the Hungarian artist, photographer, filmmaker and erstwhile Bauhaus instructor, was but one. Incorporated within and distributed under the cover of *Cahiers d'Art*, their contributions on a wide range of topics – painting, sculpture, architecture, archaeology, poetry, photography, cinema, even music – were so many steps in a wider campaign for legitimation that have since become the visual and textual traces of modernism's historical ascent.

Modernism, here, comprehends two distinct, but symbiotic phenomena. It describes creative developments, beginning in the late nineteenth century, in which a small, but significant group of artists questioned the nature of representation and gradually withdrew from the task of imitating the appearances of things, in favour of a new concern with form. Colours, shapes and materials began to take on a life of their own, to the point of losing, often controversially, all obvious connection with the observable world. But modernism also describes a critical tradition which emerged in

response to these trends and in support of these artists, reaching its para-
digmatic form in the mid-century writings of the American Clement Green-
berg. Modernist criticism judged the work of art according to its visual –
formal – qualities, emphasising the artist's exceptional aesthetic concerns,
his autonomy from social, political or moral claims, and his originality in
regard to past traditions.[3] The relationship between modernist art and its
criticism is what Pierre Bourdieu theorises in his essays on *The Field of
Cultural Production* as, on the one hand, "pure painting…a play of forms,
values and colours," in which the artist appeared "to rebuff every external
constraint or demand" (Bourdieu 1993, 264-265); and, on the other, "the
pure gaze, capable of apprehending the work of art as it demands to be ap-
prehended (in itself and for itself, as form and not as function)" (Bourdieu
1993, 256). The excavation of *Cahiers d'Art* to follow, in search of the ma-
terial remains of modernism's two-fold ascendency, is in part a response
to Bourdieu's thesis and his rhetorical question, "Who creates the creator?"
Who, or what, conferred upon modernist artists quasi-magical powers of
transubstantiation, and endowed their disputed creations with meaning
and value as art? (Bourdieu 1993, 76) Because if Bourdieu's answer is the
whole of the artistic field, all those "agents" within it who strive to conserve
or transform art's existing conditions, he accords a special place to the role
of publications.[4] But whereas Bourdieu's sociological purpose is to reveal
the underlying "structure" which determines the field, the question this
essay poses is historical.[5] What part did Zervos play, through his review,
not simply in the global diffusion of artworks, but in the process by which
they became art, in the consecration of select new practices and concepts
through discourse and reproduction, the published word and image? How
did the editor, as Moholy-Nagy suggested, influence an epoch, and what
imprint then has his enterprise left upon history?

   As befits a volume of this title, the issue is not the objective system from
which Zervos, as an "agent", derived his power, so much as the subjective
ways he, as an "actor", wielded it. His function, in other words, and that of
his review, as "mediators" in the terms which Bruno Latour defines: as peo-
ple or things that "transform, translate, distort, and modify the meaning or
the elements they are supposed to carry" (Latour 2005, 39). Within the scope
of this essay I am not proposing a comprehensive survey of the editor's
mediations. The focus will be a select number of the 78 issues of the review
published during the interwar period, at the height of its global influence
and circulation, in relation to the following lines of inquiry. Firstly, the way
in which Zervos sought to champion contemporary art by enlarging the
public's sphere of reference to include long-neglected forms of archaic or
so-called "primitive" art, a meeting of past and present that rested upon the
editor's post-Nietzschean convictions: man's instinctive disposition to seek
spiritual ends through material means; and the artwork as manifest of its
creator's unique spiritual force and creative invention. Within this cult of in-
stinct, Zervos accorded the proponents of cubism a position of exceptional

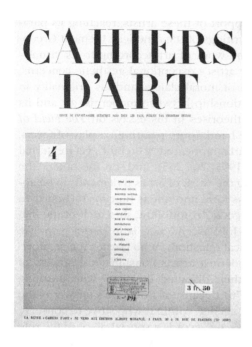

Fig. 1. Cover, *Cahiers d'Art* 1, No. 4 (1926).

privilege. My second point will be to consider the way in which, above all others, he fêted and staunchly defended the work of Pablo Picasso as the touchstone of modern art; competing developments in contemporary painting, though they found a platform, were, by comparison, observed idiosyncratically and with some reserve. As much as it was intended to be read, however, *Cahiers d'Art* was also meant to be viewed, even more so when it passed beyond the borders of the language in which it was published. And so before deconstructing the critical edifice which Zervos built around the artists and the artworks he featured in its pages, I will also consider the review materially, as an object apart, a new visual space and one which, particularly through its abundant use of photography, signalled a change in our approach to art and its history.

## Building a new visual space

Born on the Greek Island of Cephalonia, raised in Alexandria and later Marseilles, Christian Zervos arrived in Paris in 1907 to study philosophy, an intellectual grounding that shaped his perceptions of art and strongly inflected the language of his criticism. Having submitted his doctoral thesis in 1918, he began his career in the publishing house of Albert Morancé in 1923, as the editorial secretary for two of its mainstream publications, *L'Art de la maison* and *L'Art d'aujourd'hui*. It was here that he first came into contact with a core group of artists to whom he would remain unshakeably loyal: Henri Matisse, Georges Braque, Fernand Léger, Juan Gris and Pablo Picasso. But Zervos's perspectives, like his background, were cosmopolitan, and his interests extended well beyond the microcosm of Paris and the persuasions of Morancé's core readership.[6] At a time of increasing French cultural chauvinism in the aftermath of the First World War, he unapologetically looked to trends from both across the Rhine and farther afield, and as-

pired to create a new review devoted to striking developments, from across disciplines and around the globe.[7] The success of the 1925 Exposition des arts décoratifs et industriel in Paris, from which Germany was conspicuously absent, fuelled his ambitions, as did the demise of *L'Esprit Nouveau* the same year, the publication that the Swiss-born architect Le Corbusier had launched with Amedée Ozenfant in 1920. Their clear presentation of text and image and use of juxtaposition deeply impressed Zervos, but *L'Esprit Nouveau* was conceived in the spirit of a manifesto. It ranks among those staunchly partisan journals, from the turn of the century onwards, which sought to move the boundaries of art through their strident advocacy of a specific movement (in this case, Purism). Zervos, to the contrary, sought to present rather a more comprehensive picture of the contemporary scene, and to serve, through the range of subjects treated and the quality of production standards, a more broadly evaluative function.[8]

The first issue of *Cahiers d'Art* appeared in 1926 and Zervos announced the breadth of his ambition in the subtitle on the cover of the fourth number, the earliest to feature too the distinctive coloured square that was to become the magazine's trademark (fig. 1): "Review of the artistic avant-garde in all countries." This 27-page edition included, in order of appearance: Maurice Raynal's article on the cubist painter Fernand Léger; images of socially progressive residential developments in Rotterdam by the Dutch architect, J.J.P. Oud; and Jean Cassou's thoughts on palaeolithic art in "The Painting of Prehistoric Times".[9] An unattributed article on "The Art of *Mise-en-Scène*" admired the way in which constructivist-inspired sets were intensifying performances at the Meyerhold Theatre in Moscow; following which Zervos's compatriot, Émile Tériade, reviewed Parisian exhibitions by Jean Lurçat and the German surrealist Max Ernst.[10] His overview preceded an uncredited photoessay on modern Japanese interiors and finally images of the ancient Egyptian temples and bas-reliefs at Deir-al-Bahari. These reproductions illustrated passages from *Eupalinos*, Paul Valéry's fictive dialogue in which Socrates and Phaedrus meet in the afterlife and discuss the essence of the object as the work of the spirit, and the indivisibility of the maker and the made. The extract ended with Socrates' penultimate words from the text, his lament in the hereafter for the things he might have made, had he chosen a life given to thoughtful construction rather than to constructive thinking:

> Objects most precious for the body, delightful to the soul, and such as Time itself must find so hard and so difficult to digest that he will be able to subdue them only by the assaults of centuries; and that only after having clothed them in a second beauty: a mellow gold upon them, a sacred majesty upon them, and, wrought by the flight of time, a charm which comes of comparisons growing up about them.[11]

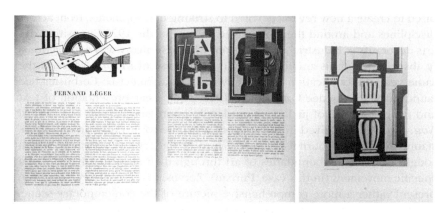

Fig. 2. Maurice Raynal, "Fernand Léger", *Cahiers d'Art* 1, No. 4 (1926), pp. 61, 64-65.

The philosopher's imagined words, published early in the life of the review, offered a prescient analogy for the discourse which Zervos was soon to shape in its pages: initiating a process by which the era's difficult objects and theories of making were compared, digested, and normalised; forming that critical veneration in which they were clothed, first affirmed as art, before entering, over time, the annals of its history.

In the complete, original text Socrates asserted the right of the "true artist", whose artistic forms were ultimately an act of the spirit, "to construct worlds perfect in themselves, though they m[ight] be so far removed from our own as to be inconceivable." "Th[is] greatest liberty is born of the greatest rigour..."[12] The critical edifice of *Cahiers d'Art* was to be built upon the same bedrock: the position that imitation was irrelevant to artistic meaning and that forms which defied orthodox representation sprung from the artist's rigorous adherence to his own creative instinct and spirit of invention. The large majority of texts that Zervos published also developed a similarly rhetorical and lyrical expression, seeking to persuade the reader of the artist or artwork's significance through the assertion of value, not its actual demonstration.[13] Authors frequently relied, in other words, on the "charismatic ideology" of the artist as a visionary blessed with unique gifts (Bourdieu 1993). Maurice Raynal, for example, claimed Fernand Léger as "one of the great plastic inventors of our time": "a [creator] of rare temperament...who surprises, seizes, sometimes overwhelms us, in short who does not work upon our sensibilities by means of a seduction, quick to attract, never long to last, but by a prolonged persuasion, which at first troubles, then convinces, before finally taking hold of us, never to let go."[14] The absence here of any sustained description or detailed analysis was in part a function of the works themselves, the aesthetic challenge posed by the artist's rejection of narrative depiction and mimetic representation. As Zervos himself later wrote: "the less we explain cubism, the better we understand it [...] Art criticism suffers difficulty in the presence of art which

implements the inexplicable [...] How can it use its principle resource, description, before paintings which are clearly anti-anecdotal?" (Zervos 1942, xxiii) Besides, in the face of these limitations, beyond poetic assertion, Zervos had new, more eloquent resources on which to call: the force of the image, photographic reproduction.

By the number of illustrations which appeared in *Cahiers d'Art*, and the considerable time and expense he devoted to their impression, photographic reproduction enjoyed pride of place in Zervos's editorial practice.[15] "Stringing the plates together", Christian Derouet has suggested, "was the essential phase of the dummy – the images did not come to the aid of a thesis, they were the thesis themselves." (Derouet 2006, 76) The layout he favoured varied. Zervos incorporated illustrations in and around the text, but he also followed one to two dedicated pages of text with a sequence of full-page or half-page plates; sometimes, as in Raynal's article on Léger, he combined both approaches (fig. 2). In any case, the illustrations took the place of detailed descriptions, and images were not linked to relevant texts by any explicit reference but by association. The primacy of the image in *Cahiers d'Art* was the corollary of its editor's critical stance: if the distinctive forms of the artwork were the unique product of the artist's creative self, by extension the artist was best understood, not through any written account of his work, but its illustration. And Zervos, through his orchestration of photography, the "almost maniacal care with which he put together [those] illustrations," promoted an ostensibly unencumbered appreciation of the artist's work:

> More than anyone else, he knew the distance that existed between the object and its photographic image, between the photograph and its mechanical translation; to reduce this distance as much as possible, we see him, nuancing the shadows and brights, modelling the volumes, avoiding obscurities, obstructed surfaces, sending, to photographers and printers successively, proofs as overwritten as those of Balzac.[16]

What the retrospective remarks of the art historian Germain Bazin make evident is the extent to which Zervos, in attempting to create as intimate encounter as possible between the reader and the work, repeatedly inserted himself into the reproductive process, in order to render it invisible. Closely cropped, insulated and framed by the white space of the page, minimally captioned – if at all – he carefully structured the viewer's experience of the images in favour of an object's "plastic" qualities, its forms, use of line, brushwork, and, if not colour, then tonal relationships.[17] Like in Raynal's article, where Léger's works were inscribed according to medium alone (*dessin, peinture*), the reader is denied a sense of scale, the entry point of a descriptive title, or the suggestion even of a genre (portrait, still life, landscape) and directed to see simply "painting."[18]

Fig. 3. Christian Zervos, "L'Art Nègre", *Cahiers d'Art* 2, No. 8-9 (1927), pp. 229, 252-253.

## Meetings of past and present

By assembling and arranging a vast array of reproductions in each issue, by bringing before the beholder an impossible meeting of diverse originals, Zervos was elaborating a new way of evaluating art and making its history, a method that not only attended exceptionally to the object, or rather its image, but also encouraged its comparison across disciplines, eras and cultures. *Cahiers d'Art* was to serve as a forum for what he himself called "encounters between the past and the present," as they met to the detriment of "art attached to the servile imitation of the appearances of nature"– western mimesis and the over-abused model on which it was based, classical antiquity.[19] Zervos enlisted here the assistance of, among others, Georges-Henri Rivière, future assistant-director of the Musée de l'Homme, but still a student at the École du Louvre when tasked with presenting recent excavations in *Cahiers d'Art*, documents from diverse cultures in which archaeology itself was revealed, as Rivière wrote, to be the "parricide daughter of humanism". "[It] presides over digs which present us with the Thinite dynasties of Egypt, pre-Columbian America, the ancient empire of China. [And] if its divests Minos of his halo of legends, it is in order to give him back his palaces, their treasures, their frescoes."[20] In the review's pages archaeology was to unearth not the course of long-dead civilisations, but the immortal force of the artwork.[21] In the ensuing field reports, ceramics from the Persian city of Susa appeared between drawings by Pablo Picasso and sculptures by the Romanian Constantin Brancusi; Easter Island statuary and Coptic textiles encountered the cubism of Georges Braque and Juan Gris; and paintings from Central Asia rubbed shoulders with the surrealism of Max Ernst.[22] In the richly tonal black and white reproductions, items chosen for their alterity were carefully staged, dramatically lit, isolated, and rendered uniform in size. Decontextualised as artefacts and reframed as art, they were presented as the historical equivalents of their twentieth-century counterparts. Or, to reprise Rivière's poetic

Fig 4. Christian Zervos, "L'Art Nègre", *Cahiers d'Art* 2, No. 8-9 (1927), pp. 254-255, 257.

manifesto,"we summon the ancients to compare them to the moderns", for, he asserted, "the two are equal."[23]

These individual accounts foreshadowed a series of special issues devoted to cultures temporally and geographically distant, the first of which appeared in 1927, a double-number focussing on objects from the French Congo and French West Africa that included articles on art by Georges Salles, conservator at the Louvre, and on architecture by the author André Gide, who published an account of his *Voyage au Congo* the same year.[24] In his own contribution, "L'Art Nègre", Zervos articulated his volition to lift out of the realm of mere curiosity those neglected objects that deserved admiration and a place in the history of human civilisation. But the textiles, masks and sculptures showcased for the reader's aesthetic appreciation were also clearly presented to cast light upon developments in contemporary art. It was, after all, "from [these] expressions [that] young painters had got their longing for possibilities [of form] hitherto unsuspected, the search for expressions, for volumes, for tones that were going to extend considerably our pictorial heritage."[25] Characteristically, Zervos asserted his thesis in the sequence of full-page illustrations that followed, which invited comparison between Picasso's *Les demoiselles d'Avignon* and *La jeune fille nue* and Matisse's *Tête blanche et rose* and *Jeune Femme* and the African artworks alongside which they appeared, despite the fact that neither painter, in fact no contemporary painter, was named in either Zervos or Salle's text (fig. 3 and 4). The pertinence of this comparison was emphasised by the fact that several of the masks and textiles reproduced were credited to the personal collections of the same painters.[26]

The confrontations that Zervos effected here were more than formalist strategy, where past met present in opposition to constraints imposed since the Renaissance, they were born of his belief in a spiritual affinity: "Every time we go in pursuit of that *instinct* which lies in the depth of our being we find ourselves involuntarily drawn closer to primitive works that best

confirm this instinct."[27] Zervos was echoing what Jean Cassou had earlier suggested in his account of the palaeolithic "perfection inscribed in the caves of Altamira and the Dordogne", in which he had likewise found "the consciousness of this profound [creative] impulse by which everything exists."[28] Subsequent special issues devoted to archaeological and ethnographic subjects further developed a critical engagement that drew on the post-Nietzschean thought of like-minded associates. In 1929, Zervos collaborated with the Romanian dadaist poet and playwright Tristan Tzara on a double number devoted to the art of Oceania. Its "poetic invention", "visionary imagination", and "mystico-magical conception of life" were offered to the reader as an antidote to what Zervos deemed the "modern mechanisation of the spirit."[29] The next year he joined with the French archeologist Henri Breuil and the German explorer and ethnologist Leo Frobenius to edit an issue on the pre-historic art of Africa. It included a catalogue of the cave and rock paintings Frobenius had meticulously copied "as the oldest tangible records of humanity", during his 1928-1930 expedition through Southern Africa.[30] Soon after its publication, the Russian-born abstract artist Wassily Kandinsky wrote to Zervos from the Bauhaus, describing a class he had given on the texts and reproductions of this particular number and congratulating the editor on his intuitive understanding that the past could be used to consolidate the present. "The interior identity of modern art and ancient art is very often the best means of showing the world the organic vitality of new art [...] If we show [the sceptics] the organic roots of this art and the great resemblance to the past, they see all of a sudden, instead of a paradox, a natural and necessary event."[31]

Kandinsky's letter highlights the sense of solidarity ("If *we* show...") Zervos forged with the artists whose work he supported, akin to that micro-society of "mutual admiration" that Bourdieu describes, built upon a shared belief in "free, disinterested 'creation', founded upon the spontaneity of innate inspiration" (Bourdieu 1993, 114-116). Solidarity, however, did not guarantee an equal share of the editor's regard, or an even coverage in the pages of his review, and the next special issue made clear which present-day artist stood above all others in Zervos's estimation. In 1932 he juxtaposed the complexity of bronzes and ivories from the Kingdom of Benin, then on display at the Trocadéro's Musée d'ethnographie, with an anthology of Pablo Picasso' work, coinciding with the artist's retrospective at the Galerie Georges Petit. Among the sumptuous illustrations, 157 reproductions in all, an impressive selection of international authors affirmed the universal importance of the artist Zervos described in his own text as "*the* painter who create[d] most directly according to his own vision," impelled by an urge "from the very depths of his being."[32] From Picasso's first appearance in *Cahiers d'Art* in 1926, Zervos fêted the Spaniard for his uncompromising commitment to art-making as an instinctive activity, rather than a clinically intellectual exercise. Here, the editor ventured, was an artist who did not allow "the revelations of the soul...to be policed by the wilful

interventions of the mind." In his debut, Zervos established Picasso as the touchstone of modern art, a creative engine upon which its every development was to be dependent: "In him all the efforts of contemporary painting collide, are counterbalanced and transformed [...] everything appeals to his creative mind and his mind contests and recreates everything."[33] Despite pretensions to an outlook that was both progressive and global in scope, the review strongly favoured cubist artists and chiefly Picasso. Put another way, Zervos devoted its pages to the task of providing a "creative interpretation" for the benefit of one particular creator (or group of creators) (Bourdieu 1993, 116).

## Cubism and the cult of the object

The editor elaborated the aesthetic criteria by which artists were judged in *Cahiers d'Art* in a series of essays, published across multiple issues in 1930 and 1931, in which he developed his reading of the "subject" and the "object" in art. According to Zervos, the artist, "when he achieve[d] true depth, inevitably detache[d] himself from the subject."[34] The triumph of twentieth century painting, as he described it, lay in Matisse and Picasso's rejection of the "subject", and the falsehood of anecdotal or literary references described naturalistically. "There are no fixed forms in nature, contrary to the assertion of all academicisms, there are only malleable elements continually transformed according to the artist's feeling, and it is to this certainty that we owe the remarkable deformations of Matisse and cubism." The artwork,

Fig. 5. Wassily Kandinsky, "Réflexions sur l'art abstrait", *Cahiers d'Art* 6, No. 7-8 (1931), pp. 350-351.

in other words, was born of the artist's power of abstraction in the face of his lived experience, which found expression in the way he plastically – formally – transformed the "object" according to his own creative instinct. "Because," Zervos continued, "it is through the *object* that the artist knows himself and knows his art."[35] His critical position here epitomises what Bourdieu nominates as the modern institution of a *"creative gaze,* capable of being applied...to lowly and vulgar objects...to insignificant objects before which the 'creator' asserts his quasi-divine power of transmutation" (Bourdieu 1993, 265). Not all creative gazes, however, were equal in their transformative power. The virtue of Matisse's œuvre, according to Zervos, lay irrevocably in the incisive style of his earliest canvases, that is, in the past. In contrast, contemporary painting's present achievements and future attainment all lay within the limitless possibilities of interpretation that Picasso, and through him, cubism, bestowed upon the object.[36] If modern art was in this way wholly contingent upon Picasso's inventive energy, by extension everything he did was charged with signification. Taking into account the 78 issues of the review published up until the outbreak of the Second World War, Picasso featured on over 60 occasions, including a further three, dedicated numbers after 1932, more than any other artist.[37]

Zervos's hagiographic treatment of Picasso, and the frequent appearance of other well-known cubists in its pages, at times lent *Cahiers d'Art* a sectarian aspect.[38] Michel Seuphor, the Belgian painter and critic, who co-founded the abstract art association and review *Cerle et Carré* in Paris in 1930, labelled Zervos's review a "small closed circle, above all founded for a couple of cubists and particularly for Picasso."[39] While undoubtedly coloured by the author's professional jealousy, these remarks do suggest that competing developments were not necessarily well served by the editor's "creative interpretation" in favour of cubism's transformation of the object. Surrealist artists, who generated images by means of arbitrary exercises, or passively reproduced dreams upon the canvas, were censured for ignoring their own creative instincts and intent.[40] Zervos disparaged their impersonal representations of improbably arranged figures and objects as signalling a regression to the "subject", a criticism bolstered by Picasso's own judgement: "Really, it was not worth all the efforts our generation made to see these people fall back into literature and forget the most elementary plastic form."[41] In surrealism, the artist's unique vision was not reflected in the expressive forms of the painting itself, and any meaning was derived only through fanciful theory or "literature". But equally, Zervos critiqued the vanity of unnamed "artists who reduce[d] art to the adjustment of a few squares and a few circles" and maligned geometric abstraction as "the decorative at its most vile". "A network of lines, a concert of masses, a piling up of values is not enough to give birth to a work of art."[42] To attempt to liberate painting entirely from the object, as abstract artists claimed the right to do, was to limit the creation of images to a facile game of colour and form that required no instinct or imagination, at which any-

Fig. 6. Jean Hélion, "La Réalité dans la peinture", *Cahiers d'Art* 9, No. 9-10 (1934), pp. 261.

one could succeed.[43] And "where," Picasso asked again, "was the drama in that?"[44]

If, however, Zervos observed developments outside cubism with a highly partial eye, he was far from systematic in adhering to his own aesthetic criteria, and as a result *Cahiers d'Art* came to be an influential platform for an idiosyncratic, but important, group of surrealist and abstract artists. Jean Hélion, the one-time abstract artist whose own works appeared in the review, nominated Wassily Kandinsky among its "monuments", and one of "the pillars of [Zervos's] edifice." He suggested, in contrast to Seuphor, that "even if cubism formed the framework of [Zervos's] vision of modern art, he knew to observe and situate surrealism, abstraction and what followed" (Hélion 1970, 26). In 1931, soon after Zervos published monographs on Kandinsky and his Bauhaus colleague Paul Klee, and partially on the strength of the dialogue he maintained with Kandinsky, Zervos invited key practitioners to discuss the aesthetic possibilities of abstract art, in light of the "charges" of which it frequently stood "accused":[45] 1) of being excessively cerebral and contradicting the sensual nature of art; 2) of having deliberately replaced instinctive emotion with an intellectual, geometric exercise; 3) of having reduced the work of art to a simple game; 4) having thus engaged art in an impasse and taken away all its possibilities for evolution and development (fig. 5).[46] The ideas that Kandinsky, Fernand Léger, Piet Mondrian, Willi Baumeister and Hans Arp submitted in defence of their art were to become *leitmotifs* in mid-century discourse surrounding abstraction. Art grew from a man, Arp suggested, like the fruit out of plant, but while in nature the fruit assumed a form independent of the plant, artistic fruit had, for centuries demonstrated a ridiculous ambition to imitate the appearance of other things.[47] As such, abstract artists had not, Baumeister insisted, reduced the possibilities of painting, but had rather emancipated it from the shackles of illusionism, that same servile imitation Zervos himself abhorred.[48] "The contact of a tri-

angle's acute angle with a circle", Kandinsky wrote, "has no less effect than Michelangelo's finger of God touching the finger of Adam."[49] Ultimately both were only, but equally, pictorial means of expression.

The form of Zervos's *enquête* was politically expedient: as the editor described in a letter to Kandinsky, his "purpose [was] to make known to [his] readers, by an *indirect manner*, those tendencies called abstract, which they still repudiate [...] of familiarising, little by little, people so far closed to modern art."[50] Zervos refrained here himself from taking an unshakeable aesthetic position and any misgivings were articulated as a line of inquiry. In his own critical writings, when contending with the work of abstract artists he admired and with whom he maintained a relationship, he frequently asserted a rhetorical link between their use of form and the perceived world. In 1929, when reviewing Hans Arp's exhibition at the galerie Goemans, Zervos compared the artist's works to those prehistoric ideographic signs by which man first expressed himself in the face of life's mysteries, suggesting that the abstract forms Arp created were similarly poetic summaries: "they are leaves, masks, birds and a host of other *objects* from the material world, that Arp represents." Far from satisfying mere "visual caprice", "Arp [was] a poet", who transformed the appearance of the exterior world according to his own profound lyrical impulse.[51] This frame of interpretation, whereby the artist translated his unique responses before the wonders of nature as signs and symbols, extended to the work of other abstract artists, like André Masson, Joan Miró, Paul Klee and Kandinsky. On the occasion of his exhibition in 1934 at the premises of *Cahiers d'Art*, for example, Zervos likewise insisted that "the painting of Kandinsky is never abstract: it excels, to the contrary, in animating the inventions of the artist, in bringing to life the universe, nay the things most seemingly inert."[52]

## Zervos and the ascent of modernism

Through such exhibition reviews, articles and judiciously placed reproductions, Zervos included the names of specific, international abstract artists within the corpus of modernism diffused under the title of *Cahiers d'Art*. He even, on occasion, offered a platform for artistic claims more radical than those he himself typically espoused, as when, also in 1934, he published Jean Hélion's reflections on the nature of reality in painting: "Reality depends on the attitude of the painter before the canvas and not before nature [...] nothing is real by definition but by fact."[53] To illustrate Helion's thesis, Zervos reproduced a full-page image of Piet Mondrian's austere neo-plasticist *Composition* from the same year, captioned by a suggestive section duplicated from the text (fig. 6):

> In fifty years we have gone from Meissonier's total submission to the subject's appearances to a total submission to the canvas. From the exterior realism of the model, to a sort of interior realism in the

> painting [...] The search for the minimum sign, for pure colour, for
> the culminating points of the spectrum [...] Painting-object, neutral,
> independent, unique; real, certainly.[54]

A painting, in other words, is first and foremost an independent object and
its only relationship to reality is one mediated by the artist's idea or vision,
as reflected in the forms of the painting itself. This is what Charles Harri-
son, more than sixty years later, still identified as one of modernism's key
articles of faith, that "it is not through correspondence with the appearance
of world, then, that realism is to be achieved, but, to the contrary, through
the achievement of an aesthetic autonomy".[55]

The primacy of the artist's independence to determine the nature of
reality in art and to pursue aesthetic virtue at the expense of more worldly
concerns was a difficult position to assert and maintain in the socio-political
context of the mid-1930s. The situation was not as perilous in France as
it was in Germany, from where Kandinsky had arrived in 1933, forced
into exile by National-Socialism, but political factiousness still resonated
in newly fervent debates about the nature of art and the role of the artist
in society. The critical texts which appeared in *Cahiers d'Art*, sown with
philosophical references, had been largely devoid of explicit ideological
tropes, but Zervos broke free of this apolitical stance in 1935 to deplore the
tense political circumstances, which threatened art's essence as a spiritual
activity. In "Social Fact and Cosmic Vision", he argued against "militants",
who demanded art's total submission to a programme of social change and
sought to control it as an instrument of revolution. Pushed into defending
the very premises of modern painting, its spontaneity, freedom and plastic
experimentation, Zervos even found himself endorsing surrealist-like
eccentricities:

> The artist must be left to penetrate beneath the mere surface of
> things, to bring to light his lucid visions of new meanings. Works
> conceived in this manner are no mere game of the mind's curiosity,
> where one elaborates strange fantasies, peculiar images, bizarreries.
> It is the manifestation of the very same search for liberty that human-
> ity seeks at the moment with courage, and that would transform the
> existing world.[56]

In Zervos's assertion that art's autonomy, its incorruptibility, was the first
condition of its social relevance lay another of modernism's abiding aes-
thetic principles: the belief, as Harrison once again argued, more than half
a century later, that human meaning and value in art cannot be created
by any "attempt to represent or to advance what we may take to be the
proper direction of our history and our societies." To the contrary, "it is
only when the artist...abandons the pursuit of...relevance, that the work of
art will testify truthfully to the historical condition and moment of its pro-

duction."[57] As the political situation across Europe intensified and conflict loomed, *Cahiers d'Art* was occupying ever more lonely – eventually untenable – critical terrain. But the postwar triumph of modernism, especially in the United States, would bring with it a certain vindication, even as it also heralded the review's obsolescence.

I began this essay with a tribute the artist Moholy-Nagy forwarded to the editor in 1945, alongside a photograph of one of his recent works, and by way of conclusion I would like to complete the citation:

> Christian Zervos in the *Cahiers d'Art* has shown...magnificent courage, enthusiasm and artistry. In two decades *Cahiers d'Art* has become the best and most valuable source material for artists, art historians and the layman. Without it, modern art would be less known, less valued and less creative. My greetings and my gratitude to Zervos, in which I am joined by my students who enjoy every one of the copies they can obtain.[58]

By his reference to the editor in the third, rather than second person, the artist likely intended both his text and image for publication, but while Zervos reproduced *Space*, 1945, in the next biennial issue, he declined to reprint the artist's words. Sent as a message of support following the review's enforced hiatus during the war, in retrospect it reads as an epitaph, and not only because Moholy-Nagy himself would die the following year. The epoch and influence he was describing had come to an end. Other editors and publishers had already or were soon to come along, to do what Zervos had done, only better, and now in colour.[59] *Cahiers d'Art* would continue to appear annually or biennially up until 1960, but its editorial outlook became ever more retrospective as art's centre of gravity shifted irrevocably from Europe to the United States, a move of which the Hungarian artist himself had been a part. Yet from his new seat as the founding director of the Institute of Design in Chicago, Moholy-Nagy was well placed to consider the influence *Cahiers d'Art* had enjoyed as source material for artists and the like, in the United States and elsewhere, not least of which in the canonisation of Pablo Picasso and cubism.[60] In his own *Vision in Motion*, published posthumously in 1947, Moholy-Nagy likened the importance of cubism's role in art to that of "Einstein in physics, Freud in psychoanalysis" (Moholy-Nagy 1947, 116); the following year, Clement Greenberg similarly nominated cubism "the epoch-making feat of twentieth-century art, a style that...changed and determined the complexion of Western art as radically as Renaissance naturalism once did" (Greenberg 1986, 212).

In rereading the 78 issues of *Cahiers d'Art* published prior to the war, the review's pages appear remarkably prescient. Dora Vallier, the last in a long line of Zervos's collaborators, later attributed its success precisely to the "exceptional clairvoyance deployed in its columns."[61] To credit its editor with such powers of prediction, however, is to disregard the extent

to which Zervos's very discussion of artists and his reproduction of their works were themselves substantial mediations in the artistic field, without which the modern art he favoured would have been less known, less valued, and perhaps even less creative. Through his own curiosity and the network of talented artists, writers and dealers he fostered within France and beyond, Zervos bought a wider world of art to Paris; conversely, through the international circulation of his journal, and its prominence in the United States, Germany and Switzerland, he exported an idiosyncratic vision of art worldwide. As Greenberg himself suggested, the impact of Parisian art, or rather a Parisian image of modern art, was felt more decisively through the reproductions of *Cahiers d'Art* than it was first-hand (Greenberg 1995, 20). The review's pages, however, were not only key to this global diffusion of modern art forms, to the process by which these objects were first named and valued as art, but also to the spread of a modernist doctrine that assured their continuing value, and of which Greenberg became the most eminent theologian. My purpose here has also been to trace the development, or, as Bourdieu might say, the institution of that aesthetic attitude, in a set of critical practices embedded in Zervos's review: in the juxtaposition of texts that emphasised the artist's autonomy, pure intent, and quasi-magical powers of invention, and reproductions that isolated, framed, and staged the object, inviting the viewer's visual delectation or "pure gaze". Here, in black and white, lies both the influence Zervos exerted over his era and the lasting imprint of his enterprise: the words and images of modernism, as they remain laid bare in the pages of *Cahiers d'Art,* for our historical scrutiny.

## Notes

1   This letter was among a number written by Moholy-Nagy listed in the catalogue of a sale, "Lettres et Manuscrits, dessins et gravures, Archives Zervos et divers", Paris, Hôtel Drouot, 12-13 November, 1998.

2   A review, Pierre Wat, has suggested, always "breathes with an air of conspiracy", a chronicle of the micro-society which grows up around its production. See Wat 2011, 15-16.

3   I am borrowing here from Charles Harrison's extremely useful overview of the competing claims upon the term "modernism". In addition to the two meanings outlined above, he suggests that modernism can also more generally refer to a "culture in which processes of industrialisation and urbanisation are conceived of as the principle mechanisms of transformation in human experience," and so serve as the *subject* of art. See "Modernism", in Nelson and Schiff 1996, 143. See also Harrison 1997.

4   Bourdieu includes art journals within an "unprecedented array of institutions for recording, preserving and analysing works", suggesting "one has to be blind not to see that discourse about a work is not a mere accompaniment...but a stage in the production of the work, of its meaning and value." Bourdieu 1993, 110.

5   If Bourdieu disparages sociological accounts which foreground the individual –
    the field "is not reducible to a population" – he also argues for the "the search
    for the foundation of the aesthetic disposition and of the work of art where it is
    truly located, namely in the *history* of the artistic institution." Bourdieu 1993, 255.

6   As Zervos later recounted to the American art critic Dore Ashton, he founded
    *Cahiers d'Art* when it became difficult to persuade Morancé to reproduce those
    artists that, he, Zervos, favoured. See Ashton 1957, 33.

7   Eric Michaud discusses the cultural politics behind the exclusion of the Germany
    from the 1925 Exposition, and French reticence in general, in Michaud 2002.

8   For more on the differences between contemporary journals, Yves Chevre-
    fils-Desbiolles's analysis of the evolving role of French art periodicals in the
    first half of the twentieth century remains the most comprehensive study of its
    kind. See Chevrefils-Desbiolles 1993.

9   Maurice Raynal, "Fernand Léger", *Cahiers d'Art* [hereafter *CA*] 1, no. 4 (1926):
    61-65; "Habitations", *CA* 1, no. 4 (1926): 66-69, Jean Cassou, "Peintures des
    temps préhistoriques", *CA* 1, no. 4 (1926): 70-71.

10  "L'Art de la mise en scène", *CA* 1, no. 4 (1926): 73-76; E. Tériade, "Propos sur les
    expositions", *CA* 1, no. 4, 1926: 77-81, "Intérieurs japonais", *CA* 1, no. 4 (1926):
    82-83. "Architectures égyptiennes", *CA* 1, no. 4 (1926): 85-88.

11  Paul Valéry, "Extraits de *Eupalinos*", *CA* 1, no. 4 (1926): 85-88; English transla-
    tion from Valéry 1989, 149.

12  Valéry 1989, 131-132. The final sentence, "the greatest liberty is born of the
    greatest rigour," was in the extract published in *Cahiers d'Art*.

13  As Malcolm Gee has neatly surmised, the practicality of this kind of assertion,
    in which the critic linked radical formal innovation to artistic authenticity, was
    that it "converted apparently negative aspects of this art into positive ones and
    so provided a reason both for its emergence and for admiring it." See Gee 1993,
    15-16.

14  Raynal, "Fernand Léger", 61-64.

15  Michel Frizot, who discusses the nature of photography in the review at length,
    has noted that Zervos was firm in his choice of the half-tone engraving process
    (*similigravure*) over gravure printing (*héliogravure*), and favoured glossy pa-
    per, of good quality. See Frizot 2011, 19.

16  Germain Bazin, "L'Art de la Crète, grandeur d'un peuple sans histoire," review
    of *L'Art de la Crète néolithique et minoenne*, by Christian Zervos, *Arts*, No. 564,
    18-24 April 1956, 12.

17  This is what Roland Barthes refers to as the "connotation" of the image, the
    imposition of a second meaning, "at once invisible and active, clear and im-
    plicit" and "realised at the different levels of the production of the photograph
    (choice, technical treatment, framing, lay-out)." See Barthes 1977, 19-20.

18  In Zervos's hands, the *mise-en-page* of the double-page spread thus becomes
    the printed equivalent of what Brian Doherty refers to as "the white cube", an
    "unshadowed, white, clean, artificial" exhibition space devoted to the "technol-
    ogy of esthetics" in which "the work of art is free to take on a life of its own".
    See Doherty 1986, 14-15.

19   Zervos, "Fausses Libertés", *CA* 2, no. 4-5 (1927), 125.

20   Georges-Henri Rivière, "Archéologismes", *CA* 2, no. 7 (1927), 177.

21   Jeffrey T. Schnapp, Michael Shanks and Matthew Tiews discuss Rivière's "Archéoligismes" as part of their "archeologies of the modern", in which they outline modernism's urge to unbury forms resistant to Culture and Civilisation, its excavation of apparently fragmentary pasts, whereby the old produces the effect of the new. See Schnapp, Shanks and Tiews 2004, 1-16.

22   Jean Cassou, "Derniers dessins de Picasso", *CA* 2, no. 2 (1927), 49-54; Georges-Henri Rivière, "La Céramique peinte susienne au Musée du Louvre", *CA* 2, no. 2, (1927), 64-67; Albert Dreyfus, "Constantin Brancusi", *CA* 2, no. 2 (1927), 69-74. E. Tériade, "Les Dessins de Georges Braque", *CA* 2, no. 4-5 (1927), 141-145; Georges Salles, "Une Sculpture de l'Ile de Pâques à Paris", *CA* 2, no. 4-5 (1927); 146-148; Georges Duthuit, "Tissus Coptes", *CA* 2, no. 4-5 (1927), 165-169; Christian Zervos, "Juan Gris", *CA* 2, no. 4-5 (1927), 170. Georges Salles, "Peintures de l'Asie Centrale", *CA* 3, no. 2, (1928), 60-66, Jean de Bosschère, "Max Ernst", *CA* 3, no. 2 (1928), 69-73.

23   Rivière, "Archéologismes", 177.

24   Georges Salles, "Réflexions sur l'art nègre", *CA* 2, no. 7-8 (1927), 247-249. André Gide, "Architecture nègre", *CA* 2, no. 7-8 (1927), 262-265. Gide's article was illustrated with (uncredited) photographs taken by Marc Allégret during their joint voyage to the Congo, images which also appeared in the book.

25   Christian Zervos, "L'Art nègre", *CA* 2, no. 7-8 (1927), 229.

26   Rémi Labrusse has further noted that copies of these special issues often appear in the artists' personal libraries, many times annotated, and later sketched, further attesting to the way objects, images and ideas circulated in an unprecedented fashion within the network Zervos fostered. See Labrusse 2006, 46.

27   Zervos, "L'Art nègre", 230.

28   Cassou, "La Peinture préhistorique", 71.

29   Christian Zervos, "Œuvres d'Art océaniennes et inquiétudes d'aujourd'hui", *CA* 4, no. 2-3 (1929), 57-58.

30   Leo Frobenius, "L'Art africain", *CA* 5, no. 8-9 (1930), 395-400.

31   Letter from Kandinsky to Zervos, dated 16 February 1931. Reproduced in Kandinsky 1992, 73.

32   Zervos, "Picasso", *CA* 7, no. 3-5 (1932), 87. Other authors in this issue included the Russian-born composer Igor Stravinsky, American curator James Johnson Sweeney, German critics Carl Einstein and Will Grohmann, their French counterparts Louis Vauxcelles and André Salmon and the poets Pierre Reverdy, André Breton, Paul Éluard, Ramón Gomez de la Serna, and Vincente Huidobro. This issue also coincided with the release of Zervos's first catalogue of the artist's work, *Pablo Picasso*, Vol. 1, *Works from 1895-1906* (Paris: Cahiers d'Art, 1932).

33   Christian Zervos, "Œuvres récentes de Picasso", *CA* 1, no. 5 (1926), 89.

34   Christian Zervos, "Les problèmes de la jeune peinture. Le retour au sujet est-il probable?", *CA* 6, no. 4 (1931), 195.

35   Zervos, "Les problèmes de la jeune peinture", 208.

36   Christian Zervos, "De l'importance de l'objet dans la peinture d'aujourd'hui", *CA* 5, no. 3 (1930), 120.

37 In this way, Christopher Green has suggested that not only was Picasso typically presented as the "artist-hero" of the modern movement, his work and life were reproduced as a phenomenon of the largest possible social significance. See Green 1993, 116-139.

38 In the same period Georges Braque featured on 32 occasions, Fernand Léger on 28, Juan Gris on 15, each receiving one dedicated issue.

39 Michel Seuphor, in an interview with Marie-Aline Prat, dated 25 April 1978. Cited in Prat 1981, 25.

40 Christian Zervos, "Idéalisme et Naturalisme dans la peinture moderne. III. Renoir", CA 3, no. 3 (1928), 49. Kim Grant has documented this criticism as an evolving, competitive dialogue between the review and the Surrealists themselves, persuasively suggesting the importance of this exchange both to the development of Surrealist art and theory, and the movement's subsequent place in the history of modern art. See Grant 2005.

41 Quoted by Zervos in "Dernières œuvres de Picasso", CA 2, no. 6 (1927), 190.

42 Christian Zervos, "Mathématiques et art abstrait", CA 11, no. 1-2 (1936), 10.

43 Christian Zervos, "De l'importance de l'objet dans la peinture d'aujourd'hui", CA 5, no. 7 (1930), 343.

44 Christian Zervos, "Conversation avec Picasso", CA 10, no. 7-10 (1935), 174.

45 Both monographs were written by the German art historian Will Grohmann, while he was an assistant at the Staatlichen Gemäldegalerie in Dresden. Grohmann 1930 and Grohmann 1931.

46 [Christian Zervos] "De l'Art Abstrait", CA 6, no. 1 (1931), 41.

47 Hans Arp, "À propos d'Art Abstrait", CA 6, no. 7-8 (1931), 358. Alfred J. Barr quoted Arp's analogy on page 13 of his introduction to Cubism and Abstract Art (New York: Museum of Modern of Art, 1936), the influential catalogue he wrote to accompany his exhibition of the same name.

48 Willi Baumeister, "De l'Art Abstrait, III", CA 6, no. 4 (1931), 216.

49 Wassily Kandinsky, "Réflexions sur l'Art Abstrait", CA 6, no. 7-8 (1931), 352.

50 Zervos's own emphasis. He goes own to suggest here that the success he enjoyed was "precisely because [he] did not want to attack the readers but persuade them". Letter to Kandinsky dated 10 February 1931. Reproduced in Kandinsky 1992, 71.

51 Christian Zervos, "Les expositions à Paris et ailleurs", CA 4, no. 8-9 (1929), 420.

52 Christian Zervos, "Notes sur Kandinsky", CA 9, no. 5-8 (1934), 150.

53 Jean Hélion, "La Réalité dans la peinture", CA 9, no. 9-10 (1934), 253.

54 Hélion, "La Réalité dans la peinture", 261.

55 Harrison 1997, 62.

56 Christian Zervos, "Fait social et vision cosmique", Cahiers d'Art 10, no. 7-10 (1935), 148.

57 Harrison 1997, 62.

58 See note 1.

59 In addition to Verve, the review which Zervos's erstwhile collaborator, Tériade, edited from 1937-1960, Zervos also faced competition from Gualtieri di San Lazzaro's XXe Siécle, (1938-1981), and, from 1955, L'Œil.

60  This consecration began even before the outbreak of war, notably with Alfred
    Barr's exhibitions at the Museum of Modern art in New York, including "Cub-
    ism and Abstract Art" in 1936, and the first of a series of panegyrics, "Picasso:
    Forty Years of his Art", in 1939.
61  Vallier 1981, 9. As a guide to its considerable contents, the index Vallier au-
    thored attested to an enduring historical interest in the review.

# References

*For the references to the articles in* Cahiers d'Arts, *see the notes.*

Ashton, Dore. 1957. "Champion of Artists". *New York Times*, 29 September 1957.

Barr, Alfred J. 1936. *Cubism and Abstract Art*. New York: Museum of Modern of Art.

Barthes, Roland. 1977. *Image Music Text*, ed. & trans. Stephen Heath (London: Fon-
tana Press).

Bourdieu, Pierre. 1993. *The Field of Cultural Production*, ed. Randal Johnson. New
York: Columbia University Press.

Chevrefils-Desbiolles, Yves. 1993. *Les Revues d'art à Paris, 1905-1940*. Paris: Ent'revues.

Derouet, Christian. 2006. "Christian Zervos, éditeur". In Derouet, Christian, ed.,
*Cahiers d'Art: Musée Zervos à Vézelay*. Paris: Hazan.

Doherty, Brian. 1986. *Inside the White Cube: The Ideology of Gallery Space*. San
Francisco, CA.: The Lapis Press.

Frizot, Michel. 2011. "Une dynamique photographique". In Derouet, Christian, ed.,
*Zervos et Cahiers d'Art*, Paris: Centre Georges Pompidou.

Gee, Malcolm, ed. 1993. *Art Criticism Since 1900* (Manchester and New York: Man-
chester University Press).

Grant, Kim. 2005. *Surrealism and the Visual Arts: Theory and Reception*. Cam-
bridge: Cambridge University.

Green, Christopher. 1993. "Zervos, Picasso and Brassaï, Ethnographers in the Field:
A Critical Collaboration". In Gee, Malcolm, ed., *Art Criticism since 1900*, Manches-
ter: Manchester University Press.

Greenberg, Clement. 1986. *The Collected Essays and Criticism, Volume 2: Arrogant
Purpose, 1945-1949*. Chicago: University of Chicago Press.

—. 1995. *The Collected Essays and Criticism, Volume 4: Modernism with a Venge-
ance, 1957-1969*. Chicago: University of Chicago Press.

Grohmann, Will. 1930. *Paul Klee*. Paris: Éditions Cahiers d'Art.

—. 1931. *Kandinsky*. Paris: Éditions Cahiers d'Art.

Harrison, Charles. 1997. *Modernism*. London: Tate Publishing.

Hélion, Jean. 1970. "Hommage à Christian Zervos". *Les Lettres françaises*, 23 Sep-
tember 1970.

Kandinsky, Vassily. 1992. *Correspondances avec Zervos et Kojève,* ed. Christian Der-
ouet, trans. Nina Ivanoff (Paris: Centre Georges Pompidou).

Labrusse, Remi. 2006. "Dieux cachés, mirages des origines". In Derouet, Christian,
ed., *Cahiers d'Art: Musée Zervos à Vézelay* (Paris: Hazan).

Latour, Bruno. 2005. *Reassembling the Social: An Introduction to Actor-Network-*

*Theory*. Oxford and New York: Oxford University Press.

Michaud, Eric. 2002. "La France et le Bauhaus: le mépris des vainqueurs". In Ewig, Isabelle, Gaehtgens, Thomas W. and Noell, Matthias eds. *Das Bauhaus und Frankreich. Le Bauhaus et la France, 1919-1940*. Berlin: Akademie Verlag, 3-13.

Moholy-Nagy, László. 1947. *Vision in Motion*. Chicago: Paul Theobald.

Nelson, Robert S. and Schiff, Richard, eds. 1996. *Critical Terms for Art History*. Chicago and London: University of Chicago Press.

Prat, Marie-Aline. 1981. *Cercle et Carré. Peinture et avant-garde au seuil des années 30*. Lausanne: Éditions l'Age d'Homme.

Schnapp, Jeffrey T., Shanks, Michael and Tiews, Matthew. 2004. "Archaeology, Modernism, Modernity: Editors' introduction to 'Archaeologies of the Modern'". *Modernism/Modernity* 11: 1, 1-16.

Valéry, Paul. 1989. *Collected Works of Paul Valéry, Volume 4: Dialogues*, ed. Jackson Matthews, trans. William McClausand Stewart. Princeton NJ: Princeton University Press.

Vallier, Dora. 1981. *Index général de la revue "Cahiers d'Art", 1926-1960*. Paris: Éditions Cahiers d'Art.

Wat, Pierre. 2011. "La revue, objet d'histoire de l'art total". In Froissart Pezone, Rosella and Chevrefils Desbiolles, Yves, eds.. *Les Revues d'arts: formes, stratégies et réseaux au XXe siècle*. Rennes: Presses Universitaires de Rennes.

Zervos, Christian. 1942. *Pablo Picasso, 2: Œuvres de 1912-1917*. Paris: Édition Cahiers d'Art.

# Part 3

# Politics

# Towards a Comparative History of Mediators: Double Men and Women

CHRISTOPHE CHARLE (UNIVERSITÉ PARIS I-PANTHÉON-SORBONNE)

## Abstract

This introductory chapter aims at discussing a common framework for the study of cultural mediation and more specifically for the large array of functions mediators assume within the numerous cultural domains where they are active. This implies the need to dwell upon the conditions of production, legitimation, selection and recognition of mediate cultural products. Three examples show the necessity to articulate the study of isolated cases with a general framework. The first one deals with the circulation of theater between Germany and France during the first half of the 19th century. It reveals a sort of rivalry between at least two circuits and their corresponding mediators: the (dominant) commercial circuit occupies the theatrical scene and confines the literary circuit to the editorial scene. The second example focusses on the intellectual mediation of new ideas and intellectual currents but also the resistance of local academic culture within and beyond Europe. The last example concerns artistic mediation in post academic era, when three important evolutions take place during the second half of the century: a growing independence from political tutelage in liberal regimes; the growing international circulation of the artists' products and the formal changes of the media themselves. The last part of the chapter deals with the unequal status of male and female mediators and stresses the importance of social and institutional aspects involved by the consecration of the mediator.

How can we report on a comparative approach to cultural mediators? Let us examine the three following findings[1]. Firstly, cultural history long preferred focusing on original creators or, conversely, on the process of receiving works of art (by way of critics, readers or audiences). It neglected studying the links formed between both ends of cultural circulation: the mediations and mediators working in a variety of processes, such as selecting and publishing, hearing and exhibiting or promoting works internationally.

The various branches of cultural history – such as book history, the social history of the arts, and the history of cultural transfers – have, however, successively turned towards these intermediary links, exploring the history of publishers and publishing, the history of collections, of art dealers, of musical entrepreneurs and concerts, the history of exhibitions and museography, the history of translation processes and the circulation of works in literature, in theatre, in natural sciences and in human sciences. But such renewed attention towards mediations and mediators didn't lead to the constitution of an overall premise, since the study of these topics aligned itself with the previously established empirical delimitations of the various cultural fields. Such renewed attention contributed instead to the accentuation of differentiations in time and space, based on the increasing division of labour in contemporary societies, itself seen as an irreversible trend of modernity.

Finally, the appearance of new mediators in these fields did not only stem from a process of labour division borne from labour's increased autonomy or extension. It also referred to a new phase in the relationship between a type of culture and a type of cultural project, driven by specific groups in given environments. This occurred simply because, when a given field expands or emerges, it indirectly disrupts other related or competing fields and leads the latter ones to restructure differently, thus giving new social roles to mediators. Despite the diversity of cases, the appearance of new mediators follows a certain number of general rules. We can therefore draw generalizations across similar fields or between countries that have reached similar levels in their cultural lives. Such a hypothesis is as valid in restricted spaces as it is when examining the relationships between varied spaces, as our collective survey on cultural capital cities aimed to do (C. Charle & D. Roche 2002, C. Charle 2009) or, more recently, through our overall interpretation of cultural evolutions in the European nineteenth century (C. Charle 2015).

Similarities therefore exist between mediators who work in cultural fields that reach similar audiences or that are produced by societies with the same level of cultural development: the best indicator lies in observing the speed of circulation of separate national cultures with homologous cultural productions. Examples include the relatively swift circulation of French theatrical plays since the eighteenth century in a certain number of European countries, and the Italian opera's dissemination in the rest of Europe in the eighteenth and nineteenth centuries. In these examples, a network of specific mediators stemmed from theatrical structures that had reached a similar stage of evolution in Western Europe (M. Grimberg 1998, C. Charle 2008 et 2013, R. Markovits 2014). Conversely, certain transfers in particular fields (such as some fields in human sciences that depend on discordant academic structures) have revealed themselves to be more difficult. They highlight the deep discrepancies of a given cultural field across various

countries and show how potential mediators are absent or marginal. These discrepancies are reflected in the absence of available mediators or in the fact that potential mediators may come up against guards that protect intellectual barriers and that dominate certain cultural sectors.

Of course, these broad statements can only be demonstrative when paired with tangible examples that serve to implement our double approach. I therefore aim to draw on a certain number of completed or ongoing studies to see how these different levels of analysis articulate.

My first example is taken from my current research on theatrical works exported between France and Germany in the first half of the nineteenth century. This field touches upon middlebrow culture as well as the highbrow culture of the time in a context where a relative lack of institutional organization was paired with strong ideological and political controlling forces. In my second example, I draw upon the works of intellectual history which studied how foreign authors were introduced to a limited audience in contexts of political freedom, but with a high institutionalization of the national fields of production. Finally, in my last example, I move away from cultural activities that depend on national languages and focus instead on painted artworks in the second half of the nineteenth century. In each of these case studies, the components weighing on the role, function and characteristics of the mediator are configured differently.

## Mediators and Mediations in Middlebrow Culture: The Example of Theatre between France and Germany in the Nineteenth Century

### Analysing the Figures

As I already recalled in my introduction, the importance of theatrical exchanges between France and the rest of Europe, and, interestingly, with German and Germanic countries, was an early phenomenon. These exchanges had been initiated by German princes and their court theatres, and continued with the arrival of adaptations and translations in bigger cities in permanent theatres – the latter of which had started appearing at the end of the eighteenth century. Such a massive importation of French plays did not translate into a similar movement the other way, despite the relative successes of a small number of German authors in specific literary contexts. The dissymmetry in these exchanges underlined a certain form of cultural domination, a specific lack of home-grown productions and a true and relatively stable taste for French productions among the most distinguished parts of the audience. But these abstract characteristics (which could be applied to many other fields related to the image of French cultural production abroad at the

time) only gain meaning when we examine the mediating agents involved in transfers and relationships. Here, I mostly take into account performed theatre rather than plays that were only published or translated in print. The latter plays fall within different circuits: either the cultured network of an established and old form of theatre which was not necessarily performed or appreciated by wider audiences, or the circuit wherein translated and adapted scripts were released alongside performed plays, thus confirming that the play had been popular enough to warrant the script's wider availability.

Solely examining performed theatre presents us with a disadvantage since the actual identities of the mediators were not always clear given the available documents: to save space, theatre programs did not always mention the names of all the people who had participated in the transfer of the text. The origin of the French text was also sometimes concealed, either because the true French author's name was not included or because the play's title had been modified. Such factors make the task of identifying the original work or comparing it more difficult. Taking into account the unreliable nature of these sources, our ongoing investigation centres on a certain number of established German theatres. It has allowed us to determine that the production originating from France, whether it was spoken or sung theatre, had established itself at a relatively high rate in the first part of the nineteenth century and only started to wane after the 1860s (see Table 1).

| | 1815-19 | 1820-24 | 1825-29 | 1830-34 | 1835-39 | 1840-44 | 1845-49 |
|---|---|---|---|---|---|---|---|
| Vienna[2] | 30 | 25 | 27 | 37 | 32 | 26 | 13 |
| Proportion of new works | 25.4% | 26.0% | 30% | 37% | 35.9% | 27.9% | 14.1% |
| Berlin[3] | 23 | 50 | 52 | 17 | 14 | 19 | 12 |
| Proportion of new works | 15.1% | 37.3% | 32.0% | 10.7% | 10.3% | 19.8% | 13.6% |
| Dresden[4] | 10 (1816-19) | 23 | 29 | 37 | 46 | 26 | 25 |
| Proportion of new works | 9% | 23% | 30.8% | 32.4% | 34.8% | 26.5% | 23.1% |
| Frankfurt[5] | 15 | 23 | 17 | 20 | 24 | ? | ? |
| Proportion of plays as a whole | 9.1% | 14% | 17,6% | 16,7% | 21.9% | 20% (1840-42) | ? |
| Hamburg | 1843-1868: N=380 out of 1625; m =14.6/year; 23.3% of the total of performed plays[6] | | | | | | |
| German Theatre of Prague | 1846-1862: 21% of the non-comical plays originated from France 1846-1862: 39.3% of sung theatre works originated from France[7] | | | | | | |

Table 1: Number of plays originating from France performed at the Burgtheater (Vienna), the Schauspielhaus (Berlin), the Hoftheater (Dresden), the Frankfurt/Main theatre, the Thalia theatre in Hamburg and the German theatre in Prague (1815-1862).

The quasi-simultaneous presence of successful French operas and plays in various cities (as well as in other cities, such as Karlsruhe, which aren't included here but for which we have partial evidence, cf. H. Schwarmaier 2010: 267-288) shows that a truly organized import/export circuit existed at the time and was based on mandatory steps, relatively stable intermediaries and largely shared benchmarks. Existing studies on the translation of French and English novels into German have highlighted similar characteristics, albeit with a separation between well-honed professional circuits for the more important novels and a multitude of random and dispersed initiatives for the rest of the production. In the latter case, amateur translators tried their luck as they awaited better prospects (N. Bachleitner 1989). In regards to musical and spoken theatre, the professionalization of the field seemed more advanced, according to the prosopographical indicators that are available. This does in fact appear logical since the theatres discussed were in constant need of new work, while the uncertainties of success, deficits and investments implied that the whole theatrical endeavour would need to be relaunched in the case of failure. These circuits were older and relied on the achievements of previous eras. French theatres had existed in certain German cities (and still existed in Berlin at the time under consideration), leading to the establishment, as early as the eighteenth century, of a network of new plays and a stream of actors and directors directly linked to the Parisian base.

German publications on cultural and theatrical life multiplied, and regular columns about new Parisian works emerged. The target audiences of court theatres as well as theatre professionals looking for scenarios, ideas or completed plays were interested in following Parisian theatrical news. Lastly, a fraction of Francophile intellectuals who were interested in what was happening in the Parisian art scene became politically repressed after 1815 and especially in 1819 (during the Carlsbad decrees). This led to the emergence of a proletariat of authors who were looking for resources and who, given their well-travelled lifestyles, were well suited to serve as cultural intermediaries between the two theatrical spaces.

## A Witness: Heinrich Börnstein

We are fortunate to have access to the memories of Heinrich Börnstein, one of these exiled intellectuals, a translator and engaged activist. He underlined the ways in which the factors – described above in an abstract and analytical way – truly unfolded:

> [...] à la fin de l'année 1842, j'avais commencé à adapter en allemand les meilleures nouveautés de la scène française et à les transmettre

aux théâtres allemands moi-même par l'intermédiaire du bureau d'affaires théâtrales de MM. Sturm & Koppe à Leipzig. [...] Non seulement j'arrangeais les pièces librement et avec précaution pour les adapter aux conditions sociales de l'Allemagne, mais, en outre, j'envoyais aussi à l'avance, avec chaque pièce, un éclaircissement sur la distribution, la mise en scène, les costumes, etc., j'indiquais pour chaque scène la position des acteurs et, quand c'était nécessaire, j'expédiais à la demande les figurines parisiennes costumées et les esquisses de décor. Aussi, naturellement, mes adaptations que je pouvais expédier huit à dix jours après la première représentation parisienne, passaient en priorité avant les autres et étaient accueillies favorablement par les directions des théâtres. J'ai adapté pendant ces sept années environ 50 pièces françaises, soit à peu près sept pièces par an, ce qui n'était certes pas une concurrence négligeable. Mais j'avais ainsi tapé dans un nid de guêpes et tout un tintamarre en résulta. Quelques traducteurs privilégiés jusqu'alors qui en prenaient à leur aise et étaient alors tirés de leur torpeur, plus les écrivains attachés aux théâtres qui virent aussitôt émerger une concurrence dangereuse pour eux, et enfin une meute de petits journalistes, qui toujours "braillant cherchaient qui ils pourraient bien mordre" élevèrent d'une seule voix de redoutables hurlements contre moi. (H. Börnstein 1881: 325-326)[8].

[...] at the end of 1842, I had started adapting into German the best new releases of the French stage and transmitting them myself to German theatres through the bureau of theatrical affairs of MM. Sturm & Koppe in Leipzig. [...]. Not only was I arranging the plays freely and with precaution in order to adapt them to Germany's social environment, but I also sent clarifications regarding the cast, the *mise en scène*, the costumes, etc. For each scene, I indicated the positions of the actors and, when needed, I sent out costumed Parisian figurines and sketches of the sets. Naturally, my adaptations, which I could deliver eight to ten days following the first Parisian performance – took precedence over other plays and were favourably viewed by theatre directors. During those seven years, I adapted an average of 50 French plays, approximately seven plays a year, which wasn't negligible competition. But I also stirred up a hornet's nest, resulting in an uproar. Various people all yelled mightily in unison against me: a few privileged translators who had become overly comfortable and who were thus roused from their torpor, writers who were linked to theatres and who were seeing the arrival of dangerous competition, and, finally, a pack of small-minded journalists, who were always "wailing and looking for whom to bite".

This text underlines the fact that an institutional circuit of importation existed in the heart of the German book world by way of the "bureau of theatrical affairs" in Leipzig. The latter city was a high place of publishing exchanges and the headquarters of the *Börsenverein*. The second point mentioned by Börnstein concerns the high demand for French plays, since the speed to adapt the plays was an appealing argument to encourage competition among theatres and authors. Our witness's Stakhanovism (7 plays translated in a year) is obviously linked to his need for money as an expatriate in France with no other resources to survive. But such productivity also implicitly alludes to the mediocre pay for each manuscript, since Börnstein wouldn't otherwise need to translate so intensively. Furthermore, when we attempt to reconstitute this translator's bibliography, we are unable to find as many titles as he claims. This either means that he exaggerated his rate of translations or that several submitted manuscripts weren't chosen or weren't printed. It could also mean that Börnstein did not always sign his translations or that his name was not mentioned on the cover due to his sulphurous political reputation. I painstakingly put together a list of his translations by crossing the data from the catalogues of several libraries, and I was only able to find approximately 15 of the 50 titles mentioned in his testimony.

Beyond Börnstein's colourful character, the most interesting part of this testimony on mediators resides in what is not explicitly said but merely suggested. Börnstein mentions in passing the "hornet's nest" of competitors and "privileged translators" bothered by his activity. This shows the extreme competition among mediators who all searched for French works that could interest large theatres. It was also very hard to entice patrons, as the latter wearied of investing in shows, either because they feared censorship authorities or because they worried about pleasing their audiences. Börnstein understood these challenges since he always included texts to clarify his translations in an effort to be understood beyond the French framework of Louis Philippe. He did not hesitate to anticipate requests for changes, taking into account the local situation of *Vormärz* Germany.

The second significant expression, "privileged translators", alludes to the ways in which large theatres – who imported many French plays – gave work to designated translators and adaptors. These writers wrote to order and occasionally spearheaded importations by incidentally producing their own plays, depending on the theatres' needs and selected programs. Adaptations consisted in filling voids of inspiration or bridging gaps when a programmed play had not been met with the anticipated success, as this often happened. Such a "privileged" circuit referred to an economy founded on an old cultural framework made up of personal and lasting relationships. Börnstein promoted the opposite system based on free market and free

competition, as he sent his translations to publishers and theatre directors spontaneously. Does this "spontaneous" sociology – established by one of the protagonists of the Franco-German theatrical world – conform with the form of reality that we can recreate based on the prosopography of a certain number of adaptors-translators?

## Towards a Prosopography of Mediators

Identifying translators and adaptors is not an easy task since authors were not mentioned in many translations. The names referenced in a fraction of translations were so generic (first names were not included) or commonplace (Schmidt, Meyer, etc.) that it proved impossible to find basic biographical facts attached to them. The prosopography attempted here suffers from this initial bias, since we can only make cultural and social observations based on the small minority of translators and adaptors who left traces in obituaries, biographies, autobiographies, or general and individual biographical dictionaries. Their presence in these biographical volumes was largely due to some of the other things they had done in their lifetimes, as translation was deemed to be a subaltern, anecdotal or unworthy activity. Such biases cannot be redressed, and yet they send out a much more positive image of reality, since our analysis can only be founded on the more famous and recognized translators or on those who became known for successes and social activities other than the lowly task of translation.

We can at least indirectly evaluate the bias linked to the effects of posterity: the number of names that were found but not identified represents at least the *double* of the number of known translators. If we add anonymous translations fictitiously, the adaptor-translators identifiable with a biography only represent less than a fourth of the potential population. Even the relative elite on which our analysis is based was far from being homogenous. Steady and nearly professional writers coexisted with translators of large productions, alongside others who had multiple parallel activities and for whom translation was an occasional way of making ends meet, or yet other people for whom translation was a functional need linked to other professional obligations, or even dilettantes for whom translation represented an elevated hobby linked to a specific passion for music, theatre or for a particular author.

Our sociology is bound to be coarse due to the fact that the notices all differ in their levels of precision, especially the nineteenth century German biographical dictionaries. These volumes did not lend much importance to this type of information, unless it related to the "well-born" or, conversely, to "social miracles" whose unlikely stories contrasted with the highly hierarchical society of the time. We did, however, notice two indicators

that signalled a high dispersion in the social profiles of German translator-adaptors. Firstly, women and men coexisted in our sample, which was a rare or unknown occurrence in the official world of letters in the first half of the nineteenth century. For once, in this instance, women weren't overly selected based on their social statuses, as was the case for female writers and artists of the time such as Mme de Staël, George Sand, Delphine Gay or in Germany, the first women of letters associated with the Romantics and the Feminists from 1848 and onwards. However, this phenomenon might be biased, since many anonymous translations – which we are not taking into account here – may have been composed by women whose work was not independently acknowledged.

Secondly, the non-negligible presence of people who were noble from birth or who were made noble for their role in society (at least four out of approximately forty notices) shows how close these adaptors were to the ruling class and to high positions of power. This reminds us of observations made on the group of high-level translators who introduced foreign literature in France in the nineteenth century (see B. Wilfert 2002). These noble adaptor-translators were often senior officials who worked in endorsed theatres and operas under royal or aristocratic patronage in the Germanic space. Such a phenomenon did not exist in France, as the French theatrical system was much more commercial than Germany's. In France, the aristocracy was not interested in theatre, apart from being the privileged audience of very particular institutions such as the Opéra or the Opéra italien. These institutions were not concerned with the issue of translation since works could only be sung in French and in Italian, and the proportion of German repertoire translated at the Opéra remained negligible until the 1870s[9].

The dispersion in the translators' profile is further accentuated by the chronological spread of the sample. The oldest translator, August von Kotzebue, was born in 1761 during the Enlightenment era. The youngest, Hiltl, was born in 1826 in the Germany of the Holy Alliance. Three relatively balanced generations sit between these two extremes: the generation born between 1760 and 1780, which was active at the end of the eighteenth century (15 known biographies), the generation born between 1781 and 1791, which came of age in Germany during troubled Napoleonic times and was subject to French hegemony, either adapting to it or rejecting it (10 known biographies). The third generation was born after 1792 (16 known biographies) and had to carve a place for itself in the literary world of Germany under Metternich's surveillance. Two of the three generations were therefore caught in the world of court theatre and in a European context in which French theatre dominated. Two forms of French theatre were in competition: on one hand, a general commodity form, and on the other, a more cultivated type of theatre that was not often performed. The third generation

of translators arose when German theatre affirmed itself in the face of an invasion of French plays. Translators participated in the national struggle: those who were closer to progressive and innovative schools of thought tended to choose more subversive French plays as opposed to consumerist French productions. In doing this, they hoped to liberate German theatre of its old-fashioned conventions. In the same way, the introduction of German and British plays in France served to support the French Romantics' subversion strategy against Parisian commercial *boulevard* theatre.

## Hypotheses

We shouldn't draw excessive conclusions concerning the unequal distribution of adaptor-translators according to their generation, since there was, as mentioned above, a high rate of non-answers. We can nevertheless hypothesize on two facts that may explain why there was a smaller number of translators in the last – and longer spanning – generation. Such a reduced number could be linked to the fact that these literary labourers tended to write anonymously more often, in a climate in which German repertoire translations were on the rise and in which the Carlsbad decrees imposed repressive measures on this generation of intellectuals. These negative conditions led to more anonymity and to the use of pseudonyms as a way to continue working to make a living and avoid prosecution. The other hypothesis, which is compatible with the first one, lies in the rise of cultural nationalism among this generation faced with an invasion of French plays. Some new authors partially rejected translation work for political reasons. They in fact attempted to protect their collective rights when they founded writers' associations in the 1840s. Other authors continued to translate as a way to survive but did so undercover so as not to be criticized for their lack of consistency between their overt anti-French discourse and their need to translate to make a living (see the previously cited case of Börnstein).

The meaning associated with a breakdown of translations into generations must also be put into perspective. The practice of translation was not uniformly reserved for young writers while older and more affluent writers no longer engaged in this type of work. Several cases show that translation was an activity for younger writers as they awaited better circumstances, but it also was a solution for older writers who had lost their standing in other sectors, such as actors or retired public servants with diminished resources. It could also represent a permanent parallel activity as a supplement to other more central endeavours. In a given time period, translators from older generations were competing with newcomers from younger generations. Older translators adhered to past writing practices and benefited from a standing that allowed them to maintain their activity

despite the evolutions of the theatre of the time, while younger translators waited for more promising opportunities, as the journalistic boom of 1848 was to demonstrate.

In order to cross and compare information, it is necessary to categorise translator-adaptors according to their main professional affiliations. However, it is also questionable to do so for reasons that are specific to the time period under consideration. On the one hand, as we have written previously, the general rule consisted in translators belonging to several sectors and exercising several activities in parallel. The status of the translator – as well as that of playwright and man of letters – was indeed problematic in the Germanic world, except for a small privileged minority close to power and to cultural institutions supported by the authorities[10]. It can therefore appear hazardous to discern which activity in the individual's career tended to better characterize him socially. On the other hand, the sources which are being used, as seen previously, had a tendency of favouring the known biographical elements which enhanced the person mentioned in the entry. Therefore, certain functions may have been amplified over others when, in reality, the actual main source of income may not have been the one most described in the individual's life story.

The German translator-adaptors of the sample bring to light the hidden and less impressive side of the persistent old cultural regime: the large mass of aspiring authors had to perform several parallel functions in more or less sustainable ways before they could be admitted into the circle of authors with privileges. This is why our population's logical centre of gravity was found in the world of theatre with 21 actors, stage managers, and directors out of 42 (half of the known cases). These professionals were followed by a group of more or less professional playwrights, authors and journalists (some were also probably public servants or worked in theatres as stage managers and directors) (N=11). Together, these two groups formed three thirds (32 out of 42) of the total sum of individuals. On the other side, ten privileged individuals from court society were either noble from birth (2 individuals), or had been ennobled due to their function (8 civil servants made noble through their duties). Although not all of them held the highest offices in the administrative hierarchy, they all enjoyed the security of an official treatment, which they completed with their original literary creations or, more often, with works of imitation. In so doing, they escaped the routine, gave way to their authentic vocations or even sought to conquer a more enviable position as adaptors or writers in their own name, with the aim of gaining notoriety on stage. Most of these translators did indeed practice both, either simultaneously or consecutively.

This basic analysis objectively confirms H. Börnstein's text, cited above. It also shows that rivalries did indeed exist among different mediation

networks and mediator profiles, even in the context of literary exchanges that mainly centred on commercial interests. The study, which I am unable to do here in detail, of the French mediators who introduced a few rare German works to the Parisian stage, shows how, in that case, the commercial circuit dominated the more literary and privileged network due to the Parisian theatre's high degree of autonomy. The literary circuit was confined to bookstores and rarely resulted in plays being actually performed. Two populations of translators/adaptors could be identified: the first ones had skills and links with Germany, as well as a good level of education. They prepared the work for the second group of dramatic writing professionals who adapted the first versions to conform to theatrical needs, to censorship, to the trends of the time, and to the type of theatre in which these works were to be performed. This ideal diagram mainly applied to the more famous authors. For other less considered playwrights, workers didn't need to appear in the credits and were recruited among pools of actors who had participated in German tours of plays and who had a minimum linguistic level, or among the many exiled German intellectuals, or even among a few members of high society who were of German origin and who had links with the world of theatre; they occasionally helped the real professionals, such as the Baron von Bilderbeck, former senior official who lived in Paris and cooperated with local playwrights.

## Mediators for Autonomous Symbolic Productions

This last example provides us with a transition to talk about the second type of mediators that prevail in exchange networks in which symbolic productions have a low economic exchange value but a high symbolic exchange value. Unlike the theatre and novels, which had large audiences and could hope for reasonable returns on translations and adaptations, most transnational intellectual exchanges, whether in print or in fleeting oral forms (conferences, classes, seminars) cost more than they earned, unless it related to mid- to long term gains or symbolic earnings. Mediators therefore had to have an interest in selflessness or had to aim for other types of profits. This therefore implied that the mediators were in some ways over-qualified (socially, intellectually, culturally, politically, etc.) and that there had to be an encounter with a coalition of lasting or conjectural interests for ideas, works of art and marginal intellectual movements to be introduced in a given culture. Intellectual and cultural history, through the flow of cultural transfers, has concentrated a lot on these types of often improbable importations and interactions in the last twenty years.

The over-selection of the people involved here contrasts with the heterogeneity and the fragility of the mediators described in the previous section.

This may explain why academics have paid closer attention to the works of elite mediators and figureheads, as the latter mediators secretly fit in with their own sets of characteristics. It is indeed much more gratifying to retrace the history of the great overseas innovations and cutting-edge personalities that crossed over several intellectual arenas than it is to reconstitute the improbable itineraries of literary workers and intellectual day-laborers in a mass market sector, as we did earlier.

When the cultural gap between two exchanging countries is wide, the field closes in on itself more sharply and larger gates prevent entry to the culture. Male and female mediators must therefore accumulate assets and converging strategies. In the case of transfers between particularly distant countries, Michel Espagne showed that an intermediary culture often stepped in to mitigate the cultural divide: Japanese mediators came between China and Europe (C. Charle, J. Schriewer & P. Wagner 2004, p. 294-295), German mediators have sometimes intervened between Russia and France (K. Dimitrieva & M. Espagne 1996). The mediators themselves are often endowed with a double culture thanks to their own biographies. Alsacian intellectuals, such as Charles Andler, Lucien Herr and Fernand Baldensperger come to mind. During the French Third Republic, they contributed to opening up French academic culture to the German university. In the first half of the nineteenth century, German Jewish intellectuals who had emigrated or were exiled in France also served as mediators. Yet others, such as Alexandre Kojève, also made lasting contributions. Hewas originally Russian, spoke French thanks to his family and studied the philosophy of Heidelberg in Germany (D. Auffret 1990, M. Espagne 1996). His seminar at the École Pratique des Hautes Études started in 1933 and attracted brilliant minds. There, Kojève provided a modern reinterpretation of Hegel, an author who had been misunderstood in France due to the philosophical dominance of Kantism and Cartesianism and because Hegel's work had been instrumentalised into becoming a popularized form of Marxism which bore little resemblance with the original thought.

Similarly, Frédérique Matonti's study (2009) on the Russian formalists in France in the 1960s – at the same time as the Structuralist movement's emergence – shows how highly skilled mediators operated at that time. They combined high positions in the intellectual and literary fields with specific abilities in philology, linguistics, and in certain areas of human sciences. However, despite these amassed assets, the rediscovery of challenging authors – who had been active during the interwar period and who were previously unknown in France – would not have taken place if the French context had not tended towards more cultural openness. New avant-gardes were emerging (with the magazines *Change* by J.-P. Faye, and *Tel Quel* by Philippe Sollers), a wider cultural press was developing, and,

finally, internal struggles within these publications and inside the French communist party were weakening the party's monopoly over relationships with Soviet intellectuals. While Matonti analyses mainly the ways in which the formalists were received in the specific context of the Parisian intellectual world, she also highlights the importance of the mediators' characteristics: Tzvetan Todorov was born in 1939 and published the volume *Théorie de la littérature* in which seven authors from the formalist movement were featured and translated (1965). He was of Bulgarian origin, spoke Russian and was born into a family of academics. He immigrated to France in 1963. Roman Jakobson (born in 1896), the writer of the preface, was more than 40 years Todorov's senior and also came from an intellectual bourgeois family. He was one of the surviving exiled members of the initial group; he obtained academic recognition in Prague and later in the United States, with a late translation in 1963 of his *Essais de linguistique générale* at the Éditions de Minuit. But neither authors would have been able to promote their writing beyond specialist circles if they hadn't gathered allies in the avant-garde groups of the time, such as Claude Lévi-Strauss, whom Jakobson met while he was in exile in New York (Loyer 2005 and 2015), Gérard Genette, whom Todorov met at the Sorbonne, and Roland Barthes who was the director of studies at the École Pratique des Hautes Études. The Russian authors also forged bonds with members of the literary avant-garde such as Marcellin Pleynet and Philippe Sollers, who were linked to the Éditions du Seuil as the directors of a collection and a magazine. These latter intellectuals sought academic guarantees for their theses which broke with the established literature. Linguistic skills (knowledge of Russian) and theoretical skills (linguistic and philological training) would not have sufficed to win over publishers, even those who were more innovative. The mediators cited above had to place these foreign texts back into the heart of the academic and literary world of the years 1964-1966 and in its very specific struggles. The older generation confronted itself with the moderns, structuralism had become a dividing line that crossed over various fields (Boschetti 2014, chapter 4) and the far edges of contemporary literature rejected the dominance of average realism and socialist realism. Aragon further broadened the reception of Soviet works to new audiences and introduced new and more political issues. He did this through his collection "littérature soviétique" (Soviet literature) at Gallimard, through his personal close ties with Jakobson, Elsa Triolet's childhood friend, and through his support of Sollers at the time. Given her own life path and her ties with her sister (Lili Brik), Elsa Triolet also associated with a part of the poetic Russian avant-garde and the 1920s formalists. Aragon gave a larger place to the publications of formalists in his own publication *Les Lettres françaises* and led an internal battle to ease the communist party's hold on intellectu-

al issues. Thanks to Aragon, who was the surviving member of a previous avant-garde movement (surrealism) and who had become a political and literary authority, the battle between the Russian avant-garde and the Soviet Union took place once again in France, but was a success this time. The aim was to liberate the French intellectual avant-garde from the remains of the intellectual Cold War of the 1950s embodied by the PCF's Jdanovism.

## Artistic Mediators

The examples developed so far referred to intellectual and literary realms and depended on vehicular languages, on publishing and media apparatuses and even on political issues. We could think that, in artistic sectors less tied to national languages, the problem of mediation and mediators applies in sensibly different ways, especially in the second half of the nineteenth century when new institutions and new figures were emerging. These new institutions and figures contested the monopolies held by the traditional institutions which controlled the fine arts (academies, fairs, commissions). We are aware of the former thesis of sociologists Cynthia and Harrison White, who spoke of the passage from an academic system to a merchant-critic system, thus implying a fundamental change in dominant artistic mediators (C. & H. White 1991 [1965]).

The academic system existed in most of Europe, but it was most rigorously and systematically applied in France, due to the heritage of the Ancien Régime, to its strict reestablishment by Napoleon and to the fact that the following regimes maintained such a system without making many changes to it (apart from the brief episode of the "Salon ouvert à tous" in 1848). According to the Whites, this system lapsed into crisis in the 1840s and 1850s because of its inability to tackle the increasing number of painters and works of art aiming to become known at the Salon de Paris. A contradiction did indeed emerge between a regulated system on one hand and the economic and sociological transformations at work in France on the other, with the expansion of liberalism, of the market economy (and the art market in particular), and the rise of individualism, which touched all cultural forms. We must note that, while the Napoleonic cultural order regulated the fine arts academic system, it also framed theatre until 1864, as well as bookstores (with the patenting system), the press and education. But, in these other fields, accommodations of this form of cultural Bonapartism had started much earlier Conservatism had a stronger hold in the fine arts due to the fact that rulers continued to view themselves as the protectors and inspirers of the arts by way of the public commissions system (the decoration of official buildings, churches). This phenomenon had almost no equivalent in other sectors, apart from a few subsidized

theatres (devoted to performing an older repertoire), the prizes academies gave to printed works (but which were of much lesser importance than the prizes and medals of the Salon for a successful artist's career). The disruption was much more brutal in the French artistic world than in the rest of Europe due to the fact that restrictions had been so strong and that painters and exhibits were so centralized in Paris. The diversification of the elites, commonly known as "the rise of the bourgeoisie", was a second sociological factor contributing to change. But "bourgeoisie" should be put in the plural form since it was comprised of financial, industrial, commercial, liberal, and professional groups. Many members of the bourgeoisie started collecting art by imitating aristocrats, but they had differing views. Academic art was an art of the pomp designed for the monarchy and for the higher echelons of aristocracy. With the social emancipation and enrichment of the bourgeoisie, new groups of people bought works of art which were more in line with their tastes and their lifestyles (small formats)[11]. A partially independent art market developed at that time while the official Salon was buried in artworks and no longer had enough prizes to designate the artistic elite. Merchants therefore attempted to circumvent the Salon's recognition depending on the requests they received from these new categories of art enthusiasts and buyers. The third element in the triangle of mediators – which also contributed to the collapse of the former system – consisted in the role of the press, which acted as a critical and polemical body, alternately defending and attacking certain painters and movements. Many journalists and writers spent much of their time criticizing the choices of the jury and defending mistreated painters. It became a way for them to be recognized as new intermediaries. They established dividing lines and shared their aesthetic and political readings of the new painting styles. They also claimed, in the name of public opinion, to be fulfilling a pedagogical role for an increasingly large and heterogeneous audience, as the latter no longer seemed able to navigate the art world due to the sheer amount of available artworks and to debates sparked by the official instances which were, in turn, more and more contested. Innovative painters and movements needed allies in the press to respond to the attacks of conservatives and of Salon juries. They also needed help to attract the eyes of merchants and art lovers. Authors who are still renowned today brilliantly served this function (Baudelaire, Gautier, Zola, Mirbeau, Huysmans, Mallarmé, plus tard Apollinaire), although the number of unknown critics was much larger. Most have been forgotten and were rarely on the side of the moderns. And yet, with the rise of the press, these writers and critics at least formed a sort of symbolic counter-power to the official symbolic power in place.

Although the Whites insist that these volatile factors formed the basis of the modern revolution, they omitted to cite three factors on which other

interpretation attempts have relied. The first factor is political: in liberal parliamentary-style regimes, the notion of an art form defined by the State no longer made as much sense as it did in a monarchical or Bonapartist system. The first crack in the system appeared as early as Napoleon III's reign which, while authoritarian, was in its more liberal phase. A few members of the imperial elite had already bought and supported work from painters who were clearly setting themselves apart from academic art. Traditional painters who taught high art at the École des Beaux-Arts and who were very active in juries were the only ones left to fully defend the entire system and its aesthetic principles. Due to its changing tastes, a large portion of the elite neglected the main academic genres well before the system failed.

The second factor was international: France, keen on being a modern country and the heart of the artistic world was increasingly open to foreign influences (free trade was adopted after 1860, foreign painters and art dealers entered the Salons). Painters who failed at being recognized in France could count on the international circulation of their works to escape the dictates of the Parisian academic scene as was demonstrated by Béatrice Joyeux-Prunel (2009 and 2015).

The third factor was media-related: the industrial image, the increased circulation of newspapers and magazines, caricature and photography... none of these things had existed when the academic system had been established. Little by little, these new media forms became elusive counter-powers and destroyed academism from the inside: jury decisions were mocked, exclusions were announced, certain painters were promoted, other works were caricatured, etc. Journalists and critics were recruited among very diverse pools of people, which exacerbated divergent points of view; being a critic could be a way of entering the literary world or it could be a reconversion in the case of personal failings in art or literature. The competition among newspapers and the precarious role of the critic led to an ever-mounting escalation in distinctions, thus leading to controversies, all in an attempt to talk about painters and to hear one's self being discussed (N. Mc William 1991).

By omitting to mention these factors, the White model failed to distinguish the various types of mediators who founded the merchant-critic system: art dealers had somewhat diverse statuses and strategies, as well-known biographies and more comprehensive studies have indicated (Gérôme and Goupil 2000, P. Fletcher & A. Helmreich 2011, F. de Maupeou, & L. Saint-Raymond 2013). The degree of loyalty between artists and art dealers varied greatly, depending on whether or not the merchant had an established reputation, if he had a rich, average, eclectic or special client base. It also depended on the artist's ability to find clients without his dealer, based on his social legacy or his negotiating qualities.

The same types of disparities or relationship imbalances occurred between painters and critics and depended on the media outlets in which favoured journalists wrote: the general or the specialized press, large circulation press or more confidential titles, etc. There too, tensions sometimes arose when artists fulfilled the rising expectations linked to the commentary of their own artwork. Painters who had the right training or who mastered the art of rhetoric started engaging directly in this task (the interview genre had started surging, painters wrote collective manifestos without involving avant-garde writers, theoretical brochures were published by the painters to accompany their exhibits, etc.).

Finally, the model offered by the American sociologists omitted to consider the increasing importance of mediators who could either lock or give access to international exchange networks or to institutions facilitating the exhibition of work outside one's country of origin. This included art dealers with branches abroad, artists and writers who travelled to other countries, and art enthusiasts who circulated between countries through their cosmopolitan and annuitant lifestyles and who protected certain artists. The end of the nineteenth century and the inter-war years are rife with such examples of mediators: Kahnweiler for the Cubists, the count Harry Kessler in Germany, rich heiresses living in Europe such as Peggy Guggenheim. These additional parameters render the initial sociology proposed by the White sociologists significantly more complex. The financial capital invested by various people to facilitate the circulation and promotion of artworks was always unequally assigned since symbolic capital also mattered, the characteristics of which were linked to the social assets and social handicaps of the mediators handling the relationships.

Since art history is filled with narratives of winners and successes, all of the processes, encounters and providential men and women who contributed to the birth and recognition of "geniuses" and movements have irremediably been placed under the labels of conversion, love at first sight, selfless love, as if to echo the beautiful love stories with happy endings. However, the critical history of feminist art has highlighted the large disparity in accolades between men and women, particularly among historical aesthetic avant-garde movements. This reminds us that the gender variable remained a major obstacle in the success of mediation processes when the protagonist was a woman, even when she made the same risky bets as her male counterpart in a given movement. But we must go further than the feminist reading since, within particular avant-garde groups, from the most renowned to the more obscure, a drastic selection also occurred among male artists, from being featured in initial lists to having one's paintings hanging on the walls of museums, which was the sure sign of entering in the final canon. Art history simply saw this selection process as being the

work of time or the work's ability to preserve its originality on the mid to long term, in other words, as having talent or being the work of genius.

This explanation has the merit of being simple, but it does not take into account how often modifications to reputations were made, even within the older canon. Such subsequent variations in the scale of prestige are not only related to subsequent audiences and critics' changing tastes and outlooks. Nor is it only linked to the game of references between historical avant-gardes. It must also take into account the extent to which a chain of mediators could be implemented, mediators capable of instructing the initial canonization and recognition processes through review. This recurring phenomenon shows how the first act of selection towards the recognition of artists aspiring to pictorial glory was profoundly social and institutional, beyond being aesthetic, even after the academic system had ended. As Pierre Bourdieu has reminded us in his course on Manet, the ability a painter such as Manet had to "hold on" in the face of initial incomprehension and sarcasm towards his work largely depended on the mediators' environment (family, friendships, relations). Thanks to the mediators' encouragements and appreciation, through their gestures of solidarity, a mistreated painter could persevere, he could continue believing in himself and searching for or coining new strategies to circumvent the initial roadblocks, which were more social than aesthetic or symbolic (P. Bourdieu 2013).

## Conclusion

We could evidently use a number of examples taken from other fields or delve deeper in the ones presented here. The examples developed in this contribution seem to confirm the theses which I had outlined in the introduction:

• More general lessons can be gleaned from a systematic comparison and critical overview of specific cases.
• The diverse range of intellectual activities resulted in differentiated forms of mediation and mediators. However, these different fields – while they are all similarly situated on the scale of cultures and audiences – followed homologous paths. What are the commonalities between the introduction of new Western practices in the Chinese world at the end of the nineteenth century and the rediscovery of forgotten avant-garde movements in human sciences and the literary avant-garde in the 1960s? Nothing, on the face of it, binds these two themes. And yet, the over-qualified profiles of the mediators and the coalitions of interests needed to implement the mediation process are ripe with obvious analogies.
• Finally, each case study, when viewed in hindsight, allows us to decipher

the lineaments of a general history of the mediation process. We can therefore replace in the greater scheme of cultural and intellectual history the various figures that were forgotten by canonical history but without which a social history of these fields would only highlight impoverished visions and apparent concordances, all the while dismissing the processes at work.

## Notes

1   I will start with ideas which I have previously explored in other publications and which I have been attempting to implement empirically in an ongoing collective project. This project, on literary circulation and translation between France and Germany, is conducted in the context of ANR-DFG research.
2   Tallies according to O. Rub (1913).
3   Tallies according to C. Schäffer & C. Hartmann (1886).
4   Tallies according to M. Fürstenau (1971 [1861-1862]).
5   Tallies according to B. Frank (1967).
6   Tallies according to A. Schönwald & H. Peist (1868).
7   Tallies according to M. B. Tautrmanovà (2012).
8   Regarding this controversy, see N. Bachleitner (2007: 27-47, p. 30-33 in particular).
9   4.5% between1814 and 1836, 3.4% from 1837 to 1848, 5.2% from 1849 to 1871, according to T. de Lajarte 1969 [1878] (C. Charle 2013).
10   The data provided by M. Grimberg on theatre translators offers striking parallels with previous generations (Grimberg 1998). The previously cited article by N. Bachleitner on the translations and translators of novels also confirms this analysis (Bachleitner 1989: 14).
11   Rise of portraits in the Salon, as well as genre paintings and landscapes, interest for foreign schools such as those from Holland, Spain and England, which were less impeded by the academic tradition, etc.

## References

Auffret, Dominique. 1990. *Alexandre Kojève. La philosophie, l'État, la fin de l'Histoire*. Paris: B. Grasset, 1990.

Bachleitner, Norbert. 1989. "Übersetzungsfabriken. Das deutsche Übersetzungswesen in der ersten Hälfte des 19. Jahrhunderts". *Internationales Archiv für Sozialgeschichte der Literatur* 14, 1-49.

—. 2007. "Heinrich Börnstein als Übersetzer und Vermittler französischer Lustspiele". Bernd Kortländer & Hans T. Siepe (Hrsg.). *Forum Vormärz Forschung, Jahrbuch* 13 (2007). Bielefeld: Aisthesis Verlag,. 27-47.

Börnstein, Heinrich. 1881. *Fünfundsiebzig Jahre in der Alten und Neuen Welt, Memoiren eines Unbedeutenden*. Leipzig: Verlag Otto Wigand, 1881.

Boschetti, Anna. 2014. *Ismes. Du réalisme au postmodernisme*. Paris: CNRS éditions

Bourdieu, Pierre. 2013. *Manet, une révolution symbolique*, coédité par P. Casanova, P. Champagne C. Charle & F. Poupeau. Paris: Le Seuil.

Charle, Christophe. 2008. *Théâtres en capitales, naissance de la société du spectacle à Paris, Berlin, Londres et Vienne, 1860-1914*. Paris: Albin Michel.

—. 2013. "La circulation des opéras en Europe au XIXe siècle". *Relations internationales* n° 155, 11-31.

—. 2015. *La dérégulation culturelle. Essai d'histoire des cultures en Europe au XIXe siècle*. Paris: PUF.

—, Jürgen Schriewer & Peter Wagner, eds. 2004. *Transnational Intellectual Networks. Forms of Academic Knowledge and the Search for Cultural Identities*, Frankfurt/Main: Campus Verlag.

—, Hans-Jürgen Lüsebrink & York Gothart Mix, eds. 2017. *Traductions, Transferts Culturels et instances de médiations. La transculturalité des espaces nationaux en Europe (XVIIIe-XIXe siècle)*. Göttingen: Vandenhoeck et Ruprecht.

Dmitrieva, Katia & Michel Espagne, eds. 1996. *Transferts culturels triangulaires France-Allemagne-Russie*. Paris: Éd. de la Maison des sciences de l'Homme.

Espagne, Michel. 1996. *Les juifs allemands de Paris à l'époque de Heine, la translation ashkénaze*. Paris: PUF.

Fletcher, Pamela and Anne Helmreich, eds. 2011. *The Rise of modern Art Market in London 1850-1939*. Manchester: Manchester U.P.

— and Anne Helmreich, eds. 2000. *Gérôme et Goupil, Art et entreprise* Paris, RMN, Bordeaux, Musée Goupil, New York et Pittsburgh, Frick Art and Historical Center, Danesh Museum.

Frank, Bernhard. 1967. *Die erste Frankfurter Theater AG (1792-1842) in ihrer Entwicklung von der "Nationalbühne" zur "Frankfurter Volksbühne"*. Frankfurt am Main: Verlag Waldemar Kramer.

Fürstenau, Moritz. 1971. *Zur Geschichte der Musik und des Theaters am Hofe zu Dresden*, Reprograf. Nachdr. der Ausg. Dresden 1861-1862. Hildesheim [u.a.]: Olms.

*Gérôme & Goupil. Art et Entreprise* (cat. exp.). 2000. Bordeaux: RMN/musée Goupil.

Grimberg, Michel. 1998. *Die Rezeption der französischen Komödie. Ein Korpus von Übersetzervorreden (1694-1802)*. Bern: Peter Lang.

Joyeux-Prunel, Béatrice. 2009. *Nul n'est prophète en son pays? L'internationalisation de la peinture des avant-gardes parisiennes (1855-1914)*. Paris: Éditions du musée d'Orsay, Nicolas Chaudun.

–. 2015. *Les avant-gardes artistiques 1848-1918, une histoire transnationale*. Paris: Gallimard, Folio.

Loyer, Emmanuelle. 2005. *Paris à New York, Intellectuels et artistes français en exil 1940-1947*. Paris: Grasset.

—. 2015. *Lévi-Strauss*. Paris: Flammarion.

Markovits, Rahul. 2014. *Civiliser l'Europe, politiques du théâtre français au XVIIIe siècle*. Paris: Fayard.

Matonti, Frédérique. 2009. "L'anneau de Moebius. La réception en France des Formalistes russes". *Actes de la recherche en sciences sociales* 176-177, 52-67.

Maupeou, Félicie de & Léa Saint-Raymond. 2013. "Les 'marchands de tableaux' dans le Bottin du commerce: une approche globale du marché de l'art à Paris entre 1815 et 1955". *Artl@s Bulletin* 2 (2013). On line at http://artlas.ens.fr.

Mc William, Neil. 1991. "Opinions professionnelles, critique d'art et économie de la culture sous la Monarchie de Juillet". *Romantisme* 71, 19-30.

Rub, Otto. 1913. *Das Burgtheater, statistischer Rückblick auf die Tätigkeit und die Personalverhältnisse während der Zeit vom 8. April 1776 bis 1. Januar 1913.* Wien: P. Knepler.

Schäffer, C. & C. Hartmann. 1886. *Die königlichen Theater in Berlin, statistischer Rückblick auf die künstlerische Thätigkeit und die Personal-Verhältnisse während des Zeitraums vom 5. December 1786 bis 31. December 1885.* Berlin: Berliner Verlagscomptoir.

Schönwald, Alfred & Hermann Peist. 1868. *Geschichte des Thalia-Theaters in Hamburg von seiner Gründung bis zum 25 jährigen Jubiläum desselben (1843-1868).* Hamburg: Gebrüder Schönwald Buchhandlung.

Schwarmaier, Hansmartin. 2010. "Hof und Theater in Karlsruhe: ein Überblick". Achim Aurnhammer, Wilhelm Kühlmann, Hansgeorg Schmidt Bergmann (Hrsg.). *Von der Spätaufklärung zur Badischen Revolution Literarisches Leben in Baden zwischen 1800 und 1850.* Freiburg, Berlin, Wien: Rombach Druck- und Verlagshaus, 267-288.

Tautrmanovà, Markéta Bartos. 2012. *Eine Arena deutsch-tschechischer Kultur, Das Prager Ständetheater 1846-1862.* Berlin: Lit.

Todorov, Tzvetan. 1965. *Théorie de la littérature. Textes des formalistes russes*, réunis, présentés et traduits par Tzvetan Todorov. Paris: Le Seuil.

White, Cynthia & Harrison. 1991 [1965]. *La carrière des peintres au XIXᵉ siècle.* Paris: Flammarion.

Wilfert, Blaise. 2002. "Cosmopolis ou l'homme invisible. Les importateurs de littérature étrangère en France, 1880-1914". *Actes de la recherche en sciences sociales* 144, 33-46.

# Mediating Through Translation: Irish Cultural Nationalism and European Importations

ANNE O'CONNOR (UNIVERSITY OF GALWAY)

## Abstract

This chapter looks at Irish translators who published in the Nation newspaper during the nineteenth century and examines how these translators mediated between cultures and acted as conduits for the spread of influential ideologies. It considers clusters of translators and analyses the translations of major European writers by Irish translators such as James Clarence Mangan, Charles Meehan, Denis Florence MacCarthy and Lady Wilde. Particular attention is paid to members of Young Ireland, their relatives and associates who were active in translation (e.g. John O'Hagan, Susan Gavan Duffy, Michael Joseph Barry). The contribution questions if translation of European literature was framed by a nationalistic agenda and it also examines the impact of translation on emergent nationalism. The active participation of important figures of Irish cultural nationalism in translation has never been examined in a cohesive manner and this paper shows the value of examining this cohort as a group, highlighting the light it can shed on cultural activity in this period and in particular, the European influences on native trends. The chapter uses translation history to widen our understanding of cultural exchange in this period and creates new perspectives on historical, political and cultural debates of the era. With a few notable exceptions (O'Neill 1985, Cronin 1996, Milan 2012), studies of translation in Ireland have largely been restricted to transfers between Irish and English (e.g. Welch 1988 and Tymoczko 1999). The chapter builds on this work in order to examine the ideas, forms and motifs that translators were importing from Europe and circulating, and how these influenced and challenged native trends and traditions.

Translation is not always an immediately obvious element of cultural nationalism: the former is defined by translingual links while the latter can often be informed by national distinctness and separateness. Nonetheless in the mid-nineteenth century the two elements combined to powerful ef-

fect as this case study of Irish cultural nationalism demonstrates. In this period translation functioned as an important mediating factor in cultural nationalism and inspired developments in Irish nationalist ideology. With a few notable exceptions (O'Neill 1985; Cronin 1996; Milan 2013) studies of translation in Ireland have largely been restricted to transfers between Irish and English (Tymoczko 1999; Welch 1988). However, the strong presence of translation from European sources in mid nineteenth-century Ireland underlines the importance of examining how Irish cultural mediators imported ideas, forms and motifs from Europe which in turn influenced and challenged native trends and traditions. The remarkable prevalence of these translations in the Irish nationalistic press serves as a pointed reminder of the international nature of nationalism in this period. It also demonstrates the desire of Irish cultural nationalists not merely to infuse locals with patriotic fervour but also to select, package and mediate European knowledge which would further Ireland's nationalist cause.

## Young Ireland and the *Nation* newspaper

Irish cultural nationalism in the 1840s and 1850s was largely driven by a group of people termed the Young Irelanders and their publication the *Nation* newspaper. These nationalists are known to history as political agitators and nationalists, and yet many high-profile Young Irelanders were also translators whose cultural mediations shaped the development of Irish nationalism in this period. Thomas Davis, Jane 'Speranza' Wilde, Mary 'Eva' Kelly, Denis Florence McCarthy, James Clarence Mangan amongst others, all translated European texts in the mid-nineteenth century for an Irish audience and acted as conduits for the spread of influential ideologies. The presence of a variety of people publishing translations in the *Nation* points to a cluster of activity and the translations can thus be analysed as a wider cultural phenomenon rather than merely the individual preferences and interests of a sole translator. Of course the *Nation* was not the only outlet for such activities but it was an important one which brought together a group of cultural activists whose mediating roles were impacted by their interactions and network. As Tymoczko has observed,

> political effectiveness is most likely if there is a group of translators acting in concert and if the translators as a group operate within the context of larger cultural and political movement, which might include the production of other textual forms, as well as diverse forms of activism and direct community organization. (Tymoczko 2000, 41)

The clustering of translation activity by Young Irelanders around the *Nation* paper warrants particular attention for the manner in which it facilitated the importation of European ideas and recycled them in an Irish context.

As the title would suggest, the *Nation* newspaper was fuelled by notions of patriotism, nationality and distinctiveness. Founded in 1842 by Thomas Davis, Charles Gavan Duffy and John Blake Dillon, the readership of the paper, even from its early years of circulation has been estimated at about 250,000. The paper had an immediate impact and greatly outnumbered other Irish publications in circulation and sales. (Andrews 2014) It was also available in reading rooms throughout Ireland where it could be shared and read aloud, thus widening its dissemination and reach. (Ó Ciosáin 1997, 185; Higgins 2011, 267) The prospectus of the paper (written by Thomas Davis) stated that:

> The necessities of the country seem to demand a Journal able to aid and organise the new movements going on amongst us – to make their growth deeper, and their fruit 'more racy of the soil' – and, above all, to direct the popular mind and the sympathies of educated men of all parties to the great end of nationality. (Duffy 1973 (1881), 80)

The goals of the paper were inclusive and encompassed a non-sectarian notion of nationality – it became a central voice for the articulation of Irish nationalism in this period and was a channel for the dissemination of cultural nationalism throughout the country. The decision of a paper whose focus was to enhance Irish nationality, to include many translations from European sources is explained by one of the co-founders John Blake Dillon in the second edition of the paper 22 October 1842:

> The literature of the continent has been hitherto a sealed book to the Irish public. The sayings and doings of the people on the other side of the English Channel are as completely unknown to us as to the inhabitants of New Zealand. Some of the greatest works that have ever seen the light have, within the last few years, been published in Germany and France; and we are utterly ignorant, not only of their contents but of their very names. There are many reasons why we should regret this ignorance of foreign literature. It may be stated as a general truth, that the more intimately acquainted the people of any country are with the sentiments, the actions, and the condition of their neighbours – the more aspiring, the more liberal and the more intolerant of oppression, that people will be.

Dillon frames ignorance of foreign literature as a hindrance for an aspiring and liberal people and he also frames this ignorance as a result of British rule in Ireland. He then proceeds to explain that the *Nation* will introduce continental literature to the readers (at some trouble and expense) for the amusement and instruction of the public. The act of accessing and reading translated literature from the continent was thus conceived as an act of rebellion against English hegemony which had restricted the flow of know-ledge to Ireland and caused ignorance amongst the Irish population. The translations, particularly from German and French were considered to be a counterbalance to the ideology emanating from England and were chosen with a very specific didactic and social aim in mind. Rejecting a translation entitled "The girl I love" by M.J.N in 1845, the editor of the paper stated that it would only publish translations if they exhibited some 'characteristic aspect of national mind worth noting for warning or encouragement.' (*Nation*, 15 March 1845) Translations were not published as literary works to be enjoyed, rather the translations were ideologically motivated and politi-cally engaged; they were the work of deliberate transfer by the mediators.

A striking example of this politically-engaged translation activity is the presence of many nationalist poems from other European languages pu-blished in the newspaper in the 1840s. These translations were intended to inspire and rouse the Irish people and generate a national community which could then produce similar works. The ideological potentialities offered by translation in the Irish context identified by Tymoczko (2000) were certainly harnessed in the nineteenth century. Translating in an engaged and ideologi-cally-charged nationalist atmosphere, translation and literature had a distinct purpose in the *Nation* as is captured in this editorial comment:

> It is really too provoking that people will continue to "bother" us with elegiae and sentimental nonsense, which they call poetry. We suspect they are labouring under a delusion that we must remove. Be it known then, that we write and publish national ballads to revive historical recollections, which it is material to the honour of our peo-ple to keep fresh in their memory; that we furnish political songs to stimulate flagging zeal, or create it where it does not exist; and that we translate the poetry of other countries to familiarise our country-men with foreign literature, a knowledge of which is always an evi-dence of, as well as an agent of, civilisation. (*Nation*, 11 March 1843)

The three elements identified here as benefits of ballads and poetry are revival, encouragement and the spread of knowledge. The translators who published translated verse in the *Nation* aimed to stimulate and inspire with their work and in so doing mould emerging and developing concepts

of nationality and culture. A civic ideology underpinned their choice, and the importance of the functionality and utility of the translations in an Irish context is captured in Thomas Davis' discussion of the necessity for importing knowledge from Europe into Ireland:

> We want the Irish who go abroad to bring something back besides the weary tale of the Louvre and Munich, and the cliffs of the Rhine, and the soft airs of Italy. (...) We want our friends to carry a purpose for Ireland in their hearts, to study other lands wisely, and to bring back all knowledge for the sustenance and decoration of their dear home. (Davis 1914 (1844), 209)

Importation from Europe therefore formed part of a progamme of knowledge acquisition for local purposes and Davis looked to Europe as a means of improving Ireland.[1] This ideology transferred to the *Nation* where translations were valued for their utility at a local level; for Davis, European countries offered the possibility of seeing agricultural, educational, industrial and cultural examples which could be imported into Ireland. Therefore in the *Nation* we see the publication of translations of extracts from Sismondi's *Constitutions des Peuples Libres* (2 September 1843) and at the start of the potato famine in 1845, the paper published a "Report of the Commission of Agriculture of the Province of Groningen on the disease affecting the potato in the Netherlands" (25 October 1845).

From a very early stage the paper put forward the view that ignorance prostrated Ireland before England and therefore the country must help itself through education. The diffusion of knowledge through the *Nation* was therefore part of its core educational crusade, and translation was one means of achieving this aim. The editors of the *Nation* hoped that their publication would add to the national wellbeing through the acquisition of knowledge; as Thomas Davis put it:

> if Ireland had all the elements of a nation, she might, and surely would, at once assume the forms of one, and proclaim her independence. Wherein does she now differ from Prussia? Why can Prussia wave her flag among the proudest in Europe, while Ireland is a farm? The difference is in knowledge. (Quoted in Stöter 1998, 177)

The notion that Ireland was lacking in knowledge was an important aspect of the Young Ireland ideology and informed the translation enterprise: a lacuna was deemed to exist in Irish material and so it was necessary to fill this gap from outside sources through translation. John Blake Dillon summed up this scenario in stark terms:

(...) it should be recollected that we have no literature of our own
– none, at least, to which we have access. Foreign literature or no
literature, for some time at least we must have; it is the alternative
which the policy or the barbarity of England has left us. (*Nation*, 22
October 1842)

This pessimistic appraisal of the state of Irish letters reflected the loss of
access to Irish language texts as a result of the shift from a predominantly
Irish to a predominantly English-speaking population in nineteenth-cen-
tury Ireland. Furthermore, it reflected the depressed state of Irish publis-
hing following the Act of Union with Britain in 1800. The latter situation
only began to improve in the 1840s and 1850s and in the interim, texts
which reflected the Irish cultural milieu rather than British culture could be
imported through translation. The pursuit of knowledge which informed
much of Young Ireland's social cultural agenda in this period was therefore
sustained and fanned by importations through translation.

## Translation in the Nation

Figure 1. Verse translations published in the *Nation*, 1842-1849

From an analysis of translations published in the *Nation* in the 1840s and
1850s, some clear trends emerge. The first is the continuous presence of
translation work in the paper from its foundation in 1842, peaking in the
years just preceding the 1848 rebellions.[2] From 1848 translations represent

a smaller but nonetheless steady presence in the paper. Figure 2 documents the language preferences of Irish translators in the *Nation* between 1842 and 1849. In the 1840s 36% of the translations were from German; 31% from French, 18% were from Irish; 9% were from Italian; 2% were from Latin and 4% from other languages. Translations from the German language were popular in Ireland in this period for a variety of reasons – the high profile of German romanticism; the interest of the Young Irelanders in German literature, particularly philosophy and poetry, and emerging Prussian nationalism all served to fuel interest (O'Neill 1985). French translations were also popular due to the widespread study of the French language in Ireland, to emerging literary and historical trends in France and to the easy access to such texts. (Maher and Neville 2004; Milan 2013) French historians such as Thierry and Michelet were a source of inspiration to the Young Irelanders such as Thomas Davis, and key figures in the Young Ireland movement were influenced by prevailing European ideologies. German and French continued to be the dominant European languages for translations from European languages in Ireland throughout the nineteenth century and represent a constant stream of importations and mediations.

Figure 2. Source Language of Translations published in the *Nation* 1842-1849

It is important to observe that translations from European languages were published side-by-side with translations from Irish in the paper. Irish language translations were a continuous presence at this time and testify to the belief in the importance of the Irish language held by many Young Irelanders. Thomas Davis for example said that "a people without a language of its own is only half a nation". (Davis 1914 (1843), 98) Although they were publishing in English, the desire to access and circulate native lan-

guage verse was an important tenet of their approach. To this end the *Nation* published Irish poetry in translation in English as a means of demonstrating the significance of the local tradition. Placed side by side with European examples, the Irish poetry fulfilled similar didactic and patriotic functions and indeed some translators such as James Clarence Mangan translated both European and Irish language texts in the paper. The native and the European translation were not seen in any manner to be in competition with each other and in fact, as was repeatedly stated by the editors, it was hoped that the European trends would inspire emulation in an Irish context.

## Poetry and Song in Translation

An examination of translations in the *Nation,* reveals a marked preference for poetry and song in the publication: the huge majority of the published translations are in verse – taking the form of poems, songs and ballads. To understand this choice, we must turn to the words of the editors of the paper who said:

> Into the current poetry of Europe, mere English readers can have small insight. Translations are commonly made from authors of long standing; while of the active, present mind of their contemporaries they are left ignorant. To some small extent we may be able to reme-dy this omission in *The Nation*; and to that end we purpose giving, from time to time, a few specimens of the modern poetry of Euro-pean nations. They will be selected, as far as possible, so as to reflect the public mind of each country, which is always to be gathered in some shape from its popular poetry. (*Nation*, 23 November 1844)

The editors of the *Nation* clearly subscribed to the notion that poetry could reflect the public mind and that it would help understand a people. When replying to a correspondent to the paper on 11 February 1843, the editor agrees that Irish versions of the popular songs published in *The Nation* should be provided and circulated by thousands in the provinces. This is because, he says, music and poetry are the best possible popular agitators. He then says that they will publish Gaelic versions of some patriotic songs for the use of the millions, thus demonstrating the ambition and intended impact of the verse translations published in the paper. In fact, it would be another decade before Irish translations achieved a position of dominance in the paper and at this stage, it was translations from Irish into English which were popular, rather than translations into Irish.

The publication of poetry and ballads formed an important part of the *Nation's* success and this is clearly seen in the related publication of antho-

logies such as *The Spirit of the Nation* and the *Library of Ireland* by James Duffy, friend and collaborator of the Young Irelanders. The overwhelming success of these anthologies and their multiple editions and publication in cheap and accessible editions, brought poetry, ballads and verse to the people, all tinged with a political message. (Higgins 2011, 271; MacCarthy 2012)[3] Cronin has noted that in the period leading up to the Year of Revolutions, verse became a standard part of the arsenal of nationalist dissent. (Cronin, 2013, 30) The publication of translations of this European verse in the *Nation* points to the easy transfer of the verse between countries, despite the seemingly paradoxical national uniqueness proclaimed in such works. The sentiments circulating in Europe at this time were so similar that is was possible for cultural mediators to translate and disseminate verse from France, Italy and Germany with a distinctly Irish national impact in mind. As has been clearly documented by scholars such as Joep Leerssen, European nationalism in this period must be viewed as an interlinked phenomenon, with interlocking networks based on human and print contacts. Mediating through translation across Europe was an important element of this engaged exchange. Leerssen has also pointed out that in cultural consciousness raising, all nations in Europe are each other's immediate neighbours and therefore open to dense patterns of mutual influence and exchange. (2006, 2011) The Irish translations of patriotic verse for a nationalist paper were part of the transnational dynamic of ideas and cultures, and also part of the contagion of ideas that has been identified by nationalist scholars in this period. With increased modes of communication and travel in the nineteenth century, Ireland was open to the "swirl of cross-border intellectual traffic" prevalent in Europe in this period. (Leerssen 2006) Therefore the European pandemic of mutual contact and inspiration influenced Irish cultural nationalism and travelled through translations into Irish publications before being internalised and transformed.

Inspired by these European currents, the Irish nationalists of the *Nation* looked to poetry, songs and ballads as vehicles for the transmission of political ideologies. The impact and reception of Thomas Moore's *Melodies* in Ireland and abroad gave them a clear example of how verse could be embraced by an enthusiastic populace and how it could travel to different countries in Europe. The paper reported on the success of Moore both in Ireland and further afield:

> [Moore's *Melodies*] are no longer as they were, popular only in the drawing rooms of Europe and America, they are gradually becoming known to the middle classes in Ireland, and the Irish translation bids fair to reach the mind of our peasantry. It may be fault or excellence in them; but Moore's songs bear translation. They not only have ap-

peared in every European language, but they supplied the Poles with three most popular revolutionary and national songs during the last war (*Nation,* 29 October 1842)

The cultural mediators publishing in the Nation were aware of how literature moved through Europe and they wanted to participate in this movement of ideas and forms. The diffusion through translation allowed for a flow of tropes, ideas and forms from Europe to the corners of Ireland. What was happening to Moore's *Melodies* in translation was replicated for European literature in the *Nation* in order to enhance the supply of the most popular revolutionary and national songs.

## Translation choices

The Irish mediators took from the European literary and political currents the elements that were most suited to the Irish situation and then proposed them internally, translating many texts for circulation and diffusion. The attraction of Irish nationalists to European writers such Filicaia, Herwegh, Béranger and Lamartine attests to an international nationalism and a spread of nationalist ideology across borders. Leerssen has coined the phrase "viral nationalism", a concept which neatly captures the speed, spread and diffusion of trends and tropes across Europe in this period. (Leerssen 2011) The viral diffusion of nationalism through translation can be seen in the choice of text for translation and circulation in Ireland by Irish cultural nationalists. For example, the patriotic outpourings of Georg Herwegh seemed to particularly chime with Irish sentimentalities in the early years of the *Nation:* James Clarence Mangan published a translation of "Der Freiheit Eine Gasse" on 23 November 1844 and the nationalistic tropes and revolutionary imagery which feature largely in this form of poetry are skilfully rendered into English by the Irish translator:

> *A Lane for Freedom*
> 'My suffering country SHALL be freed,
> And shine with tenfold glory!'
> So spake the gallant Winkelreid,
> Renowned in German story,
> 'No tyrant, even of kingly grade,
> Shall cross or darken my way'
> Out flashed his blade, and so he made
> For Freedom's course a highway.
> (...)
> Yes! Up! And let your weapons be

Sharp steel and self-reliance!
Why waste your burning energy
In void and vain defiance,
And phrases fierce but fugitive?
'Tis deeds, not words, that *I* weigh-
Your swords and guns alone can give
To Freedom's course a highway!

The original by the German revolutionary poet had only been published in 1841 and the translation in the *Nation* shows the relative speed of dissemination and the influence of the poet in Europe at this time; the poetry was very much of the moment. Further poetry by Herwegh was translated by other contributors to the *Nation* in the following years demonstrating the concerted effort by a group of translators to promote and publish the German's poetry.[4] These nationalistic effusions of a German contemporary were rendered into English for circulation and inspiration in Ireland and the interconnectedness between patriotic and revolutionary poets and translations can be seen in the circular movement of the verse throughout Europe. For example, Alphonse de Lamartine was regularly translated into English by Irish poets and the Frenchman even came to visit the *Nation* newspaper which allegedly inspired the foundation of his own paper *La Patrie*. (Andrews 2014, 58) Lamartine's poetry was translated into German by Georg Herwegh and Herwegh's poetry was translated in Ireland. Thus political poems expressing German nationalistic aspirations could be appropriated and domesticated for Irish circumstances, just as Lamartine could be influential in Germany. In the years immediately preceding the revolutions of 1848 (in which all of the figures mentioned above were involved) there was an affinity and closeness of patriotic sentiment in Europe which was facilitated by translations and the activities of key cultural mediators. These entangled histories in the nineteenth century were able to surmount language barriers through the medium of translation and active cultural mediators.

There were many European figures who appear in translation in the *Nation*, James Clarence Mangan translated "Our Fatherland" by E.M. Arndt (28 December 1844) and "Freedom and Right" by Ferdinand Freiligrath (4 April 1846); Speranza Wilde translated "The past" by Frederick Rückert (3 June 1848), and "Reveille" (25 April 1846) and "Our Fatherland" (21 November 1846) also by Herwegh. Speranza Wilde's translation choices for the *Nation* show a distinct preference for European poetry informed by patriotic and political sentiments. (Cronin 2013, 30; Howes 1998) These translations and the promulgation of a nationalist cultural ideology was very much of the time and reflected the frenzied pre-1848 belief in imminent change. The

choice of translated texts was determined by local needs and the political ideology of those associated with the *Nation*. When we examine some of these choices, the preference for the politicised writer over what might be termed 'beautiful and fashionable' literature, is striking. For example, along with the preponderance of German revolutionary poets, there is also a remarkable interest in the now relatively obscure French poet Béranger who, according to Milan, provided a "decisive model of political resistance and cultural national representation". (Milan 2014, 81)

The Italian case is also quite striking – famous contemporary figures such as Alessandro Manzoni and Giacomo Leopardi are ignored (even though they could have offered some politicised writing) instead the rather obscure figure of Vincenzo di Filicaia is published in the *Nation*. This poet would not be the first to spring to mind as a major European influence but his eighteenth-century sonnet to Italy seems to have struck a chord in Ireland and attracted the interest of Irish nationalists. It was translated and published in the *Nation* on 29 April 1843 with the title "To Prostrate Italy" but in order to further the transfer process initiated through translation, it was decided to place the words "read Ireland" in parenthesis after Italy. The suggestion from this intervention is that Ireland and Italy could be used interchangeably in this poetry, thus illustrating the perceived transferability of national sentiments. The overt national sentiments in this poem spoke well to Irish sensibilities and it was felt to translate smoothly into an Irish context. Thus when Filicaia mourns the fate of Italy, it was deemed to be equally applicable to Ireland:

> The fatal light of beauty bright with fell attraction shone,
> Fatal to thee, for tyrants be the lovers thou hast won!
> That forehead fair is doom'd to wear its shame's degrading proof,
> And slavery's print in damning tint stamp'd by a despot's hoof! (*Nation*, 29 April 1843)

Indeed, the paper had previously noted that "Filicaja's divine hymn to Italy was circulated through the press here with the proper names altered, and passed as the wailing of an Irish bard" (*Nation* 25 February 1843). The affinity was deemed to be so close that the two countries were interchangeable, a point which was emphasised only a few days later:

> The beauty and the blight of Ireland are so accurately pictured here that, even had we not been so fortunate as to procure the direct evidence given above, the reader would naturally and justly conclude that Filicaia had used the Irish prophecy of Laurence O'Toole. (*Nation*, 29 April 1843)

The poetic tropes expressed in the poem of the downtrodden country, under the hoof of tyrants, suffering because of its fatal gift of beauty proved popular in Ireland, and Filicaia's imagery was transported it to an Irish realm in the hope of cross-fertilisation and inspiration.

The nationalist mediators in Ireland were not the exclusive translators of many of the poets mentioned above. Béranger and Filicaia, for example, were also translated by unionist writers and were published in the *Dublin University Magazine*, a unionist periodical. In the unionist context, however, the translations were devoid of the revolutionary and patriotic undertones which so appealed to Irish nationalism. The framing of these authors in nationalist terms as seen for example in Filicaia's sonnet in the *Nation*, transformed the Italian author into an unlikely champion of Irish nationalism. Paratextual presentations and choice of text were crucial in driving home the nationalist message and in this context, it is interesting to observe that although the *Dublin University Magazine* published many translations from French and German authors in this period, none had the political undertones such as those evident in Herwegh. The *Dublin University Magazine* showed a preference for authors such as Schiller and Goethe, authors who rarely appeared in the *Nation*. Even translators who published in both periodicals such as James Clarence Mangan selected their work to suit the audience and so Mangan translated romantic poetry from Freiligrath for the *Dublin University Magazine* while saving his translation of more belligerent works by the same author for the *Nation*. (O'Neill 1985, 103) The work of the European authors was therefore refashioned for Ireland through translations by certain mediators who domesticated the poetry and presented it so that it could have a pointed significance in the nationalist realm.

Apart from the overtly nationalistic discourses exemplified in national hymns such as the above, other tropes were imported from European poetry which were felt to reflect Irish circumstances. In particular, the notion of oppression and struggle emerged as common concerns for Ireland and for other European countries. Although nationalism likes to focus on unique national heritage and originality, in reality it is possible to identify many common tropes and trends in European nationalism in the nineteenth century. Translators were particularly aware of these communalities and rather than reject outside influence in favour of insularity, the Irish mediators opted instead to import from Europe in order to perform a central role of transfer, transmission and transformation through the medium of translation. In the case of the Young Irelanders, this function has not always been immediately obvious and, although the name Young Ireland would appear to demonstrate clear links with other contemporaneous European movements bearing similar titles, Young Ireland's links with Eu-

rope have been questioned and examined. In particular, the proximity of Young Ireland to European nationalist ideology (especially Mazzinism) has been the subject of debate and the links between romantic nationalism in Ireland and Europe questioned. (Huggins 2013; Costigan 1973) Leerssen has argued that Irish cultural nationalism benefits from being studied in a European context and asks whether parallels which can be identified between Irish and European patterns of nationalist development are as a result of parallel development or active involvement. (2002) I would argue that the translation activity of many Young Irelanders demonstrates strong and active links with Europe, particularly with France and Germany, and also an awareness of developments on the continent. Through their commitment to publishing translations in the *Nation* and also in their choice of texts, we can see the steady influence of European nationalism on Young Irelanders and can situate developments in Irish cultural nationalism firmly in a European paradigm.

## From Europe to Ireland

As we have seen, the desire to translate and import European works in this period derived from a perceived gap in Irish cultural nationalism which could be plugged by influential European works. These inspirational and motivational works were published in order to spur on a generation of Irish writers to emulate their European counterparts. By 1852, the *Nation* certainly felt that this aim had been achieved and, only ten years after John Blake Dillon had lamented the lack of any Irish literature, the paper was happy to pronounce in hyperbolic terms that, "The present generation in Ireland has produced more true poetry of the lyrical order, than any other in Europe since the age of Schiller and Goethe." (*Nation*, 25 September 1852) The nature of this poetry is described as "Irish in all its main characteristics, and such as only a central fire of inextinguishable nationality could develop." (*Nation*, 25 September 1852) Interestingly the authors that are selected for praise are Denis Florence MacCarthy, Samuel Ferguson and James Clarence Mangan, three of the most prominent Irish translators of the era. Their poetry is lauded for its contribution to Irish literature and the translation activity has served its purpose of inspiring accomplished native literature. The influence of European literature on the new original Irish work is not ignored, however, and MacCarthy, a renowned translator from the Spanish is, for example, praised for the "the Spanish gracefulness and ornature" (*Nation*, 25 September 1852) of his original works.

This pride in (English-language) Irish literature is mirrored by the rise and ultimately dominance of Irish language translations in the *Nation*. As can be clearly seen in the charts below, Irish overtakes the European

languages as the main source language for translations in the 1850s. Whereas in the early years of the paper, ideas were imported from Europe, in later decades, the paper focused more on national sources, translating Irish language texts for diffusion amongst the people. Rather than familiarise the Irish with European poetry, the *Nation* sought to familiarise the Irish with their vernacular history and traditions; consequently as the decades progressed, more local knowledge was mined and disseminated through translation.

Figure 3. Verse translations published in the *Nation*, 1851-59

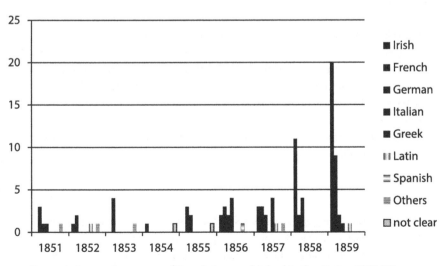

Figure 4. Source Language of Translations published in the *Nation* 1851-59

The continuous presence of translations in the *Nation* in the 1840s and 1850s shows an engagement with European nationalism, an engagement which ultimately fed into the promotion of vernacular traditions and inspired local developments. A clear desire on behalf of Irish cultural mediators associated with the *Nation* to infuse Ireland with patriotic fervour but also knowledge (selected and mediated through translation) emerges through their publications. Their works testify to the international nature of nationalism in this period and the cultural transfer occurring throughout Europe. An analysis of the translations also shows the influence of key cultural mediators who had a significant impact on the links between Ireland and Europe. This can particularly be seen in the cases of Thomas Davis and James Clarence Mangan, both of whom died at a young age before the close of the 1840s. Following their demise, there was a marked decrease in the amount of European translated literature published in the *Nation* and fewer efforts were made to establish links and parallels with the continent. The loss of these cultural mediators combined with factors such as the famine and the defeat of the 1848 revolutions throughout Europe, meant that in the 1850s the *Nation* turned less to Europe and more to the Irish national past which was in turn mined for inspiration and motivation.

## Notes

1   For example, Davis said that "The schools and galleries, museums and educational systems of Germany deserve the closest examination with reference to the knowledge and taste required in Ireland" (Davis 1914 (1844), 213)

2   I would like to acknowledge the work of José Brownrigg Gleeson Martinez in helping prepare the statistical information contained in this paper.

3   On politicised poetry, on 24 August 1844, the *Nation* approvingly quoted "a young German poet" as saying "Let us be understood; once and for all, we say, we have done with poesy of peace, with all soft, rose-and-violet poetry. We banish the 'eternal feminine' into the realm of the distaff and the kitchen ... Poetry now, like the Maid of Orleans, must put on armour." Quoted in O'Neill (1985, 103).

4   See for example translated poetry from Herwegh published on 12 April 1845 and 4 April 1846.

## References

Andrews, Ann. 2014. *Newspapers and Newsmakers: The Dublin Nationalist Press in the Mid-Nineteenth Century*. Liverpool: Liverpool University Press.

Costigan, Giovanni. 1973. "Romantic Nationalism: Ireland and Europe." *Irish University Review* 3:2, 141-152.

Cronin, Michael. 1996. *Translating Ireland: translation, languages, cultures*. Cork: Cork University Press.

—. 2013. *Translation in the digital age*: Routledge.

Davis, Richard P. 1987. *The Young Ireland movement*. Dublin: Gill and Macmillan.

Davis, Thomas. 1914 (1843). "Our National Language." In *Essays, Literary and Historical: by Thomas Davis*, edited by D.J. O'Donoghue, 97-107. Dundalk: Dundalgan Tempest.

—. 1914 [1844]. "Foreign Travel." In *Essays, Literary and Historical: by Thomas Davis*, edited by D.J. O'Donoghue, 207-213. Dundalk: Dundalgan Tempest.

Gavan Duffy, Charles. 1973 (1881). *Young Ireland*. New York: Da Capo Press.

Higgins, Roisin. 2011. "The *Nation* Reading Rooms." In *Irish Book in English, 1800-1891*, edited by James Murphy, 262-273. Oxford: Oxfor University Press.

Howes, Marjorie. 1998. "Tears and Blood: Lady Wilde and the Emergence of Irish Cultural Nationalism." In *Ideology and Ireland in the nineteenth century*, edited by Tadhg Foley, and Sean Ryder, 151-171. Dublin: Four Courts Press.

Huggins, Michael 2013. "The Nation and Giuseppe Mazzini, 1842-48." *New Hibernia Review* 17: 3, 3.

Leerssen, Joep. 2002. "Irish cultural nationalism and its European context." In *Hearts and minds. Irish culture and society under the Act of Union*, edited by B. Stewart, 170-187. Gerrards Cross Colin Smythe.

—. 2006. "Nationalism and the cultivation of culture." *Nations and nationalism* 12:4, 559-578.

—. 2011. "Viral nationalism: romantic intellectuals on the move in nineteenth-century Europe." *Nations and Nationalism* 17:2, 257-271.

MacCarthy, Anne. 2012. *Definitions of Irishness in the "Library of Ireland" literary anthologies, Reimagining Ireland*. Oxford; New York: Peter Lang.

Maher, Eamon, and Grace Neville. 2004. *France-Ireland: anatomy of a relationship: studies in history, literature and politics*. Frankfurt am Main; New York: Peter Lang.

Milan, Michèle. 2013. *Found in Translation: Franco-Irish Translation Relationships in Nineteenth-Century Ireland*, Dublin City University, Dublin.

—. 2014. "For the People, the Republic and the Nation: Translating Béranger in Nineteenth-Century Ireland " In *France and Ireland in the Public Imagination*, edited by B. Keatinge and M. Pierse. Oxford: Peter Lang

O'Neill, Patrick. 1985. *Ireland and Germany: a study in literary relations, Canadian studies in German language and literature*. New York: P. Lang.

Ó Ciosáin, Niall. 1997. *Print and popular culture in Ireland, 1750-1850*. Houndmills: Macmillan.

Stöter, Eva. 1998. "'Grimmige Zeiten': The Influence of Lessing, Herder and the Grimm Brothers on the Nationalism of the Young Irelanders." In *Ideology and Ireland in the nineteenth century*, edited by Tadhg Foley, and Sean Ryder 173-180. Dublin: Four Courts Press.

Tymoczko, Maria. 1999. *Translation in a postcolonial context: early Irish literature in English translation*. Manchester, United Kingdom: St Jerome Pub.

—. 2000. "Translation and Political Engagement: Activism, Social Change and the Role of Translation in Geopolitical Shifts." *The Translator* 6:1, 23-47.

Welch, Robert. 1988. *A history of verse translation from the Irish, 1789-1897, Irish literary studies*. Gerrards Cross, Bucks.: C. Smythe.

# Germany as a Cultural Paragon: Transferring Modern Musical Life from Central Europe to Finland

VESA KURKELA (UNIVERSITY OF THE ARTS, HELSINKI)
AND SAIJALEENA RANTANEN (UNIVERSITY OF THE ARTS, HELSINKI)

## Abstract

This chapter highlights the 'translation process' by which classical and popular music scenes in Finland were more or less Germanized at the end of the 19th century. The 35 years before founding independent Finland in 1917 were a highly important period in local music history. Almost all institutions on which 'modern' music life was built – public concerts, symphony orchestras, music theatre, conservatory, musicology, music criticism, music festivals, instrument and sheet music market and music publishing – saw their birth or were consolidated during that time period. None of them was formed indigenously or independent of international influence but rather in constant interaction with continental music life and new aesthetic ideas brought from Europe by foreign musicians, mostly from the German speaking countries, with the aid of some local music intellectuals. The emergence and formation of the Finnish music and music life was, in fact, a transnational process through which the musical styles, institutions, conventions and performance practices of the continental 19th century Europe were transferred to Finland, transformed into the existing institutional frames of music, and "translated" to satisfy the needs of the bourgeoisie. The focus of the chapter is on music publishing, orchestral life and conservatory teaching. Attention will be given to the group of influential musicians and other musical experts with various backgrounds that formed a mutual network communicating in German and Swedish and transmitting new ideas, trends and practices to local music life. A couple of examples on the central 'agents of change' will be presented and their role in the translation process analysed.

From the customary point of view, the two decades before and after the turn of the 20ᵗʰ century form the era when the national music culture of

Finland was born. During these years, the first symphony orchestra (1882), the first conservatory (1882), the Finnish National Opera (1911), the Finnish Musicological Society (1916) and the first chair of musicology at the University of Helsinki (1918) were founded (Mantere 2015, 57). Further, in the wake of the first symphonies (1900-1902) and other orchestral music by Jean Sibelius, the concept of 'national style' was born, and Finnish orchestral music witnessed a breakthrough in the Western world (Down Goss 2009, 199-319). In addition, the years between the mid-1880s and the Great War became famous for national song festivals with unprecedented large audiences and a great number of performers: thousands of nationally-inspired citizens assembled at the festivals, organised almost every summer in regional centres, in order to listen to tens of choirs, brass bands, string orchestras and solo performances (Rantanen 2013a, 61-84).

On closer inspection, however, we also find the formation of a new music culture in the transnational context of general European music, both art and popular. This development can be seen as a long-lasting process, in which German music and musical culture were transformed and translated to a prominent part of modern national culture in Finland. This chapter highlights the process of transfer from two angles: professional and amateur music making. The former covers music authorities, conservatory training, orchestral musicians and even music trade. The latter refers to music festivals that were organised according to the Estonian model. However, the actual paragon came from Germany, where song festivals with huge numbers of participants formed an important part of the German national movement since the 1820s at the latest.

In this grand narrative German musical culture appears as the *primus motor*, irresistible model according to which local musical life was organised. In Finnish society in general, Germany and German culture were highly esteemed at the turn of the 20th century, and the strong cultural and economic influence from Germany to Finland did not weaken until the end of the Second World War. This relation had a long history. The roots of Finland's affinity for German culture go back several hundred years into cultural history, to the medieval urban cities that developed around the Baltic Sea and, thereafter, the Lutheran Reformation. Finland was an eastern part of the Kingdom of Sweden and local clergy and academics had close ties to the centres of learning in northern Germany for centuries. In the early 19th century, Finland parted ways with Sweden but the connections to Germany remained and were further strengthened in the 20th century: German was the most studied foreign language in secondary schools, and before the Second World War, half of the guest lecturers at the University of Helsinki came from Germany, which at the time was the leading nation not only in philosophy and humanities but also in modern natural sciences (Hietala 1986, 180-182).

In the arts, ties to Germany were particularly strong in the area of music, and they were further reinforced when modern musical life based on a continental model began to emerge around the turn of the 20th century. This was when the foundation was laid for Finland's current music education system, network of symphony orchestras as well as music trade and publishing. However, it is important to keep in mind that German influence was by no means limited to art music. Around the same time, urban and continental popular music – operetta and *variété* – also arrived in Finland (Jalkanen & Kurkela 2003, 209-226). The flow of influences and imports, often directly from Germany, was so strong that we could reasonably describe this process as the Germanification of Finnish music.

## Challenging the nation

Despite the strength of German influence at all levels of musical life in Finland, in the following, we use the concepts of 'Germanification' or 'German influence' rather cautiously. Their uncritical use would simply be repeating an old conventional viewpoint, methodological nationalism, which over-simplifies the actual diversity of musical influences and transfers. For a similar reason, in this chapter we do not like to speak about 'Finnish' music but music, musicians and musical activities in Finland. On the macro level, national labels can be stripped away to reveal the underlying classical music scene in Europe, with a shared consensus on the autonomy of music, the criteria of good taste and the status of the classics. During the time under discussion, popular music was still simply a branch of the great system of art music. 'Continental music' was an umbrella concept for everything: classical and modern, serious and light, religious and secular.

At the grass-roots level, the national perspective obscures just how far-reaching the networks of musicians and other influential people in music were. As far as these networks were concerned, the constituents were primarily members of the general European community of music professionals and only secondarily national operators. There is an obvious parallel here with academia: theologians and mathematicians from Helsinki went to German universities and elsewhere (Hietala 1986, 180; Hietala 1983, 32-34), certainly not to affirm their Finnishness, but as members of an international scientific community.

The song festival movement in Finland in the late 19th century forms another interesting example of micro level networks around music. The early music festivals in Finland have scarcely been studied (Inkilä 1960; Smeds & Mäkinen 1984; Särkkä 1973) and the few existing studies have emphasised the national romantic ideology underlying their organisation. However, music festivals were not generated independently as Finnish innovations,

but in close interaction with the continental development, and aesthetic ideas brought from Europe by Finnish music intellectuals and composers. Their actions became prominent especially in the planning of the music programmes of the festivals.

From the very beginning, the management of the festivals aimed at recruiting the leading figures in Finnish musical life to take part in the events. Alongside with programme planning, they often acted as conductors for the choirs and brass bands performing at the occasions. Their presence had a great impact on the nature and character of the festivals and raised their public status both musically and ideologically. In addition, the festivals provided an opportunity for the composers to introduce their new music to the public and advance their careers through this kind of self-promotion. We argue that the emergence of the music festivals in Finland was a transnational process, and that its effect was felt all over the Finnish music life at large.

The studies employing transnational perspectives have exploded in quantity in recent years. Following Steven Vertovec, the transnational approach focuses on the on-going exchanges among non-governmental actors across national borders, as well as the collective attributes of such connections, their processes of formation and maintenance, and their wider implications (Vertovec 2009, 3). Jessica C. E. Gienow-Hecht has come up with a similar kind of definition in her research on the transatlantic connections of music from the 1850s to the 1920s. She stresses the importance of cultural and emotional connections within the European and North-American relations. She argues that music as a soft form of interaction proved much more intense and enduring than political or economic ties. She does not, however, rule out the social dimensions of the networks formed around music. On the contrary, among the European intelligentsia of the 19th century, music was seen as a cultural phenomenon, which had a number of political and social implications. In particular, universally distributed and glorified German art music was seen as an important counterbalance to the rugged reality of industrialisation and international wars (Gienow-Hecht 2009, 4-5; 9-11).

The transnational perspective within music historiography creates an opportunity to understand the complex, multicultural and mediated forms of interaction in the musical context of 19th-century Europe. As Celia Applegate has emphasised, "the most obvious effect of active musical travel and the spreading of different musical practices was to create a transnational space, one recognised by the end of the eighteenth century in the phrase 'the musical world'." (Applegate 2011, 230-231) In this context, Applegate also points at the 19th century choir movement as an important maintainer of transnational networks (Applegate 2011, 239). Especially with the rise

of music festivals, amateur choirs started to travel more and more. The development of the European railway network enabled more affordable and considerably faster travel, also across the nation states.

## Universal super-culture

From the transnational perspective, the 'German' aspect in music appears as a universal "super-culture"[1] that conquered the world – at least the Western world – in the 19th century. Its hard core consisted of the great Classical masters – Haydn, Mozart and Beethoven. These composers were German-speaking Austrians; but more to the point, they worked in a multicultural environment. The Habsburg Empire was not so much 'German' as a mishmash of ethnic groups and languages, and there were many noteworthy composers in Vienna at this time whose roots were in Bohemia, Italy or Hungary. The music of the Viennese Classics very quickly became international: the music trade took Beethoven's Piano Sonatas to Moscow, Constantinople or New York with equal swiftness.

It was not only printed music that was mobile but musicians as well. Since the 18th century, itinerant musicians from the German-speaking countries were famous for their professional skills. They had an influential position in the centres of the Baltic Sea region: Copenhagen, Riga, Stockholm and St. Petersburg. Due to the central role of the Germans in the fields of music, philosophy and literacy, the idea of German culture as highly appreciated human capital became widely accepted already one hundred years before the German nation-state (the *Kaiserreich*) was fully formed. As Applegate states: "Itinerant musicians and music making formed the German nation, not in the sense of determining its borders or shaping its politics but in the sense of making it a lived experience." (Applegate 2014, 61)

The canon of classics – works by old masters or "dead composers", as William Weber puts it – took over the core repertoire of symphony orchestras from the mid-19th century onwards, and this at the very latest made the Central European system of concert music universal (Cf. Weber 2008, 169-177). Music theory reinforced this trend: budding composers all around the world studied J. S. Bach's counterpoint, seeing it not as a specifically German musical system but as a generic one.

The super-culture of music was strong enough to foster uniform music practices in nearly all the European countries. In emerging smaller nation-states, such as Finland, the continental models were brought in as completely new models, not as replacements of old ones – this is why the 19th century is so important in the music history of Finland. The new super-culture was mainly conveyed to Finland by a group of musical authorities, a handful of music merchants and a body of foreign musicians.

## Authorities and businessmen

In Finland, a handful of active individuals played a highly significant role because of the small size of the community. In the 19th century, there were two Germans and two Finns advocating universal German culture in Finland: Fredrik Pacius (1809-1891) and Richard Faltin (1835-1918), and Robert Kajanus (1856-1933) and Martin Wegelius (1846-1906), respectively. Pacius, Faltin and Kajanus held the post of Music Director at the University of Helsinki, one after the other. Hermann Paul, a lecturer in German at the University and a well-known music critic, was also an important influence in the music scene. Two cosmopolitan institutions, music and academia, supported each other at the level of individuals.

All of these musical authorities had been trained in Germany – and three of them, Faltin, Kajanus and Wegelius, were students of the Leipzig Conservatory. Leipzig was an important place of study for all the future top musicians in Finland prior to the 1880s, when Martin Wegelius founded the Helsinki Conservatory. Thereafter, Finnish talent gradually began to explore further afield: Sibelius studied in Vienna and Berlin, and in the early 20th century many Finnish musicians went to Paris (Down Goss 2009, 99-128).

Richard Faltin and Hermann Paul were not only university teachers but also involved in the music business: Faltin imported pianos, and Paul published sheet music. The music business in Finland was generally in foreign hands at the time. The first notable sheet music publisher in Finland was Ludvig Beuermann, a German musician who set up shop in Helsinki in 1850. His business was continued by a Finn, Axel E. Lindgren (1838-1919), another alumnus of the Leipzig Conservatory.[2] Lindgren must have picked up more than just musicianship in Leipzig, as the city was a focal point for the music trade in central Europe at the time, and contacts made there with publishing houses would be of immense value for future composers and music entrepreneurs.

At the turn of the 20th century, music trade and publishing in Finland evolved rapidly. Several domestic businessmen entered the field, the most prominent among them being K. G. Fazer, R. E. Westerlund and Alexei Apostol. Most of their business involved selling musical instruments, but they all had an almost ideological mission to publish Finnish music in printed form. During the period 1890-1910, the production of Finnish printed music substantially increased and became manifold in quantity: from 88 items during 1891-1895, the number of new titles grew almost seven-fold during 1906-1910 (605 items) (Kurkela 2009, 312).

In those days, music publishing was a truly transnational business and relied heavily on international networks. The Finns had a lot to learn, but luckily they had the wits to hire an army of experts from abroad to help

them. By now, it should come as no surprise that these foreign experts had German names: Kaibel, Cornelius, Koch, Zingel, Succo, Binnemann, Falkner – to mention only the most well-known. Many of them settled in Finland (Kurkela 2009, 112-115, 147).

## Leipzig students and cosmopolitan musicians

Between 1856 and 1900, at least 44 Finnish musicians studied in Leipzig, one third of them women. This may seem like a small number among the more than 8,000 names in the Leipzig student register,[3] but the list of Finnish students in Leipzig includes all major Finnish musicians and composers of the 19th century, including Finland's first conductors, educators, orchestral musicians, a few concert virtuosos and Ilmari Krohn (1869-1960), the founding father of Finnish musicology.

The first students were sent to Leipzig on government grants, but in most cases going to Germany to study required the student to have substantial independent funds and a sufficient basic education: German language skills were essential. In 1887, Oskar Merikanto (1868-1924), subsequently one of Finland's most beloved composers of solo songs, began his studies in Leipzig. Talented but penniless, he had to go to a lot of trouble to find patronage for his studies abroad (Heikinheimo 1995, 57-61). Many of the Leipzig students came from Swedish or German upper-class families, thus having musical training and language skills needed in Leipzig as part of the upbringing typical of the educated classes. However, Merikanto and other Finnish-speaking students in Leipzig with a lower middle-class background were by no means monolingual or musically uneducated. Most of them had gone to secondary school where German was the first foreign language, and some sort of earlier musical training – normally music lessons from a distinguished local musician – was self-evident for every Leipzig student (The Student register, Leipzig Conservatory; Heikinheimo 1995, 24-29).

Due to the extensive and systematic training in Leipzig and other continental music centres, a group of native Finnish top musicians formed in Finland at the turn of the 20th century. The group was rather tiny, consisting of a few dozen musicians, music teachers, critics and composers. But this group of experts actually built new musical life – mostly according to universal German models. This founding cadre was assisted by a much greater group of musical amateurs, schoolteachers, politicians, businessmen and academic music lovers. It was this group of nationally-tuned citizens that assembled at music festivals and presented the new universal idea of music to ordinary people, the musically uncivilized masses.

Still, the real powerhouse in spreading the Central European super-culture far and wide consisted of the hundreds of orchestral musicians trained

in German music centres. By the middle of the 19th century, they consti-
tuted a rapidly growing body of professionals whose numbers created a
glut on the market on the continent, thus forcing them to seek employ-
ment opportunities in countries where the modern music scene was newly
emerging.

The best musicians employed themselves on concert tours all over Eu-
rope and even in America. Many managed to find posts as music directors
or teachers abroad, but the majority ended up as ordinary members in a
wide variety of orchestras. The musicians' backgrounds and careers varied
considerably, covering, on the one hand, poor female village musicians
from Bohemia and Saxony performing popular music in restaurants and
fairs, and, on the other hand, top musicians with conservatory training
hired by the Russian Royal Opera in Saint Petersburg. Itinerant musicians
from Central Europe were usually available whenever new orchestral mu-
sic was publicly performed in the Nordic or Eastern European countries
(Schwab 2005, 34-41; Werner 2005, 159-164).[4]

Accordingly, it is not surprising that, in Finland by the turn of the 20th
century, professional orchestral music was for the most part in the hands
of 'Germans' – a blanket term for foreigners in this context. Actually, the
music profession in Finland was ethnically highly diverse, including – in
addition to actual Germans – Danish, Swedish, Baltic, Russian, Hungari-
an, Polish and Bohemian musicians. This cosmopolitan community had a
common foundation in the Central European tradition, and the working
language was usually German.

The community of foreign musicians in Northern Europe moved from
country to country as the seasons dictated. The labour market was remark-
ably large, covering, in addition to the coastal cities of the Baltic Sea, the
western part of the vast Russian Empire, and many centres around the
North Sea, including London, inland cities and spa centres in Germany as
well as those in the northern part of the Austrian Empire. The large labour
market also involved various orchestras with different styles and reper-
toires: a great part of musicians of the Helsinki Philharmonic Orchestra
had previously acted as restaurant or military musicians; normally, they
had no conservatory background, were more or less self-taught and im-
proved their skills by taking private lessons from distinguished musicians.[5]

As recently as the early years of the 20th century, Robert Kajanus' or-
chestra – the Helsinki Philharmonic Society Orchestra – performed only
from October to late April. At that point, a large number of musicians left
Finland to play in orchestras in nearby metropolises and spa towns for the
intervening months. In the autumn, Kajanus had to recruit his orchestra all
over again; turnover was high. As a result, during the years before the Great
War, Finnish orchestral life was truly cosmopolitan, and it was not until

recently, a hundred years later, that similar circumstances could be seen in local symphony orchestras, with a number of foreign players and a shared non-local working language – now English instead of German.

## National music festivals – spreading universal music to ordinary people

In the last decades of the 19th century, a new universal art music culture was budding in Finland, through the agency of domestic top musicians and music authorities trained in Germany. However, one element was missing: a way of presenting new music to the masses and educating them to understand it. The method for this mission was found in music festivals.

The first modern music festivals in Finland were organised in the 1880s by the Finnish Association for Folk Enlightenment, *KVS Foundation*. They had a huge collective significance for the participants socially, musically and ideologically. These early festivals were the first extensive music events in Finland and also the first mass events in the proper sense of the word. From the very beginning, they gathered together hundreds of performers and thousands of listeners from all over the country.

The first festival in Jyväskylä in 1884 attracted so much enthusiasm that it was decided to start planning the next one right away. At first, festivals were meant to take place every three years, but as a result of their big success, cities were soon competing to be the festival organiser. This led to, in particular in the 1890s, a national music festival being held almost every year, the venues alternating between all larger Finnish towns (Inkilä 1960, 216-220; Smeds & Mäkinen 1984, 29-36). Consequently, the 1890s became the decade of a real music festival boom in Finland.[6] The programme consisted of speeches, poetry reading, various concerts, festival parades, amateur plays and less formal popular feasts. The main event of the festival was a singing and playing contest in which all Finnish amateur choirs and brass bands were invited to compete.[7] When the popularity of the competitions grew, they were extended so that each choir type – men's, women's and mixed choirs – had their own competition.

Despite the fact that the festivals were, without exception, held in cities, they had a significant impact on the musical life of the countryside as well. With the rise of popular organisations, the festivals contributed significantly to the spread of choirs and brass bands all over the country. The festival enthusiasm also appeared as smaller festivities organised by local youth associations, temperance societies and other associations.

Music festivals in Finland could not have been possible without the wide networks of the organisers. The most influential musicians and authors behind them were the same, above-mentioned music authorities Richard Faltin,

Robert Kajanus, Martin Wegelius and Oskar Merikanto. Among them, Ilmari Krohn and Emil Sivori (1854-1929) had an important role in the increase of the phenomena. Additionally, Fredrik Pacius was a notable figure behind the early rise of the choir movement in Finland as a choirmaster and a composer.[8]

To get a more detailed picture of the music festival phenomenon in Finland, we will use the Kirvu[9] music festival as a case example of the organisation and networks of the festivals. It was organised in 1898 by the Karelian youth association. The Kirvu festival was the first music festival held among the youth movement, which was gaining popularity in the country, and therefore it attracted a lot of publicity in the local and national press. At the same time, it is a concrete example of utilizing European, especially German models in the development of the music festivals in Finland. Even though the Kirvu festival was local and locally organized, it had, at the same time, both national and transnational connections. In Kirvu's case, the macro and micro levels of research can be combined in a way that enables a broader analysis not only of Finnish but also of European development.[10]

## Between German and Estonian

Music, and especially choir singing, was considered an important tool for the transmission of Finnish national identity (See Kurkela 1989; Rantanen 2013b). From the outset, the music festivals in Finland had a very national character. However, it was clear to the public who followed the newspapers and attended the festivals that influences for the phenomenon came from abroad. The model for the Finnish music festivals was imported from Estonia and Germany by travelling individuals (Smeds & Mäkinen 1984; Zetterberg 1974). Estonia was geographically close to Finland, and the networks between the countries were tight. Therefore, the Estonian example was often highlighted in the Finnish newspapers and in the festival speeches.

Both the national, and along them, the local song festivals copied their structure and content in detail from European models. The first music festivals organised entirely around choral singing were held in Germany already in the 1810s. The driving force of the European choral festival movement, however, was the establishment of the German Singing Confederation (*Deutsche Sängerbund*) in 1862. As a central organization, its main goal was to increase cooperation among the local choirs. Soon after its establishment, it started to organize national music festival. The basic meaning of the festivals was to reinforce the idea of a united Germany. The soul of the movement was mixed amateur choirs operating like associations. The model spread quickly to other parts of Europe (Applegate 2013, 9-10). The most effective distributors for the phenomenon were touring

choirs, musicians and music students residing abroad, who introduced the festival idea both in their home countries and abroad. Especially with the rise of music festivals, amateur choirs started to travel more than ever. During the travels the geographical awareness of the festival participants also grew, when the remotely familiar places that they had read about in school books and newspapers were put into a real context through travelling: the *imagined communities* (see Anderson 2007) became visible.

The musical programmes of the festivals were similar across Europe. Their core consisted of the European art music of the great classical masters, spearheaded by Beethoven, Händel, Haydn and Mendelssohn. Art music was used as a tool for educating lower classes. This was also the cardinal principle behind the music festivals in Finland. Among the European intelligentsia, the high status of the classical music canon of the 19th-century musical life was often explained with its musical as well as its spiritual effects. According to the German philosopher Wilhelm von Humboldt (1767-1835), a shared musical canon was an ideology that embodied many humanistic values such as open-mindedness and free spirit, and a way of life unconstrained by geographical or intellectual preconditions with many integrating social and physical effects. Furthermore, the classical canon was considered a transnational medium of communication, "the international language", which made it possible to go beyond the borders of different nationalities (Gienow-Hecht 2009, 65; Weber 2011, 211-212). However, when European music culture was imported to Finland, it was shaped to fit the national and local conditions, needs, and purposes.

## The Kirvu Music Festival

During the 1890s, musical practices gained increasing popularity among the Finnish youth associations.[11] Musically, the most spectacular innovations were the associations' own music festivals, the organising of which started to be discussed in the mid-1890s. Local music festivals had been organised previously by the branch associations of the KVS Foundation but the festival fever had not spread among the other organisations yet, except for the participation of individual choirs and brass bands in the national festivals. From the perspective of youth associations, the main goal of the festivals was to increase the number of choirs and brass bands at a local level. Although different musical events had increased throughout the country during the 1890s, the number of choirs and brass bands was still relatively low (see Rantanen 2013b).

The Kirvu music festival forms a typical example of how music festivals were organised in the Finnish countryside in the late 19th century. It was held in Midsummer in 1898. Because of the easy access, a large natural

field close to the local train station was selected as the place for the event.[12] According to the local newspaper *Laatokka*, more than 6,000 people attended the festival. Altogether 10 mixed choirs, seven male choirs and six brass bands, approximately 300 singers and 50 musicians, participated in the competition. When adding music clubs that did not compete, the number of musicians rose to more than 500. It was just as many, or even more, people than in previous national festivals.

Everything was planned well beforehand. The festival committee, which anyone could join, was founded first. The leader of the committee was the local organist and choirmaster Nestor Huoponen (1861-1916). He was the key figure of the festival. Because of his activity and successful career, he had wide connections to Finnish musical life. Most importantly, he had previous experience in the national song festivals as a conductor. These networks were crucial to the success of the Kirvu festival.

Socially, the impact of the festival was manifold both at a local and at a regional level. At local level, the organising of the event had a huge collective importance among the inhabitants of Kirvu. The whole parish was recruited to take part in the festival arrangements – all capable help was needed. Together, they formed a large community sharing the same goal and social action and created new experiences, which had far-reaching significance in people's lives. In the newspapers people were coaxed to participate in organising activities, and reminded about the importance of the festival to Kirvu. All choirs and brass bands in the region were invited to take part in both the festival and the competition. By encouraging people to participate in singing and other musical and organisational activities, the most important goal was to evoke a sense of nationality and patriotism in the Karelian area, which was regarded as the home district of ancient Finnish culture.

The Kirvu music festival began with welcoming words by the local primary school teacher A. J. Vartiainen. The speech was followed by a collective rehearsal for all choirs and brass bands participating in the event. The organisation of the Kirvu festival was in accomplished hands. The leader of the brass bands was Nestor Huoponen's friend and colleague, organist Emil Sivori from Vyborg – again an alumnus of the Leipzig Conservatory. The male-choirs were conducted by a notable choirmaster, Arthur Siegberg[13] (1862-1948).[14] Huoponen himself took charge of leading the mixed-choirs. As highly experienced musicians, both Sivori and Siegberg, like Huoponen, had visited many national music festivals before. Sivori also had experience as an organiser of national music festivals.

After the rehearsal, it was time for a celebration concert. It started with the national anthem of Finland *Maamme* [Our Land], which was sung jointly with horn accompaniment. According to the newspapers, the concert

also included the hymns *Jo joutui armas aika* [All Things Fair] and *Jumala ompi linnamme* [God is our Mighty Fortress], a few folksongs arranged for a choir, as well as the well-known Finnish patriotic songs *Porilaisten marssi* [Pori March] and *Oi terve Pohjola* [I Greet you, the North]. A similar kind of format was echoed in the music programmes of the music competition and the popular feast held the next day.[15] In addition to Finnish music clubs, a choir from Ingria (a district near Saint Petersburg) performed in Kirvu.[16] Local newspapers also reported about many Estonian festival guests.[17]

## From the elite to the masses

The ideology and structure of the Kirvu festival was copied directly from the national festivals, but the aims were set more locally. The main difference between national and local festivals was that locally organised festivals were smaller and usually only lasted one or two days instead of three. Furthermore, the standards of music did not always correspond to the level of national festivals. For example, local festivals did not usually include commissioned compositions or competitions for composers. In addition, it was normal to modify the programme based on the local needs and possibilities.

In spite of its popularity, classical music never did become a universal art form embraced by all ranks of society – not even among festival audiences in Finland. Especially at the local music festivals, instrumental music was in minority. The lyrics were considered more important than the melodies, as they transmitted the objectives of the events to the public more effectively. The programme of the Kirvu festival is a good example of this. It consisted of religious hymns, folk songs and patriotic songs, which, following its European models, highlighted the central themes with regard to building the Finnish nation state. The same practice was also replicated at the national festivals, especially at the competitions and popular feasts. Few years later, after the Russian revolution of 1905, when Labour movement with its Marxist programme stressing the concept of class struggle arose in Finland, the role of singing as a means of pursuing politics and raising awareness gained even more strength.

Because the choir movement in Finland started relatively late compared to Continental Europe, women were a part of the movement from the beginning. As the idea of mixed choruses became more popular, women gained access to the choral singing activity on a more equal basis with men. In addition to educational and moral goals, new associations that formed around music offered independence from traditional social structures and "individualism in the form of freedom of choice" (Ahlquist 2006,

266). Even though it was not common in Finland to form an organisation only around music,[18] choirs and brass bands outside the societal organisations often acted like small associations with rules and statutes. At the same time decision-making, programming, formulation of rules, elections, financial management, membership controls, and public outreach "not only put organisational power into the members' hands, but also taught them – often in the important general meetings – how to use it" (Ahlquist 2006, 266). This practice helped later political movements and also the rise of labour and other political associations.

## Conclusion

The late 19th-century music festivals in Finland formed a complicated network of local, national and transnational interdependency. They produced an entirely new type of publicity, giving people the possibility for experiences that went beyond the limits of their local environments and that were individual and collective at the same time. Alongside displaying national and local identities, playing in a band, singing in a choir or taking part in an organising committee, music festivals offered the common people a possibility to catch a glimpse of a shared European identity (see also Pollari 2012). This was the situation especially before the Russian revolution of 1905, after which the previously remarkably monolithic musical culture started to fragment alongside with the whole Finnish society.

At the turn of the 20th century, professional and trained musicians, amateur choral singers and concert audiences were a firm part of a musical super-culture that was mainly formed in the German speaking countries and consisted of widespread models of musical training, repertoires, and concert and festival conventions. However, this new culture did not make Finland's musical life identical to that of Germany. In Finland, the new music culture was called national, but actually it was pan European and more or less universal. The cultural transfer from the continent made Finnish music and musical institutions universally European much in the same way as the European Union today is unified by the legislation and administration of its Member States.

In this process German music was favoured and distinguished. However, this does not mean that only German repertoire, musical trends or models for composition ruled among Finnish music professionals. Music festivals had a strong local tinge. As the theory of transnationalism tends to emphasise, cultural transfer is seldom based on one-way traffic. Usually cultural change is mutually constructed and based on multipolar exchange of influences. Everything occurs in a network of several actors and multilateral operations. Many features in our Finnish case refer to a quite similar situation: French, Russian and Scandinavian music was highly popular in

the Finnish orchestral repertoire, and 'German' orchestral musicians came from various national backgrounds – as did the foreign music teachers at the Helsinki conservatory.

Still, German knowhow was held in high regard even in the field of music with non-German origin. French *variété* and operetta were mainly performed in Finnish restaurants and theatres by German, Swedish and Russian troupes – thus being at least partly Germanised before presented to local audiences in Finland. Even new American dance music, jazz of the 1920s, was not imported to Finland directly from the US. The first jazz bands in Helsinki were named "Lärm-Jazz-Orchester" (noise jazz orchestras) – and they came straight from Berlin (Jalkanen 1989, 73-78). The last evidence of German influence can be found in Finnish music terminology. The Finns do not call the third smallest interval a *third* but *terssi* as the Germans do (*Terz*), neither do we use Bb7 chords but H7 – except in popular music and jazz. The example may sound trivial and self-evident, but it indisputably shows how deeply J. S. Bach and the other gods of German universalism have settled in Finnish musical soil.

## Notes

1   The term 'super-culture' has mainly been used in cultural anthropology to denote a 'higher-order culture' that is characterised by a number of distinctive common elements or cultural regularities and consists of several sub-cultures; accordingly, we can speak of "the regional Scandinavian sub-culture of the Western European super-culture". (Bagby 1959, 105)

2   The student files, Leipzig.

3   The last Finnish in the register of students filed in 1900 was pianist Elli Rängman with the student number 8155. The student register, Leipzig Conservatory.

4   For detailed information on various careers of German-speaking musicians in the Russian Empire, see Koch 2005, 343–406.

5   The card files of the staff, 1905–1955. Helsinki Philharmonic.

6   National music festivals in Finland were organised in Jyväskylä 1884, Jyväskylä 1887, Tampere 1888, Vyborg 1889, Jyväskylä 1890, Kuopio 1891, Turku 1892, Vaasa 1894, Sortavala 1896, Mikkeli 1897, Helsinki 1900.

7   Professional music groups were able to participate to the festivals but not the competition.

9   He had close connections to Germany, and was, for instance, invited as a guest of honour to the choral festival in Hamburg in 1882. Namen-Verzeichniss 1882.

9   Kirvu is the name of the county where the festival was organised. It is located in the Karelian area which is now a part of Russia.

10   About Kirvu festival and its networks as well as connections to the European festival movement in more detail, see Rantanen 2014.

11  Youth movement was the most popular form of mass organisation at the time.

12  Railway formed an important factor for the emergence of the music festivals, since the towns and villages selected as the festival venues usually were located near a train station.

13  Siegberg was the leader of Finland's best-known male choir at the time, YL Male Voice Choir (university students' choir).

14  *Laatokka* 25.6.1898; *Wiipurin Sanomat* 26.6.1898; *Mikkeli* 1.7.1898.

15  *Laatokka* 25.6.1898; *Wiipurin Sanomat* 26.6.1898; *Mikkeli* 1.7.1898.

16  *Laatokka* 29.6.1898; *Wiipurin Sanomat* 27.6.1898.

17  *Päivälehti* 28.6.1898.

18  Normally amateur choirs and brass bands operated under bigger organisations, like youth associations.

## Reference list

Archives:

The student files Leipzig. Inskriptionsregister bis 1913. Hochschule für Musik und Theater "Felix Mendelssohn-Bartholdy", Bibliothek/Archiv, Leipzig.

The card files of the staff. Helsinki Philharmonic. Henkilökortit 1909-1955. Helsingin kaupunginorkesteri Ba:1. The City Archives, Helsinki.

Newspapers:

*Laatokka* 1898

*Mikkeli* 1898

*Päivälehti* 1898

*Wiipurin Sanomat* 1898

## Literature

Anderson, Benedict. 2007. *Kuvitellut yhteisöt. Nationalismin alkuperän ja leviämisen tarkastelua*. Suom. Joel Kuortti. Tampere: Vastapaino.

Applegate, Celia. 2011. "Mendelssohn on the Road: Music, Travel, and the Anglo-German Symbiosis". In *New Cultural History of Music*. Edited by Jane F. Fulcher, 228-244. Oxford: University Press.

—. 2013. "The Building of Community Through Choral Singing". In *Nineteenth Century Choral Music*. Edited by Donna M. Di Grazia, 3-20. New York and London: Routledge.

Bagby, Philip. 1959. *Culture and History: Prolegomena to the Comparative Study of Civilizations*. Berkeley: University of California Press.

Down Goss, Glenda. 2009. *Sibelius. A Composer's Life and the Awakening of Finland*. Chicago and London: University of Chicago Press.

Gienow-Hecht, Jessica C. E. 2009. *Sound Diplomacy. Music and Emotions in Transatlantic Relations, 1850-1920*. Chicago and London: The University of Chicago Press.

Heikinheimo, Seppo. 1995. *Oskar Merikanto ja hänen aikansa.* Helsinki: Otava.

Hietala, Marjatta. 1983. "The Diffusion of Innovations: Some examples of Finnish Civil Servant's Professional Tours in Europe". *Scandinavian Journal of History* 23-36.

—. 1986. "Katsaus saksalais-suomalaisiin kulttuurisuhteisiin 1921-33". In *Kansalliskysymyksiä ja rotuasenteita*, edited by Aira Kemiläinen, 176-195. Jyväskylä: Jyväskylän yliopiston historian laitos.

Inkilä, Arvo. 1960. *Kansavalistusseura Suomen vapaassa kansansivistystyössä.* Helsinki: Otava.

Jalkanen, Pekka. 1989. *Alaska, Bombay ja Billy Boy. Jazzkulttuurin murros Helsingissä 1920-luvulla.* Helsinki: Suomen etnomusikologinen seura.

— and Kurkela, Vesa. 2003. *Suomen musiikin historia. Populaarimusiikki.* Helsinki: WSOY.

Koch, Klaus-Peter. 2005. "Deutsche Musiker in Sankt Petersburg und Moskau". In *Musik und Migration in Ostmitteleuropa*, hg. Heike Müns, 339-406. München: R. Oldenbourg Verlag.

Kurkela, Vesa. 1989. *Musiikkifolklorismi & järjestökulttuuri. Kansanmusiikin ideologinen ja taiteellinen hyödyntäminen suomalaisissa musiikki- ja nuorisojärjestöissä.* Helsinki: Suomen Etnomusikologinen Seura.

—. 2009. *Sävelten markkinat. Musiikin kustantamisen historia Suomessa.* Helsinki: Sulasol.

—. 2014. "Universal, National or Germanised?" *FMQ* 2/1014: 18-21.

Ollila, Anne & Saarelainen Juhana (eds.) 2014. *Kosmopoliittisuus, monikulttuurisuus, kansainvälisyys. Kulttuurihistoriallisia näkökulmia.* Turku: Turun yliopisto.

Pollari, Mikko. 2012. "Teosofia ja 1900-luvun alun suomalaisen ja amerikansuomalaisen työväenliikkeen transatlanttiset yhteydet". In *Työväki maahanmuuttajana*, edited by Sakari Saaritsa & Kirsi Hänninen, 46-69. Väki voimakas 25. Helsinki: Työväen Historian ja Perinteen Tutkimuksen Seura.

Mantere, Markus. 2015. "Writing Out the Nation in Academia: Ilmari Krohn and the National Context of Beginnings of Musicology in Finland". In *Critical Music Historiography: Probing Canon, Ideologies and Institutions*, edited by Vesa Kurkela and Markus Mantere, 57-68. Surrey: Ashgate.

*Namens-Verzeichniss der Ehrengäste der Mitglieder des deutschen Sängerbundes-Ausschuffes, und sämmtlicher bei den Fest-Concerten mitwirkender Sänger.* Hamburg 1882.

Rantanen, Saijaleena. 2013a. "Laulu- ja soittojuhlat suomalaisen kansakunnan rakentajina 1800-luvun lopulla". *Musiikki* 3-4: 61-84.

—. 2013b. *Laulun mahti ja sivistynyt kansalainen. Musiikki ja kansanvalistus Etelä-Pohjanmaalla 1860-luvulta suurlakkoon.* Helsinki: Sibelius-Akatemia.

—. 2014. "Kirvun lauluseura ja Eurooppalainen laulujuhla-aate". *Etnomusikologian vuosikirja* 26: 68-101.

Schwab, Alexander. 2005. "Migration deutscher Komponisten und Musiker zwischen dem südlichen Ostseeraum und Russland im 18. Jahrhundert". In *Musik und Migration in Ostmitteleuropa*, edited by Heike Müns, 21-49. München: R. Oldenbourg Verlag.

Smeds, Kerstin & Mäkinen, Timo. 1984. *Kaiu, kaiu lauluni. Laulu -ja soittojuhlien historia.* Helsinki: Otava.

Särkkä, Irma-Liisa. 1973. *Laulu- ja soittojuhlat Suomessa autonomian aikana v. 1881-1917.* Jyväskylä: Jyväskylän yliopisto.

Vertovec, Steven. 2009. *Transnationalism.* London and New York: Routledge.

Weber, William. 2008. *The Great Transformation of Musical Taste. Concert Programming from Haydn to Brahms.* Cambridge: Cambridge University Press.

—. 2011. "Cosmopolitan, National, and Regional Identities in Eighteenth-Century European Musical Life". In *New Cultural History of Music*, edited by Jane F. Fulcher, 209-227. Oxford: University Press.

Werner, Elvira. 2005. "Fahrende Musikanten – eine böhmisch-sächsische Erfahrung". In *Musik und Migration in Ostmitteleuropa*, edited by Heike Müns, 153-166. München: R. Oldenbourg Verlag.

Zetterberg, Seppo. 1974. "Suomi ja Viron ensimmäiset yleiset laulujuhlat". *Historiallinen Aikakauskirja 4/1974*: 281-297.

# Dada – Rag-time – Cabaret: Artistic Internationalism and Multilingual Writing in Walter Mehring's Work[1]

DIRK WEISSMANN (UNIVERSITÉ TOULOUSE JEAN-JAURÈS)

## Abstract

The poet, writer and journalist Walter Mehring (1896-1981) was an emblematic artist in 1920s Berliner cabaret. His contribution to the art of the cabaret flawlessly illustrates the hybrid character of Weimar culture. His songs and poems fell between popular and high culture and formed a part of the contemporary project of an international form of communication in the arts, allying many European and American influences, from the Dada movement all the way to jazz. This article mainly focuses on Mehring's multilingual poems which were written between 1919 and 1924. It aims to underline two central ideas which the author defended at the time: that of "international literary artwork" (internationales Sprachkunstwerk), largely based on multilingual writing, and that of "literary 'rag-time'" (Sprachen-'Rag-Time') born from the influence of the first wave of jazz in Europe.

When we examine the beginning of the twentieth century, to what extent can we establish a link between multilingualism as a literary practice and cultural mediation as an international space for intellectual and artistic exchanges, both acting as counterpoints to the political realities of the time? Although cultural mediation on an international scale could take place in differents manners (trips, translations, narratives, etc.), multilingualism appears to be an ideal vehicle for cultural openness and to overcome any culture's ethnocentric tendencies (see Berman 1984, 16 et passim). This seemed to apply in a European context in which there were nationalist and ultranationalist movements, notably in Germany, and where the building of the nation was largely founded on a battle between linguistic diversity and a powerful monolingual ideology[2]. Going back to the beginning of

the nineteenth century, the essentialization of the German language as an identity-forming focal point was institutionalized during the Wilhelmine Empire and evolved into becoming a sort of linguistic form of racism (see Stukenbrock 2005, 327 et passim; Ahlzweig 1994, 169sq. et passim). Its ideology consisted in locking the members of the national community in a German language that was focused on its Germanic essence and seen as the absolute foundation of Germanic identity. The other idioms (whether they were home-grown or foreign) were seen as threats to this identity. In this context, the promotion of any multilingualism, notably implemented by certain writers, opposed itself to the norms of the official culture and necessarily collided against it (Kremnitz 2004, 63).

Although the practice of multilingualism can't be qualified as an unequivocal marker of left-wing political leanings[3], it was nevertheless used by writers who had taken critical stands towards the Wilhelmine Empire and towards the more conservative movements of the Weimar Republic. As early as the 1880s, Friedrich Nietzsche's polyglot style tied in with his criticism of Wilhelmine culture (Michaud 2000, 192). In the period of the First World War, Theodor W. Adorno brought to light the link between individual preference for the use of foreign words and resistance to warmongering nationalism (Adorno 2004, 61). More generally, this whole era of literary modernity showed a great affinity towards multilingual forms of expression[4]. In Germany, such a historical sequence extended from the marked literary renaissance of the 1890s to the 1933 disruption, without forgetting the Dada movement and other types of avant-garde movements in between.

When discussing the subject of multilingualism in the context of the German literature of that time, one might first think of great poets such as Rainer Maria Rilke or Yvan Goll, who, in those years, had written verses in several languages (see Kelbert 2010, 201-224; Schmeling 1996, 157-174). However, multilingualism in German culture at the beginning of the twentieth century wasn't limited to great poetry; nor was it exclusively held in the margins of the German literary space, as it was the case of the two extraterritorial writers I just mentioned. At that time, multilingualism could also be found in the art of the cabaret, an artistic form which, while being very popular, also maintained a relationship with the most advanced artistic and literary movements of the time. The Cabaret had been imported in Germany around 1900 and was considered one of the most emblematic cultural productions of Berlin in the 1920s.

In what follows, we will focus on Walter Mehring's (1896-1981) multilingual aesthetics. This poet, writer, journalist and famous figure of the Berliner Cabaret under the Weimar Republic saw his work being forgotten after his exile under Nazism. In 1921, Mehring, who had initially been a

member of the expressionists and the Dada movement in Berlin, proclaimed in one of his cabaret shows that the literature of the future would be multilingual and internationalist[5]. He was inspired by jazz, then at its first peak of reception in Germany, and created what he called a polyglot "literary 'rag-time'" (*Sprachen-'Rag-Time'*) in the context of a poetic view which concurred with the metropolitan cosmopolitanism of his time.

In this regard, it has to be noted that Mehring's multilingual literary practice spanned from 1919 and 1924 approximately and thus only concerned a relatively short period in his artistic life. A brief estimation shows that this period saw the emergence of about twenty texts that significantly relied on foreign languages, with a total of a little less than ten idioms used. Although these texts were often quite long, we must admit that these polyglot poems probably represented less than 10% of Mehring's entire poetic production. Despite the somewhat marginal character of the work, such multilingual writing, as we will see, filled a strategic function in the genesis of Mehring's original poetic style, and in his overall literary program.

Furthermore, for those who are interested in multilingual writing within German literature, Mehring's case allows us to establish a genealogy of literary multilingualism from the 1890s to the 1920s, where affinity for cabaret is a sort of common thread. Two cultural transfers played a central role in this evolution: the art of cabaret imported from France, from Paris more specifically, and the new popular music and dances hailing from the United States (two-step, cakewalk, rag-time, etc.). In addition, the artistic revolution initiated in 1910s by the Dada movement, which was an inherently international artistic movement, comes as the third influence.

## Overview of Mehring as a Cabaret Artist

It is not easy to define Walter Mehring's place in German literary history. On one hand, he is considered as one of the most prolific, talented and emblematic writers of the Weimar Republic (cf. Schulz 2013; Hellberg 1983); on the other hand, he is not discussed much in the overviews dedicated to that period of German literature. Such an oversight is most likely due to the disruption of 1933, to Mehring's exile and his inability to integrate the post-war literary scene. The originality of his poetic forms, including his multilingual writing, may also serve as an explanation. In any case, it has been established that, in 1920s Berlin, Mehring was a true star on the cultural scene, first known as a poet and cabaret artist, and later as a playwright, novelist, journalist, and also as a translator. The main commonality between Mehring's various activities consisted in his criticism of Weimar society and politics, expressed in a singular style, and characterized by

satirical sharpness. In this context, we will limit our analysis to Mehring's contributions to cabaret, without however meaning to reduce his overall opus, which is considerably rich and diversified.

Although the world of cabaret became a literary theme early on in Mehring's expressionist period[6], he made his debut in 1919 only, when German literary cabaret was resurging. At that time, the great Max Reinhardt gave a second birth to his famous establishment *Schall und Rauch*, initially founded in 1901. It was the beginning of the golden age of German Cabaret, which formed an integral part of the mythical image of Berlin during the "Roaring Twenties", when up to 75 cabaret stages adorned the city (Hoeres 2008, 141). For the reopening of the *Schall und Rauch* cabaret, Mehring – who was 23 at the time – pronounced a "*conférence*" (talk) that took on aspects of a manifesto in which he declared, in both a polychrome and polyglot style, that the literature to come would have to resort to a multitude of idioms and languages without which it would risk dying of "poetic anaemia"[7]. This specific reference to polyglossy (we could also use the term heterolingualism[8]) for the inauguration of a cabaret stage is hardly surprising since, from the very beginning, German cabaret stages hosted foreign artists as well as numbers and shows combining various languages. In this regard, the multilingual song "Madame Adèle" (reproduced in Budzinski 1964, 9-21), written in 1899 by Ernst von Wolzogen, one of the founders of the German literary cabaret, remains a genre model[9]. Mehring imitated this model later in his own song "Die Kleine Internationale" ("The Little Internationale", 1921), set to music by Friedrich Hollaender and combining German, Dutch, French, English, Italian, as well as the Berliner dialect (Mehring 1981, 126). Meanwhile, the Dadaists, who founded their own "Cabaret Voltaire" in Zurich, were able to pursue such a multilingual tradition.

During the first half of the 1920s, Mehring acquired the status of a sort of official poet for the Berliner Cabaret; he was performing in all of the big literary cabarets of the capital city and collaborated with the greatest artists of the time: Friedrich Hollaender, Rosa Valetti, Paul Graetz, Gussy Holl, Blandine Ebinger, Trude Hesterberg, Kurt Gerron, who set his texts to music and sang them when Mehring wasn't performing them himself (Budzinski 1964; Hippen 1996, 254; Schulz 2013, 34). During this time, he created four cabaret shows respectively called *Das politische Cabaret* (The Political Cabaret, 1920), *Das Ketzerbrevier* (The Heretics' Breviary, 1921), *Wedding-Montmertre* (he borrowed the variant of the title coined by Aristide Bruant, 1922/23) and *Europäische Nächte* (European Nights, 1924). These shows were performed at the *Schall und Rauch* (Noise and Smoke), at the *Wilde Bühne* (Wild Stage) and at the *Café Größenwahn* (Megalomaniac Café), and were all very successful. Towards the middle of the 1920s, when the Berliner literary cabaret started declining in the face

of music-hall and variety theatre, which mainly operated for profit and called on the baser instincts of the audience, Mehring turned away from cabaret to focus on theatre and journalism.

## A Hybrid Artform Related to Several Transnational Filiations

Mehring's poetic art drew from two sources, combining popular and erudite culture, embodied by the cabaret, on the one hand, and by the avant-garde, on the other. In this way, Mehring exemplified the new "hybrid culture" (Hoeres 2008, 105; Jelavich 1993, 26) which the society of the Weimar Republic bore. His poems and songs transgressed the frontier between literary highbrow and entertainment, between a certain form of elite avant-garde art and the culture of the masses (Cf. Bayerdörfer 1988, 46). As early as 1915/16, he had been a part of the circle of expressionists gathered around the literary magazine *Der Sturm*; in 1918 he started participating in the Dada movement in Berlin. He introduced the aesthetics of these avant-garde movements to the cabaret culture, which constantly struggled with its loss of artistic viability and its increasing commercialization, embodied by music-hall and variety theatre. This is why the art of cabaret, in its most literary shape, was only able to exist for two brief periods in German cultural history – around 1900 and around 1920.[10]

Beyond such a hybrid dimension, Walter Mehring's art of the cabaret was part of a network of transnational filiations ranging from the songs of the French revolution and Aristide Bruant's Parisian cabaret, to American culture of the 1920s as well as turn-of-the-century German cabaret and the international Dadaist movement during the First World War. To illustrate the role played by these various influences[11], we could examine this 1919 poem by Mehring, dating from the same period as his first appearances on the Berliner cabaret stages:

???WAS IST DADAYAMA???

DADAyama ist
vom Bahnhof nur durch ein'n Doppelsalto erreichbar
Hic salto mortale!
DADAyama bringt
das Blut in Wallungen
sowie die Volksseele zum Kochen
im Melting pot
– teils Stierkampf-Arena – teils
Nationalversammlung – teils
Rot-Front-Meeting

½ Blech ½ Eisen
versilbert
gleich Mehrwert dividiert durch:

---

∞ + Null komma Nichts
Tout-le-monde-mondän – die Halbwelt
auf EIFFELtürmen – in den Tiefen des
Lasters bei Sekt – bei Kaviar und Opium
of the ... by the ... for the people

Jede Stadt hat ihre
DADA-kulmi-Nation!
In DADAYAMA kulminieren
Alle HEILstätten – SODOM – LOURDES –
POTSDAM – MOSKAU
Revolutionen – Terror –
Unzucht und Heimweh!

　　Darum:
　Jeder keinmal
in
dadayama
»dadayama Napoli e
Mori« (Mehring 1981, 48-49)

Without analysing this example in detail, we can notice that the most important influences in Mehring's poetry at the time are all featured in this text: The Dadaist influence (the very title of the poem refers to a fictitious colony created by the Berliner Dadaists) is felt through the mocking and satirical tone directed at the dominating culture and political power, but also through the provocative play with nonsense and the montage of eclectic elements, including heterolingual elements[12]. Furthermore, we can also highlight the text's cosmopolitan and internationalist spirit throughout, as seen in the large number of foreign names of places and idioms. In this overall picture, France is featured as the country of cabaret and political song ("chanson politique") while the United States represents industrial and metropolitan modernity and the cradle of jazz. Both countries were to become Mehring's most important references in the years to come. These various influences operated within a social and political critique in a text which, while being destined for the stage, affirmed its nature as a written poem through the careful spatialization of the text and its typography. It forms, all in all, a meeting point of genres, traditions and languages.

## An Aesthetic in Line with the New Metropolitan Urban Life

The young poet's interest in foreign languages and cultures as well as his openness towards the wide world was first imparted to him by his parents. Born in 1896, Mehring grew up in Berlin in an assimilated Jewish family involved in intellectual and artistic professions. Mehring's father had been a writer, journalist and translator, demonstrating in some of his texts a satirical style that was to announce his son's writing. He was also a lover of French culture, a love he transmitted to his son, whose work is filled with Parisian motifs, and which bears the stamp of Villon, Béranger and Bruant. Walter Mehring's Francophile tendencies led him to settle in Paris from 1924 to 1928; as early as 1921, he had been on several trips to the French capital and worked as a correspondent for German publications (see Hellberg 1983, 9). Some of his cabaret texts were to carry such a mark, as is illustrated in this example from 1922:

MÉTROPOLIS

Das ist die Welt
Von Sous-Paris
Die Tout-Paris
In Atem hält,
Die Menschen schluckt
Und Züge spuckt
Durch die couloirs
– Zum Geld? Ici!
„La Bourse" – La Vie !
Et „Grands Boulevards" ...
Sie öffnen rund
Affichenschlund!
C'est le goût américain
Et attention! Changez de train!
  Prenez le Métro
  Prenez le Métro
  C'est le plus beau
    Le plus beau du monde
    Dansons la ronde
      la ronde du Métro! [...] (Mehring 1981, 185)

However, when we consider the poet's career, his internationalist and multilingual aesthetic predated his journeys abroad and wasn't directly linked to the places he had actually visited. In fact, beyond being a reflection of real trips and adventures, his rendering of a multitude of places throughout the globe

related more to his imagination. Although such descriptions were certainly based on the new realities of media and society in which international and foreign notices loomed large, they also depict a general desire towards the faraway[13], fuelled by poetry and literature, and a genuine poetical vision. This proves once more that Dadaism, a movement marked by exoticism, was so crucial to Mehring. The Dada movement did indeed make several aspects of early twentieth century poetics more radical, and these aspects are essential parts of Mehring's work: an internationalist conception of the arts and literature; the theme of the modern metropolis as a theatre for a new type of cosmopolitanism; the techniques of montage and simultaneity as means of expressing a closeness between spaces, cultures and languages.

## Internationalism, Multilingualism, Simultaneism

In 1918, when the Berlin Dada manifesto required "the union of creatives and intellectuals of all countries"[14], this statement formed part of a communist perspective, but it also signalled a historical movement of openness, intense exchanges that led artists and intellectuals to increasingly broaden their horizons and their ranges of actions. Since the end of the nineteenth century, expanding modes of transportation and means of communication produced, as Alfons Knauth remarked, a "universal co-presence of cultures and languages" (Knauth 2007, 146), itself causing a new globalized conception of the arts that could go as far as producing a panlinguistic tendency. As Franca Bruera and Barbara Meazzi wrote, "independently from the waves of nationalism, the internationalization of the avant-gardes significantly contributed to the development and research of a universal and multi-expressive language, which was to progressively become an indispensable base for the arts."[15] (Bruera & Meazzi 2011, 12).

Seen from this angle, multilingualism, which strongly characterized European and international avant-garde writing from 1900 to 1930, appeared as one of the emblematic manifestations of this new wave of literary globalization (Weisgerber 2000, 8). Multilingual expression was further supported by the new urban culture in modern cities such as in New York, Paris or Berlin – all marked by immigration, cultural transfers and international influences. In this way, the use of a multitude of idioms and languages increased the sensation of being in touch with the contemporary world, whose multiple aspects converged in the great cities of the time, themselves international crossroads. Since Apollinaire and the Italian futurists, the modern poem voluntarily exposed itself to this new urban reality, on which expressionism and Dadaism were also to rely (Debon 2011, 93-103). Among the aesthetic principles born as a reaction to the

contemporary urban world, we can notably mention fragmentation and montage, two processes that aimed to go beyond an organicist and ethnocentric conception of the work of art (cf. Bürger 2013). In addition, poetic simultaneism appeared as a principle that allowed artists to combine the new realities of the International metropolis with a multilingual openness. This was particularly prevalent in the multilingual "simultaneous poems" conceived by the Zurich Dadaists (see Béhar 2000, 37-48). The simultaneous emission of several independent voices within a same text aimed to reconstitute the polyphonic complexity of a new reality produced by the shocks and the collisions of heterogeneous elements. Furthermore, the montage of these multilingual voices tended to draw the various languages nearer and even superimposed this languagues representing the main international cultural centres of the time.

Cabaret, as an art interlocked with the international metropolis, symbolising an cosmopolitical desire and an openness towards the wide world, its exotic charms and its promises of a more intense life, is directly linked to the movement of this evolution. And this is particularly true of Mehring's work. Since his first expressionist poems, and later his Dadaist poems, the themes of the new modern city were at the centre of Mehring's writing, which encompassed the city's large buildings, its factories, its department stores, its agitation and over-populated streets, its tramways and automobiles, its cafes, cabarets and theatres, its artificial lighting, its voices, its noises and roars, its bourgeoisie, its flamboyant characters which included marginal and lawless people, the underworld. Such a heterogeneous population is represented in his texts in all its diversity, and this implies the use of a linguistic diversity through sociolects, slangs, jargons and a host of foreign languages.

Thanks to his experiences in the Dada movement, Mehring frequently used the techniques of montage[16] and simultaneism[17] during his years in the cabaret, especially when representing the city of Berlin. In this way, the metropolis was presented in an ambivalent light, both as a place where the vitality and dynamism of a new world in perpetual motion was concentrated, and as a place of depersonalized masses where individuals lost their bearings, a place that was also the seat of an increasing domination of capitalistic power over men (Hellberg 1983, 105). One of the most important poems in this regard is called "Berlin – simultan" (Berlin simultaneously), a "song"[18] which he composed expressly as a literary link between Dadaist tradition and the art of the cabaret. We could say that this quasi-simultaneist poem (Jelavich 1993, 146) is the poetic equivalent of certain paintings by George Grosz at the same period, Grosz also happened to be one of Mehring's close friends:

BERLIN – SIMULTAN

I.
Im Autodress ein selfmade-gent –
Passage frei! Der Präsident!
Die Heilsarmee
Stürmt das Café!
Ein Geistprolet verreckt im Dreck!
Ein Girl wink mit dem Schottenband!
Ein Kerl feilscht am Kokottenstand –
Her mit dem Scheck!
Schiebung mit Speck!
Komme, süsse Puppe!
Is' alles schnuppe:
ob Keilerei –
Jeknutsch!
Rrrutsch mir
   den Puckel lang
   Puckel lang!
Oh! Berolina
Kutsch auf dem Schnuckelstrang
 Elektrische, hektische
 „GROSSE Berliner"!
Bei „*Mutter Jrün*"
 is' jeder mang! Darf jeder mang!
  kann jeder mang!
[...]

## The "Literary 'Rag-time'" Program

The "Dada poem" titled "Berlin – simultan" (Mehring 1974, 26) inaugura-
ted the specific style that characterised Walter Mehring's poems and songs
during his cabaret period (cf. Schulz 2013, 29). We previously saw that his
very original poetic style was based on montage and simultaneism techni-
ques, as well as on the introduction of heterolingual elements in the texts.
A syncopated meter influenced by jazz was then added, a meter based on
a halting rhythm, supported by verses with variable lengths which were
generally (very) short. This therefore created a vivacious and animated
rhythmical blueprint, often resulting in tempo variations and disruptions.
However, the particular metric characteristic of this style wasn't an absolute
novelty when Mehring created work for the cabaret, since it had previous-
ly appeared in his early expressionist works[19]. More broadly, his strong

attachment to poetic musicality – remotely different from that in Fin de Siècle German poetry – can be traced back to this beginnings in poetry in the middle of the 1910s (Schulz 2013, 14). And yet, on the cabaret stage, Mehring's metric form was to be more precisely defined by the author as being close to rag-time, and therefore becoming a program.

In 1921, to introduce the second part of his Cabaret program titled "The Heretics' Breviary", he announced the following:

> Das Chanson hat nicht nur eine ehrwürdige Tradition, sondern auch eine gloriose Zukunft! Er führt zur kommenden Dichtung: dem internationalen Sprachkunstwerk, dem Sprachen-,Rag-time'! – Wie es zum Beispiel die folgenden Chansons zeigen. (Mehring 1981, 126).

> The chanson has not only a venerable tradition but also a glorious future! It leads to the coming poetry: the international literary art work, the literary, 'rag-time'! – As show the following songs, for example.

These words express the very essence of Mehring's link between internationalist aesthetics and the musical framework of jazz, on the basis of a poetic technique that followed the example of the 1910s avant-garde, mainly founded on the montage of heterogeneous and heterolingual elements. These different aspects are best condensed in the notion of "Literary 'rag-time'", which defines Mehring's very own style (cf. Boussart 2001, 121 and Schulz 2013, 32). Rag-time, which predated jazz until the mid-1920s (see Cohen-Avenel 2013), consists in a syncopated (or 'ragged') rhythm. Therefore, when applied to poetry, it consists in a meter with a rapid rhythm and is based on continual displacement of the verses' accents and tempo variations (cf. Hellberg 1983, 80sq. and Boussart 2001, 123). Mehring also called these "quick poems" (*Tempo-Gedichte*) or "quick syncopations" *Tempo-Synkopen*).

Below is an example of this technique, the beginning of the poem "Salto mortale" taken from a cycle titled "Berliner Tempo" ("The Rhythm of Berlin"). The poem confronts the ternary rhythm of a classic nursery rhyme (which also was the rhythm dominating pre-war music) with a quick free rhythmical variation in syncopations reminiscent of jazz and the use of a certain amount of heterolingual elements. The syncopations are associated with the technique of montage and free association, both opposing themselves to the principle of continuity, coherence and organicity:

SALTO MORTALE

Ach, du lieber Augustin, Augustin, Augustin,
Ach, du lieber Au...
Schau
der Excentrics
Mit Fußtritts
Und slapsticks
Die Wände lang
längelang =
Chorgirls aus
Engel-Land
reigen am Gängelband
zeigen die Schenkel =
ihr Lullaby
  Lullaby –
Ach du lieber...
Husch – und
vorbei –
und
Vorhang und Tusch =
Seile in
Eile hin –
Kreisen Maschinen
zu Eisengardinen
im Dickichtgeschlinge
der Stricke und Ringe
Sich bäumend im Saale
die stählerne Schlange
Des SALTO MORTALE
Und Vorgang auf
Kopfhang und
Ach, du lieber Augustin, Augustin, Augustin...
[...]
(Mehring 1981, 121)

Although the use of syncopation wasn't a novelty, the reference to Rag-time marked a new orientation in Mehring's work at the beginning of the 1920s; he now openly acknowledged the American influence, while also maintaining a strong bond with the French cabaret tradition (cf. Bayerdörfer 1988, 43). Such a connection with the homeland of the cabaret can appear, among others, in reference to circus acrobats, where it also includes an

explicit reference to American jazz, as in this other example:

COUPLET EN VOLTIGE DER CONTORSIONISTIN ELLEN T

Schenkel! Arme! Hand in Hand!
Drahtseil durch die Luft gespannt!
Süße Kröte,
Und sie flöten –
Anjetret'n
Entkleidungsakt
Im Jazzingtakt
Beim Tanz!
  „I'm
  Ellen, die süße Ellen –
  Ich bin international.
  Alle Augen karussellen
  Um den traumseidnen Shawl.
  Everybody
  Gent and rowdy
  Alles staunt
  Alles raunt
  Vertikal
  Durch den Saal!
  Dos à dos
  Rosa Popo
  In der schönen, in der neuen...
  Wo sich die Soldaten freuen..."
[Rrrrrr–r]
Hallo!
Tricot!
[...]
(Mehring 1981, 106)

## An Ambivalent Relationship with Jazz and American Culture

Under the Weimar Republic, cultural, intellectual and technological trans-
fers from the United States reached unprecedented heights in Germany, to
the extent that the transfer "balance" was starting to be reversed in favour
of the United States (Hoeres 2008, 89). Within this context, jazz was one
of the most significant American importations and carried with it a very
strong societal, intellectual and artistic influence. At the end of the war,
jazz played a major part, becoming a means of liberation to break away

from the moral and national mould of the Wilhelmian era. It became the symbol of renewed vitality, of a new affirmation of the body, which took the shape, for example, in the new American dances. It was the emblem of a new modern urban society (see Cohen-Avenel 2013). Furthermore, when referring to Walter Mehring's example, Alain Larreau wrote: "In the early Weimar Republic jazz became a symbol of artistic and cultural revolution in the literary cabarets of the avant-garde." (Lareau 2002, 36).

In 1926, Kurt Weill, a composer close to the cabaret scene, said on German radio: "jazz is the rhythm of our time"[20]. We just noted that, for Mehring, the encounter with jazz led to an evolution in the literary forms he used in his cabaret songs, especially in regards to rhythm. But such an interest for the syncopated rag-time rhythm shouldn't be separated from the theme of the modern metropolis discussed above, given that, in discussions of the time, syncopation functioned as a synonym for this new urban modernity (see Cohen-Avenel 2013, 123sq). This stirring rhythm, full of life and vigour corresponded to the new machines and modern techniques, but it also recalled the idea of the wild and primitive state of man associated to blackness, images linked to the black musician, his physical strength, his (dangerous) sensuality and sexual freedom (cf. Hoeres 2008, 106 et Lareau 2002, 24 et passim). For many people of the time, jazz simply embodied blackness. From a vitalist perspective, the arrival of a young African American culture in Germany could serve to give more strength and vigour to the declining German culture.

All in all, the strong reference to the world of jazz is, for Mehring, closely linked to the theme of the modern metropolis as an international crossroad. This conjunction between rag-time and cosmopolitanism is notably illustrated by a text called "Jazz-Band" from 1921.

JAZZ-BAND

1.
*Sie kommen*
    von weither übers Meer
    *The Jazzband – the Jazzband*
und blasen wie das Wilde Heer
und rasen wie ein Wildenheer
    von New Orleans bis Westend.
    Es hüpfen wie das kangoroo
Der Frackmensch und der Nackte –
– Der Buffalo – das Steppengnu
stampeden nach dem Takte
    I want to be
    I want to be

I want to be down home in Dixie
and cowboy ring
bei scharfen drinks!
Gieß ein, sweetheart, und mix sie!
Und hopst du, wo die Farbigen springen
und grüne Dollars reifen,
dann hörst du die Skylight-Angels singen
– was die Spatzen von Dache pfeifen –.

2.
Sie spielen im Hottentottenkral
   – Sahara – oh Sahara! –
Sie spielen in einem Nachtlokal
am brausenden Niagara –
Es tanzt ein steifer Pelikan
am Turm zur blauen Pagode –
Es klingen die Glocken aus Porzellan
– und Lamas singen zum Tode:
   I want to be
   I want to be
   I want to be down home in Dixie!
Schnapsbrüder rings
bei scharfen drinks
   Sister fill up und mix sie!
Und schwingst du, wo die Dollars springen
   Und Saxophone keifen,
Dann hörst du die Engel im Himmel singen,
was die Spatze vom Dache pfeifen.

3.
Sie spielen zum Tanz auf jedem Staat
   In EUROPE – in den Tropen –
Ein abgedankter Potentat
   – ein abgesetzter Autokrat
   summt näselnd die Synkopen –
Da trommeln sie das Xyklophon
– und wüstes Heimweh packt sie –
Um Republik und Fürstenthron
Spielen im Ragtime-Takt sie:
   I want to be
   I want to be
   I want to be down home in Dixie

mit *cronies* rings
   bei scharfen drinks
Honey! Fill up und fix sie!
Und laßt ihr ein paar dollars springen,
   wollt nach der bottle greifen –
Dann hört ich alle Goldenglein singen,
   was die Spatzen von Wallstreet pfeifen –.[21]

This song, brimming with citations and elements borrowed from English, first describes the dissemination of jazz on the global scale, as it came from New Orleans and made its way to the West-End of Berlin, all the while stopping by each continent. Jazz was associated with the idea of a communion between people, regardless of their race and social origin, embodied by a dance suggestive of savagery and animality. It therefore consisted in a way of celebrating the vitality of a new artistic form and its success on a global scale. This notion of international communion through art could also be found in other texts written by Mehring at the time, which made references to the Paris of the 1920s[22].

At the same time, this text also highlights a relation to jazz that does not appear entirely positive, but rather more mixed, if not ambiguous. While the beginning of the text seems to devote itself to the celebration of this new form of music and the egalitarian spirit it conveys in the entire world through dance, the English verses quoted in the middle of the first stanza signal a different tone. The words "I want to be down home in Dixie!", repeated in each stanza, are borrowed from the chorus of an early-twentieth century song which was, as it happens, sung on a rag-time rhythm[23]. The lyrics of this highly popular song conveyed a nostalgic image of the Southern states of the United States and can be interpreted as praising slavery[24]. Especially since this song has generally been attributed to the genre of "coon-songs", the latter of which were performed by white men in blackface instead of being interpreted by black performers. It was thus a parody of rag-time music and promoted a stereotypical and racist image of African American people.

The coon song quote, along with the recurring reference to American dollars and the final appearance of the term Wall Street all usher a change in tone, the song evolving to become an increasingly savage, cynical and inhuman form of entertainment. At the end, the song depicts an almost apocalyptical vision in which jazz is shown in a clearly ambivalent light, appearing as the symbol of an empty form of entertainment devoid of meaning, of a purely hedonistic attitude, and of the decadence of capitalistic society (Lareau 2002, 38). All in all, one can read this text as a broad critique of contemporary society through the theme of jazz, the latter of

which is partially assimilated to consumerist society, to capitalism and to exploitation, and therefore becomes a truly political metaphor.

Another song, titled "If the man in the moon were a coon" (Mehring 1981, 95) reuses another coon-song in a more explicit way, by resorting directly to racist vocabulary (coon, Neger, nigger). We can wonder about the connotation of such words used by Mehring, in a historical context in which the use of such racist vocabulary was common[25]. The song is an offbeat and provocative tribute to the new jazz culture as well as a scathing parody of the contemporary craze for this music and for the fantasies and sexual attraction exercised by black musicians (see Lareau 2002, 37). A parody which, through the entertainment industry which jazz was about to become, was aimed at the capitalist bourgeoisie, and more notably its consumerism and thirst for entertainment.

## Multilingual Writing as a Critical Tool

It therefore appears that Walter Mehring, as most of his contemporaries – and independently from their political beliefs – had an ambivalent relationship towards jazz and American culture, the latter being rife with internal contradictions (see Hoeres 2008, 48). Mehring's reservations towards this culture seemed mainly aimed at his hate of the bourgeoisie and his rejection of capitalism, but there was also a dimension of *Kulturkritik* that questioned the potentially dehumanizing or even mind-numbing aspects of American influence. Yet this ambivalent relationship contrasts with the statements he made and which we cited above. In these statements, his enthusiasm could only lead us to believe that his relationship towards the United States was purely affirmative.

Such a critical distance is also felt in his relationship with multilingualism, which wasn't solely used in order to promote literary and artistic internationalism. When we examine the texts that make a massive use of heterolingual elements in more detail, we notice that these elements are far from celebrating the plurality of languages as a means of fraternization between peoples. Of course, Mehring did not engage in the nationalist and chauvinistic discourses that could be heard on other cabaret stages, but the critical nuances regarding certain foreign idioms don't go unnoticed in his texts. In this regard, it is interesting to return to the text titled "Couplet en voltige der Contorsionistin Ellen T", cited above.

At first glance, this poem follows a trapeze artist in a circus or cabaret number; its cosmopolitan nature is highlighted by the mix of languages. But when we look more closely, this text retraces the evolution that went from pre-war cosmopolitanism to a form of contemporary chauvinism opposed by the author as he simultaneously mocks American patriotism and German ul-

tra-nationalism (cf. Jelavich 1993, 147-148). At the end of the song, Ellen the contortionist's baby, a child born of American parents who see themselves as "international" is an illustration of the new political climate:

[...]
„I'm Ellens, Ellens Baby
Ich bin sehr for national!
Mein' Fress' is like the Teddy
Vom deutschen General !
Everybody
Gent and rowdy
Alles staunt
Alles raunt !
German, French,
Jedes Mensch
Einjlaß klemmt !
Hochjestemmt !
In der schönen, in der neuen...
Stehen treu und fest die Reihen...!"
Hurrra
[rrratsch bumm!]
Im Hemd!

Here, the multilingual expression is actually used as a way of criticizing nationalism whatever the language, almost to the extent of linguistic diversity correlating with the universality of such an attitude, itself derided.

This critical view of cosmopolitanism through multilingualism is, in part, due to Mehring's disillusion concerning progressive bourgeois ideology, which was embodied by Mehring's father. Before the First World War, the latter had proclaimed his unwavering faith in the future of humanity, a faith his son saw collapse in the apocalypse of trench warfare (see Mehring 1978, 26). This was heightened by a particularly tense political climate in Germany between 1919 and 1923, marked by revolts and strikes, violent marches of all sorts, street fights, attempted putsches, etc. This didn't encourage the cultivation of a harmonious view of humanity. Furthermore, Mehring's texts are marked by an overall hyper-critical and satirical attitude, attacking all forms of power and domination, perhaps going as far as attacking all forms of power and domination. The denouncing function of heterolingualism logically appears in the texts Mehring regrouped under the title "The White Mass of the Heretics" ("Die weiße Messe der Häretiker"), consisting in a polyglot parody of ancient litanies. By using the Latin language of masses and sacred texts, the author denounces religious

dogma, condemning the union between Church and State and their efforts to oppress the people. He therefore opposes an autonomous protagonist – combative individualism and terrestrial pleasures – with the tutelage and the chaste humility imposed by the church (Bader 1983, 5). Far from being a universal language, Latin therefore appears as an instrument of domination and exploitation.

The Francophone world was not spared by such a critical use of foreign languages, despite Mehring's overt interest in French culture. Such an interest seemed to shield him from those who criticized the massive importation of cultural and intellectual references stemming from France. And yet, the poem "Metropolis", cited above, was not bereft of a critical charge against Parisian realities, the city's de-humanizing aspect and the role played by money (cf. Hellberg 1983, 112). In "The Little Internationale", which we mentioned at the beginning of this contribution, the political critique is introduced through a parallel made between, on the one hand, the multilingualism of the prostitute from the Amsterdam port, and on the other hand, the Internationale used as the workers' emancipation hymn (Stein 2006, 361). The dream of a fraternization that would go beyond linguistic differences is substituted with the prosaic reality of commerce, or even of a system of exploitation on an international scale.

## Conclusion

We saw that the multilingual literary "rag-time" in Mehring's songs formed part of a whole series of traditions, from literary cabaret to Dadaism and jazz. Mehring's intense yet brief contribution to the art of cabaret didn't mark the end of such a filiation. Despite his statements on the "glorious future" of the multilingual cabaret song, Mehring abandoned the cabaret genre towards the middle of the 1920s, going on to write mainly monolingual work in the context of his political radicalization which didn't fit with the spirit of the cabaret. And yet, other artists followed the path he had traced, combining jazz and multilingual poetry. Before the National-Socialist halt order, many opera composers used the polyphony of languages, without, however, reaching the same level of formal mastery as Mehring.

In this regard, let us mention the Austrian composer Ernst Krenek and his opera *Jonny spielt auf* (Jonny Plays), created in 1927, and in which the protagonist, a black jazz musician, combines English and German in a grotesque way. More generally, adding English in song lyrics had been a recurring technique in 1920s German music, itself highly influenced by jazz (see Lareau 2002), before such works were qualified as "degenerate art" and forbidden by the Nazis. After 1945, the concrete poetry movement reconnected with the avant-garde tradition of the inter-war years. More particularly, Ernst

Jandl, the Austrian poet, maintained a close contact with jazz music. But we had to wait the 1960s to see such musical and polyglot poetry truly enter the scene. As for Mehring, he had been crippled by exile and was unable to deal with the literary scene of the Federal Republic of Germany. He never recovered the inspiration of his poetry of the early 1920s.

Even if Walter Mehring's cabaret songs did not encounter the expected "glorious future", they played a considerable role in the context of the Weimar Republic's cosmopolitan and polyglot culture, and his work had an influence on artists such as Brecht and others (cf. Schulz 2013, 41). If we go back to our initial question, which was to know the extent to which we could establish, for the beginning of the twentieth century, a link between multilingualism as a literary practice and cultural mediation as a transnational space for intellectual and artistic exchanges, we must admit that, in Mehring's case, the link is not purely affirmative. Of course, the polyphony of languages and the references to jazz as a new cosmopolitan art form contributed to creating a transnational space; but this was not a harmonious and homogenous space. It was rather marked by the national and international political divergences of its time. These transnational references, although they did promote a certain mind openness, did not however guarantee a harmonious worldwide understanding among people. We could also posit that multilingualism itself participated in fostering a spirit of competition between nations, given the contest between Berlin, Paris, London, etc. to know which metropolis was the most international and, therefore, most important (see Jelavich 1993, 112ssq).

We must therefore highlight the considerable gap between the affirmative (one could say: naïve) program put forward by Mehring when he promoted his polyglot literary rag-time, and the actual implementation of his said program, which was much more critical. This gap lies in the symbolic meaning Mehring gave to his poetic form and the actual messages he conveyed through his texts. In such a period of transition falling between the effervescence triggered by the Dada movement and the political radicalization of the end of the 1920s, the poet's political opinions finally became to prevail.

## Notes

1 First published in *Recherches germaniques*, 45 (2015), 49-71.

2 For a historical overview of the monolingual paradigm in modern and contemporary societies, see Y. Yildiz 2012, 2*sq*.

3 On an international scale, the most notable exception in this regard lies in Italian Futurism in which there existed a conjunction between multilingual writing and fascist positions among certain writers.

4 A period which we could also describe as the third phase of literary globalisa-

tion, following the periodisation put forward by (Ette 2012, 18*sq.*).

5   The term internationalism is preferred here over cosmopolitanism since Mehring himself used internationalism in several instances. In this way, the term is not used in a doctrinaire sense, but simply designates a point of view that favours and promotes an international perspective over a national framework.

6   See his poem "Cabaret" (Mehring 1981, 19).

7   Original expression: "lyrische Blutarmut" (Mehring 1974, 163).

8   For a definition of this concept, see Grutman 1997 and Suchet 2014.

9   We can add that, as early as the 1890s, Frank Wedekind, who was to become an artist in cabarets in Munich, showed a special affinity for literary multilingualism; see Weissmann 2011.

10   For a general presentation of German cabaret history until 1933, see Jelavich 1993.

11   The particular essence of the cabaret song rests on an assemblage of lyrics, music and gestures, and stage acting, in an attempt to create a perfect balance between all of these components. Approaching Walter Mehring's art of the cabaret solely through his printed texts is therefore an obvious reductionist offense. And yet, this is a general problem and seems insurmountable given the fact that we are left with little else than the texts, or, shall we say, "dead letters", to examine the ephemeral art of the cabaret of the 1920s. *Cf.* Hellberg's remarks, 1983, 53; Schulz 2013, 34; Budzinski 1964, preface.

12   Regarding the link between Dada Berlin and Weimar cabaret, also see Jelavich 1993, 143*sq*.

13   In this regard, we can also mention his early desire to leave Germany, see Schulz 2013, 37; and Mehring 1981, 91.

14   Original text: "Vereinigung aller schöpferischen und geistigen Menschen der ganzen Welt", cited from Huelsenbeck 1920, 37.

15   Original text: "indépendamment des vagues nationalistes, l'internationalisation des avant-gardes contribue de manière déterminante au développement de la recherche d'un langage universel et pluri-expressif qui devient progressivement une base indispensable pour les arts" (Bruera & Meazzi 2011, 12).

16   See in particular his poem "Dada Prolog 1919" (Mehring 1981, 55-56), "Die Reklame bemächtigt sich des Lebens". (Mehring 1974, 146-147).

17   See in particular his poem "Berliner Tempo" (Mehring 1974, 117-118).

18   According to the title of the section this text is part of (see Mehring 1981, 78-82).

19   See in particular his poems "Zirkus presto" and "Höllenbahn" (Mehring 1981, 24-25 and 28-30); see also the commentary by Monique Boussart (Boussart 2001, 120).

20   Original text: "Der Rhythmus unserer Zeit ist der Jazz ", cited from Weil 1990, 213.

21   Mehring 1981, 128; the poem was later renamed as "Tempo-Synkopen"; also published under the title "Grotesksong ". In: *Die Weltbühne*, 1921, n° 13, p. 63.

22   See in particular the cycle "Von Wedding bis Montmartre" (Mehring 1981, 181*sq*).

23   "I want to be down home in Dixie!", song composed by Ted Snyder and Irving Berlin in 1912.

24   The opening lyrics of the song, which was often sung by imitating the African American accent, are: "I'm very glad / I'm very glad / Because a train I'm takin' / To that ne'er forgotten or forsaken / Sunny land of cotton, down to the town I was born / I'm glad I had / I'm glad I had Enough to buy a ticket / Now I hope that there will be no pause / Let me tell you the reason is because: // I want to be / I want to be / I want to be down home in Dixie / Where the hens are doggone glad to lay [...]"

25   See Jelavich (1993, 170-171), who argues that Mehring's view of black people didn't lead to a racist use of these terms.

## References

Adorno, Theodor W. 2004. *Mots de l'étranger et autres essais, Notes sur la littérature II*. Paris: Edition de la Maison des Sciences de l'Homme.

Ahlzweig, Claus. 1994. *Muttersprache – Vaterland, Die deutsche Nation und ihre Sprache*. Opladen.

Bader, Urs. 1983. "Zeitbilder in den Gedichten Walter Mehrings". *Text&Kritik*, 78. 1-10.

Bayerdörfer, Hans-Peter. 1988. "'Sprachen Rag-Time'? Überlegungen zur Entwicklung des polyglotten Gedichts nach 1945". In: Dieter Breuer (ed.), *Deutsche Lyrik nach 1945*. Frankfurt/M. 43-64.

Béhar, Henri. 2000. "Le simultanéisme Dada", in Weisgerber, 37-48.

Berman, Antoine. 1994. *L'épreuve de l'étranger, Culture et traduction dans l'Allemagne romantique*. Paris.

Boussart, Monique. 2001. "Die zwei Weltkriege in Walter Mehrings Lyrik, Vom avant-gardistischen Cabaret zur Elegie". *Germanica* [online], n° 28/2001, http://germanica.revues.org/2243 [consulté le 01/07/2014].

Bruera, Franca / Meazzi, Barbara (ed.). 2011. *Plurilinguisme et Avant-gardes*. Bruxelles.

Budzinski, Klaus (ed.). 1964. *So weit die scharfe Zunge reicht, Die Anthologie des deutschsprachigen Cabarets*. Munich.

Budzinski, Klaus / Hippen, Reinhard. 1996. *Metzler Kabarett Lexikon*. Stuttgart.

Bürger, Peter. 2013. *Théorie de l'Avant-garde*. Paris.

Cohen-Avenel, Pascale. 2013. "Maître ou esclave ? Jazz, ragtime et cake walk en Allemagne avant et après la Première Guerre mondiale". *Amnis* [online], n° 12/2013, http://amnis.revues.org/1962 [last accessed 17.07.2015].

Debon, Claude. 2011. "Les ouvertures au plurilinguisme dans 'Calligrammes'". In: Bruera / Meazzi. 93-103.

Ette, Ottmar. 2012. *TransArea. Eine literarische Globalisierungsgeschichte*. Berlin/Boston.

Grutman, Rainier. 1997. *Des langues qui résonnent. L'hétérolinguisme au XIX<sup>e</sup> siècle québécois*. Montréal.

Hellberg, Frank. 1983. *Walter Mehring, Schriftsteller zwischen Kabarett und Avant-garde*. Bonn.

Hoeres, Peter. 2008. *Die Kultur von Weimar, Durchbruch der Moderne*. Berlin.

Huelsenbeck, Richard. 1920. *En avant Dada, Eine Geschichte des Dadaismus*. Hanover.

Jelavich, Peter. 1993. *Berlin Cabaret*. Cambridge.

Kelbert, Eugenia. 2010. "Reborn as René: The Interplay of Self and Language in a Selection of Rilke's Late French and German Poems". *The Yearbook of Comparative Literature*, 56. 201-224.

Knauth, Alfons K. 2007. "Literary Multilingualism I: General Outlines and Western World". In: *Comparative Literature: Sharing Knowledges for Preserving Cultural Diversity*, vol. II. Oxford/Paris. 146-169.

Kremnitz, Georg. 2004. *Mehrsprachigkeit in der Literatur, Wie Autoren ihre Sprachen wählen, Aus der Sicht der Soziologie der Kommunikation*. Vienna.

Lareau, Alan. 2002. "Jonny's Jazz, From Kabarett to Krenek. In: Michael J. Budds (ed.). *Jazz and the Germans: Essays on the Influence of 'Hot' American Idioms on 20th-Century German Music*. Hillsdale/N.Y. 19-60.

Mehring, Walter. 1974. "Conférence zur Eröffnung". *Das große Ketzerbrevier, Die Kunst der lyrischen Fuge*, Munich/Berlin.

Mehring, Walter. 1981. *Chronik der Lustbarkeiten, Die Gedichte, Lieder und Chansons 1918-1933*. Düsseldorf.

Michaud, Stéphane. 2000. "Plurilinguisme et modernité au tournant du siècle – Nietzsche, Wedekind, Lou Andreas-Salomé". In: Manfred Schmeling / Monika Schmitz-Emans (ed.). *Multilinguale Literatur im 20. Jahrhundert*. Würzburg. 189-206.

Schmeling, Manfred. 1996. "'In jeder Sprache neu': Zweisprachigkeit und Kulturtransfer bei Iwan Goll". In: Johann Strutz / Peter V. Zima (eds). *Literarische Polyphonie, Übersetzung und Mehrsprachigkeit in der Literatur*. Tübingen. 157-174.

Schulz, Georg-Michael. 2013. *Walter Mehring*. Hanover.

Stein, Roger. 2006. *Das deutsche Dirnenlied*. Cologne.

Stukenbrock, Anja. 2005. *Sprachnationalismus, Sprachreflexion als Medium kollektiver Identitätsstiftung in Deutschland (1617-1945)*. Berlin.

Suchet, Myriam. 2014. *L'Imaginaire hétérolingue. Ce que nous apprennent les textes à la croisée des langues*. Paris.

Weil, Kurt. 1990. *Musik und Theater, Gesammelte Schriften*. Berlin.

Weisgerber, Jean (éd.) 2000. *Les avant-gardes et la Tour de Babel, Interactions des arts et des langues*. Lausanne.

Weissmann, Dirk. 2011. "Mehrsprachigkeit in Frank Wedekinds Büchse der Pandora: ein (fast) vergessenes Charakteristikum der Lulu-Urfassung". *Germanisch-Romanische Monatsschrift* 3, 283-299.

Yasemin Yildiz. 2012. *Beyond the Mother Tongue, The postmonolingual condition*. New York: Fordham University Press.

# Index of names

17W77090/ T1/ 9789462701120